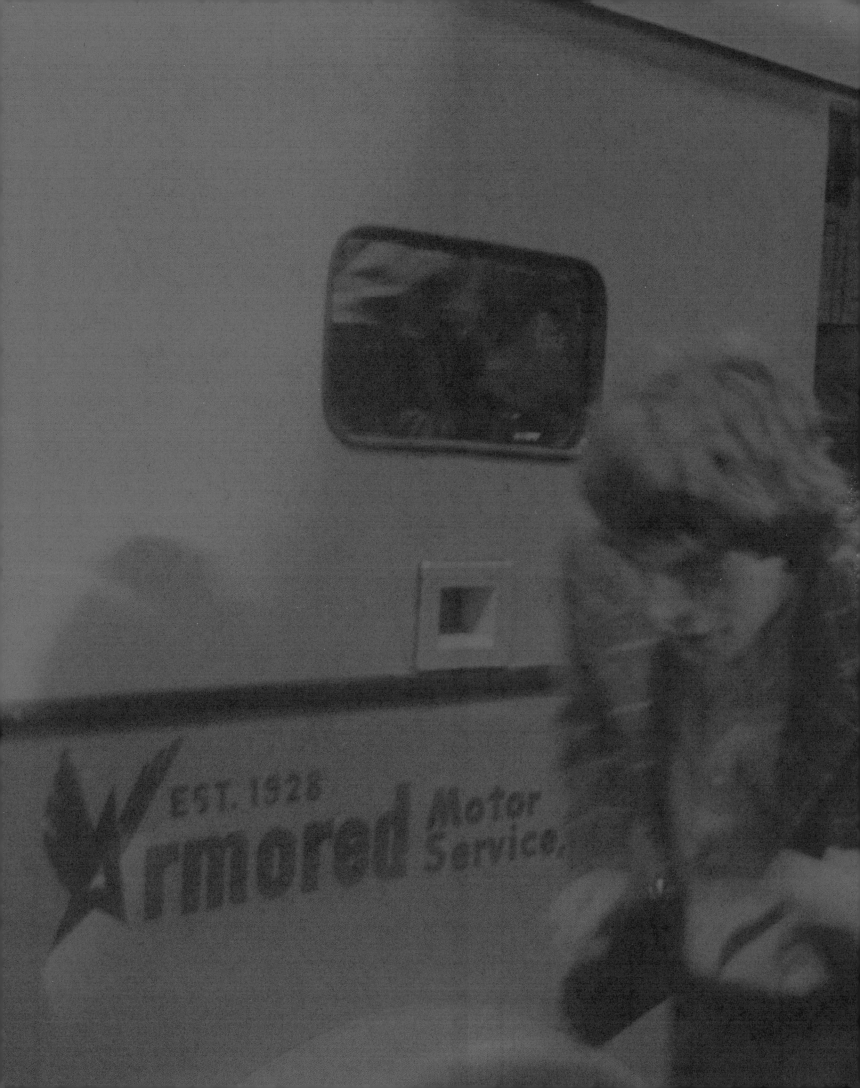

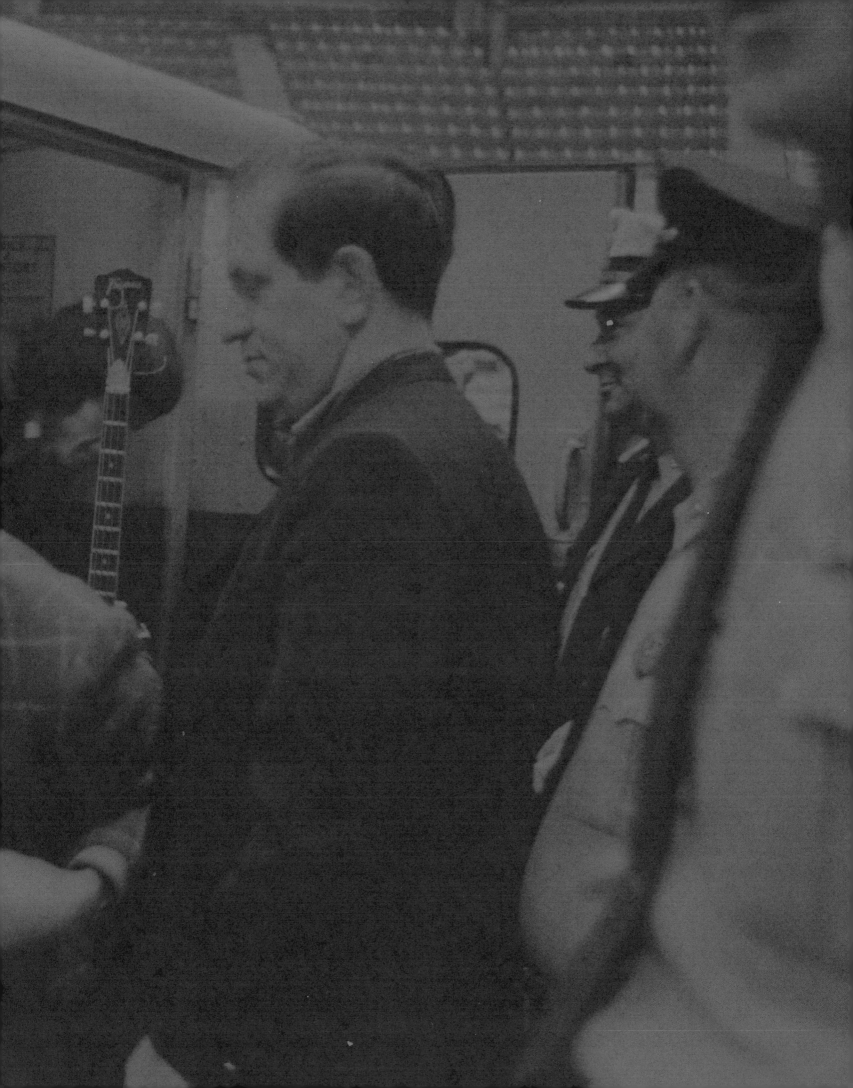

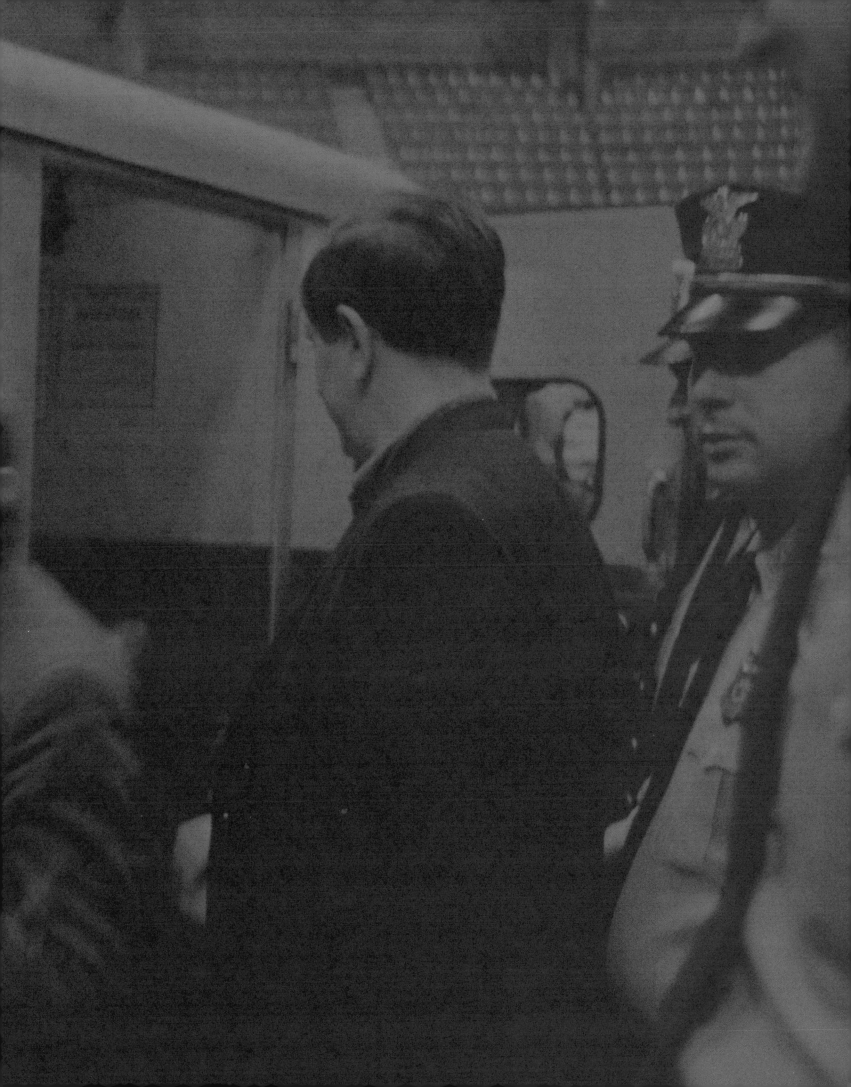

Andrew Loog Oldham co-managed and produced
The Rolling Stones from 1963 to '67.

Ladies and
gentlemen......
the Rolling
Stones!

Foreword by
Andrew
Loog Oldham,
March 2002

This is not the book of brilliantly ageing, shining Stones, of a time when Sir Elton John has been sober for twelve years, Mick Jagger has been sober "all his life" and Keith Richards continues to pay his dues. This is not a book of stars in self-conscious glory, maligned and snapped by the hack shutter that demands the lads fey forever young at umpteen award cathode carnivals. It's not even the book of the tough, magnificent second run that firmed the title "the world's greatest rock'n'roll band". This is the book that's the closest to the very beginning, when five into one did go, a book of pictures that captures forever the collisionistic wondertime of absolute rock'n'roll winners and definite beginners, and it's brought to you by Gered Mankowitz.

Nowadays, musical art seems to be the art of confidence, as in "confidence trick", an array of bravado, front and trickery founded upon a passion for fame and money but still dependent on the truth of the song and a voice in the correct key of life to deliver it. The craft of developing and honing your passion in front of what, hopefully, amounts to a crowd does not today have an instant connection to audio release and appreciation, and the world of musical entertainment is a shallower for it. "Live" (as a reference to your movement) is the cornerstone of your affinity with the crowd, the reality of shared familial experience and the basis of communication that allows the artist to become a part of the calendar of life. This present-time idea of fame and money, as I recall, came later in the '60s, when the game became incestuously entwined with survival and drugs. "Fame and money" were not completely working, so along came "peace and love". At the start of the game, for the most part, we young upstart war babes were interested in the avoidance of a regular job - the life our elders were moulding us for - and were more than happy to indulge our passion for music, fashion, a lark and art, to begin this thing that exploded with The Beatles and continues to define the present-day standards of musical and other art. Life for the British entertainer rode between clubs, pantomime and summer seasons. Appearances on the national telly and Beeb and record sales did not a mansion buy; they just added another twenty or fifty quid on to what you could eke out of the nightly stalls.

The Rolling Stones have become all of our heroes, first masters of the world and then masters of their world. We have partaken of their moments of triumph and doubt. Even as the tabloid/public execution of The Stones began at the end of Gered's and my run with the group in late 1967, they refused to comply with the accepted image of how local heroes and winners should be, rejecting the role

thrust on them, retreating, then emerging as the living, non-wavering embodiment of rock'n'roll and a way of life that protects us, nourishes us and adorns us to this day. Those awards of seeming approval were withdrawn sometime between the London Palladium roundabout fiasco, the confectioneried Redlands bust and the relentless bashing in the *News Of The World* and, to my mind, the acceptance granted in the early years has never been given back. This book is a reminder of what you can't take away.

It was the time before the nonsense, before music was merely food for the machine, when it had its say as attitude-prancing-in-the-street as opposed to automatic freeway fodder. It was a time when it was so easy to be brilliant and so hard to be average; when "special" was a given, perhaps a World War II bonus for aggressive, art-inclined wannabes; when expectations that rose above those allotted fuelled a new, clean tomorrow of music, lifestyle and image that remains the backbone of the gel-drained cultural wasteos of today.

In the time that Gered Mankowitz worked with The Rolling Stones, perhaps our greatest talent was the art of being young. Gered was born Leo in August 1946 to playwright/author/screenwriter Wolf Mankowitz and his wife, psychoanalyst Ann. Perhaps this combo of robust parenthood had the effect of divining a career for Gered that would have him reading minds into vision and image. (His father made an indelible mark on my psyche with the late 1950s stage and screen versions of *Expresso Bongo* that in no small way shaped the lad I would become.) Gered was the first of the four Mankowitz children and, to stay ahead of that pack, he left school at 15, having said "no thank you" to educational qualification and "hallo" to qualifying in life. He soon found he had ocular leanings and picked up the camera for better or worse, and for life. By 1963 he had done his run at the feet and lenses of others, picked up the basics of the craft, and was photographing Chad and Jeremy, one of the more successful UK answers to the lure of The Everly Brothers. A year later, under circumstances I cannot recall having been a

part of, Gered snapped the finest shots of Marianne Faithfull, with whom I had just had a very pleasant hit via "As Tears Go By". Thus Gered gained entry to the new generation of waifs, talented muso strays, producers and impresarios that formed the replacement brigade for the fashion world that had been, in truth, the first British Invasion. More importantly (for the sake of this agenda), Gered started to work with The Rolling Stones, and me.

GM refers to this as a major turning point in his career and, indeed, he brought his skills to us at a similarly crucial point in the career of The Stones. Art and will collided as GM captured The Stones when their craft had vulnerability, a key in the development of any true artist (as opposed to the savoir-faire-without-grounding of today). Gered had a clear view of what was going on around him, and we were it. For that wonderful while he snapped reflections of himself, us, and the day. Part of the game was the record-breaking *Satisfaction* tour of America in the autumn of 1965, and here begineth the true myth. As the pictures frame and freeze the ocular truth and observation of life, birth, and growth on the road and in the recording studio, The Rolling Stones find themselves, via song and charisma, gaining the American legs which would give them the world. From Hollywood, the seat of the American Dream and the birthplace of that first golden vinyl run, the group returned to London in the winter of 1966 and laboured under the scrutiny and criticism of the press and police, shills for the general outrage that the public unfurled on the other side of the coin: Ladies and gentlemen - The Rolling Stones! It was all right for The Beatles to have it all - MBEs, rock'n'roll manors, gurus and one-eyed Bentleys - but not The Stones. That was pushing beyond your allotted station,

frowned upon - and the frowns soon turned hostile and severe. A truth is that The Stones should have stayed on the road and never come home, but they did, and they remain celebrated and unforgiven for it. Those recordings and images and changing times merged into *December's Children*, *Between the Buttons*, *Aftermath*, *Got Live If You Want It!*, *Flowers* and *Big Hits (High Tide and Green Grass)*. The actual trials, real and perceived tribulations, plain-damned tiredness, and "changing of the guard" (i.e., my exit) are all captured by Gered. Here are images of fire, grace and the merely mortal in a time when "alternative lifestyle" meant work-as-play, and the two intertwined to give Britain an empire of new clothing, rhythm, attitude, and a place in the sun.

If I may, let me caption a few of those pictures. Gered's late-1966 album cover shoot on Primrose Hill one 5am morning for *Between the Buttons* was a moment towards the end of that first golden run and the sad continuing deterioration of Brian Jones. The Stones were off the road/studio/track of the past three and a half years and were trying their best to fit into an unreal "real" world, a world they had not really lived in since the marathon wonder-schedule kicked off in mid-1963 and didn't so much stop in late '66 as keel over. We were in Olympic Studios every evening and that, in itself, was an adjustment (we'd been weaned on an American routine of shuttling between hotel/motel on the Sunset Strip and RCA Studios in Hollywood). Now, for the first time, we were recording from home under the pressure of having "made it". Olympic was a process of learning, of getting to know its uniqueness, its room sound, and its soul, which I found easier to trace in the sunshine than in the grey dankness of London in the autumn. We were dealing with a new, easier schedule, but it was harder. The edge of the road was gone and we now had a completely different environment in which everything, including album covers, had a deadline. So Gered and I decided that the *Between the Buttons* shoot would have to be done with the arriving dawn as The Stones finished the night's recording. At 5am we had fried eggs,

fried bread and hot, strong tea and smoke and, in my Phantom V and Keith's drop-dead-drophead Bentley, drove as fast as possible from Olympic in Barnes, south of the Thames, to Primrose Hill in northwest London. Both drivers were ordered to keep their foot down, my concern being that if the drive took too long, tiredness and the needed heat in the cars would leave Gered nothing to shoot when we arrived at Primrose Hill save a bunch of sleeping Stones.

We made the ride in just under twenty minutes. To keep the group alert (and, hopefully, amused) I had my driver ease the Phantom V into the park and as far up to the top of Primrose Hill as he could go. We got out and walked the last few steps to the top where, with Vaseline-smeared lenses, Gered intended to, as philosopher L. Ron Hubbard described photocraft, "write with light". Just down the hill from where we had parked we spied another morning visitor. A long-haired, bearded, overcoat-clad hippie stood on one foot, the other crossed

"C'mon, Gered, it's bleedin' cold, get a fuckin' move on, dear!"

ballet-style, sole pressed to the inside of his knee, playing his flute to welcome the new morning. He amazed and chuffed us all by being totally immune to our arrival at the top of his manor in the long, black-windowed Rolls. He played away in the Baskerville-ish, smoky near-morning light. After ten minutes of Gered setting up his shot and barking "Luv" and orders, Moxie, our early Jethro Tull, felt the intrusion and moved off to another mound of ground to continue his morning ritual.

Mick, Keith, Charlie and Bill, with a minimum of moaning and shouts of "C'mon, Gered, it's bleedin' cold, get a fuckin' move on, dear!" were on for the shot and up for the occasion, while Brian seemed to shrink by the minute into the light brown fur coat he was wearing. As the other Stones rose to the occasion, Brian seemed to fade from it. The time came about when the four Stones knew (from experience and instinct) that Gered was close to the series of moments that counted, and they gave him that extra zap, pulled themselves

up and delivered the spark that separates the men from the toys - the look of life, of what we are about, the giving up of themselves to the camera, as art is explained by another art and audio communication gets presented via visuals. The moment is taken, or better yet, it's shared, seized on film. "This is us, Now! Look at who we are and inside this elpee cover you'll find us and our latest recording." The Stones were suddenly there, Gered was there, the picture was there, taken. Our time was up, the light had changed, the day had moved on and belonged to others, but for us it had done its turn and it was time to go home. We'd got the shot and it was time to get the Phantom out of the park and into bed before some cops arrived and asked if we had a permit. I crashed for a few hours and at 4:30 that afternoon eagerly turned up at Gered's studio to see the results of the shoot.

Gered gave me the colour and black-and-white to look at and impatiently waited for me to love it. I did. Gered's work was, as always, unusually rewarding, but in this case an extra round of "well-done" was called for. Though no shoot is the same, this one had been sailing very close to the wind, stealing time that in minutes would be gone, on Her Majesty's property without a permit. What I had in my hands was pure art. It would be, and is, my favourite album cover. And yet...

"Andrew," Gered said, "It's quite weird. Look through all the shots, do you see what I see?"

"What's that?" I was bewildered. I'd already told him in as many words I thought the result genius.

"Look, it's Brian. It's as if he wasn't really there..."

Gered was right. The camera not only did not lie, it had managed to peek round the corner into the future. In some shots it looked like Gered had superimposed Brian over the Primrose Hill proceedings; in others it appeared he had pasted Brian's head and shoulders in from another land. Mick, Keith, Bill and Charlie brought their shoulders and very being up as one and gave Gered a view from the kill. They were "on" together, and it showed. Brian looked spiritually illegal, a collection of sad deeds and doubts resigned to seeking its maker.

In the 1960s the camera started to release the artist from gloss and slavery and Gered was there, blessed to be at one with his young career and tomorrow's ideas. The camera can and had interfered with the art and misinterpreted the artists' dreams... acts have to get work, people get used to posing, photographs are seen as a tool towards employment. The results are obvious. Gered was the answer and the antidote to that way of life. He loved the music, the vision and the attitude and,

with his lens, captured a new reality, an innocence of ambition, a passion for rock'n'roll that was allowed to grow live (as opposed to at-a-video-near-you). Gered shared his run with The Rolling Stones, as I did mine. We were playing in glorious rough and tumble days, amazed at our good fortune, learning on the job, doing what we wanted, with an under-belly of passion to sustain our growth and wins. We had the common sense to bond on the job with Gered and he so ably illustrated news, because we were news, we were a warning. The private club and being of The Stones would soon bleed for better or worse into the very fabric of the society you fear today. Gered captured the time before the message seeped out of the mouths of rock operatives and into the pores of tomorrow. He captured the good time that was being had by all, when The Stones were young, proud, bright-eyed, ambitious and rebellious - and so was the world we produced in.

© Clear Entertainment Ltd. Andrew Loog Oldham co-managed and produced The Rolling Stones from 1963 to '67. He lives in Bogotá, Colombia and is the author of *STONED*. The second part of his triography, *2STONED*, is published in October 2002 by Secker & Warburg.

The
Stones
65 –
67

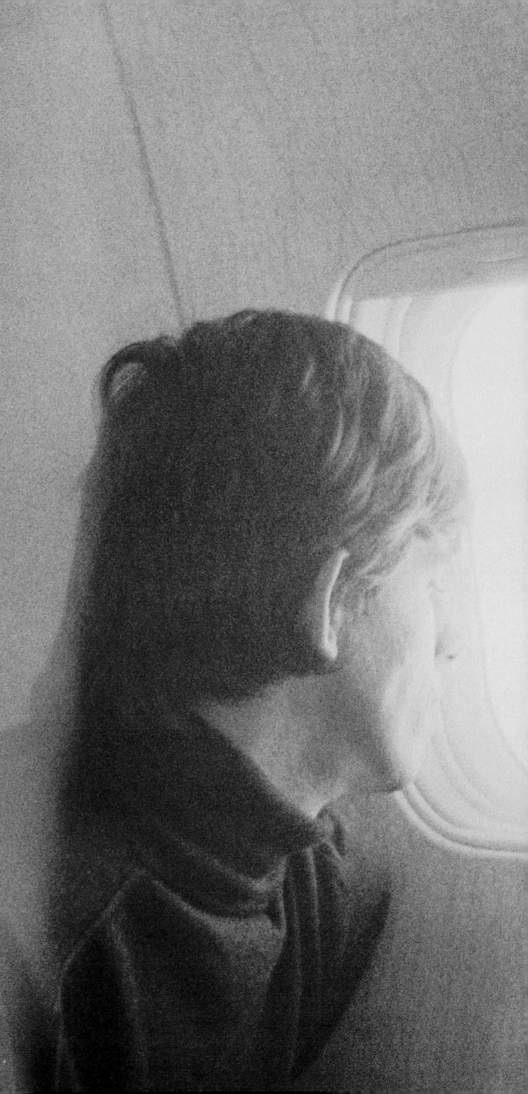

This was the second tour in '65, probably their third American tour. There wasn't any great entourage. Andrew Oldham was already in New York, so it was just seven of us, in the first-class cabin. I don't think the other passengers were too bothered. We just played cards in the lounge section. They weren't jaded about the tour but it was the third one, and they had a pretty good idea of what was to come. It was the first tour where they had their own aeroplane. I think that was exciting to them.

65 –
They had a pretty
good idea of what
was to come

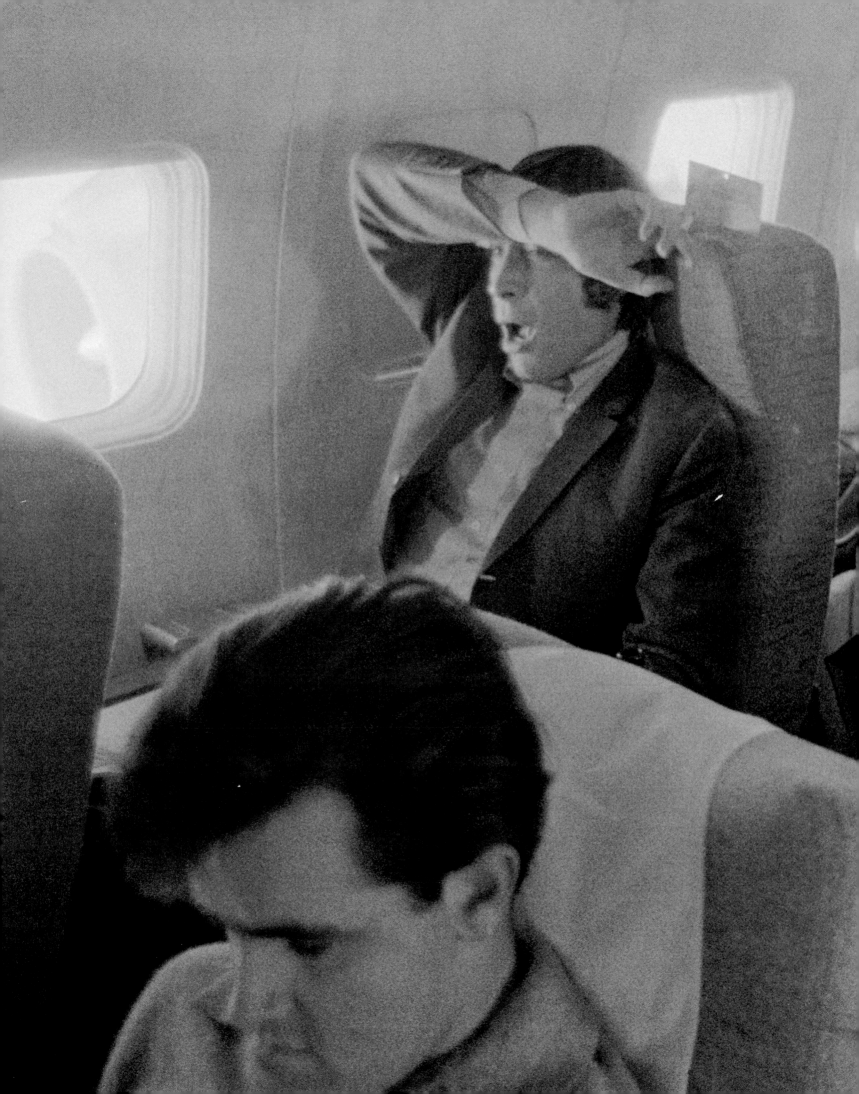

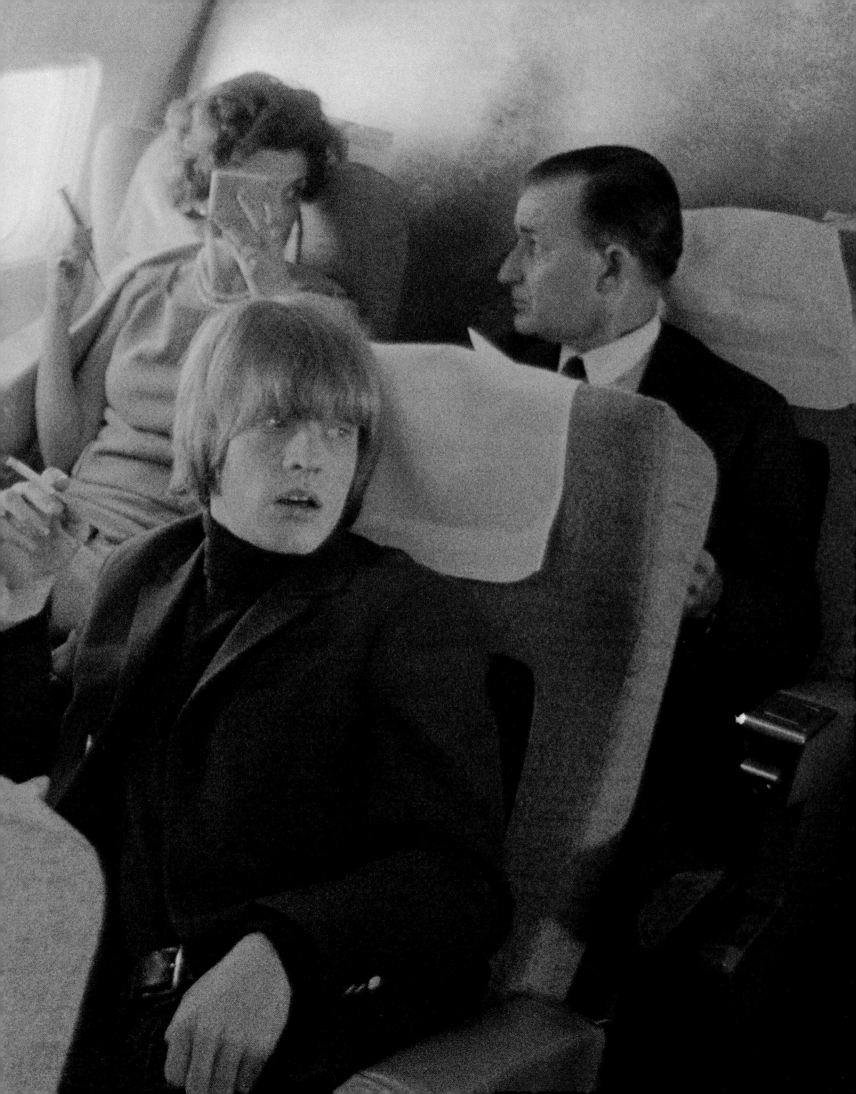

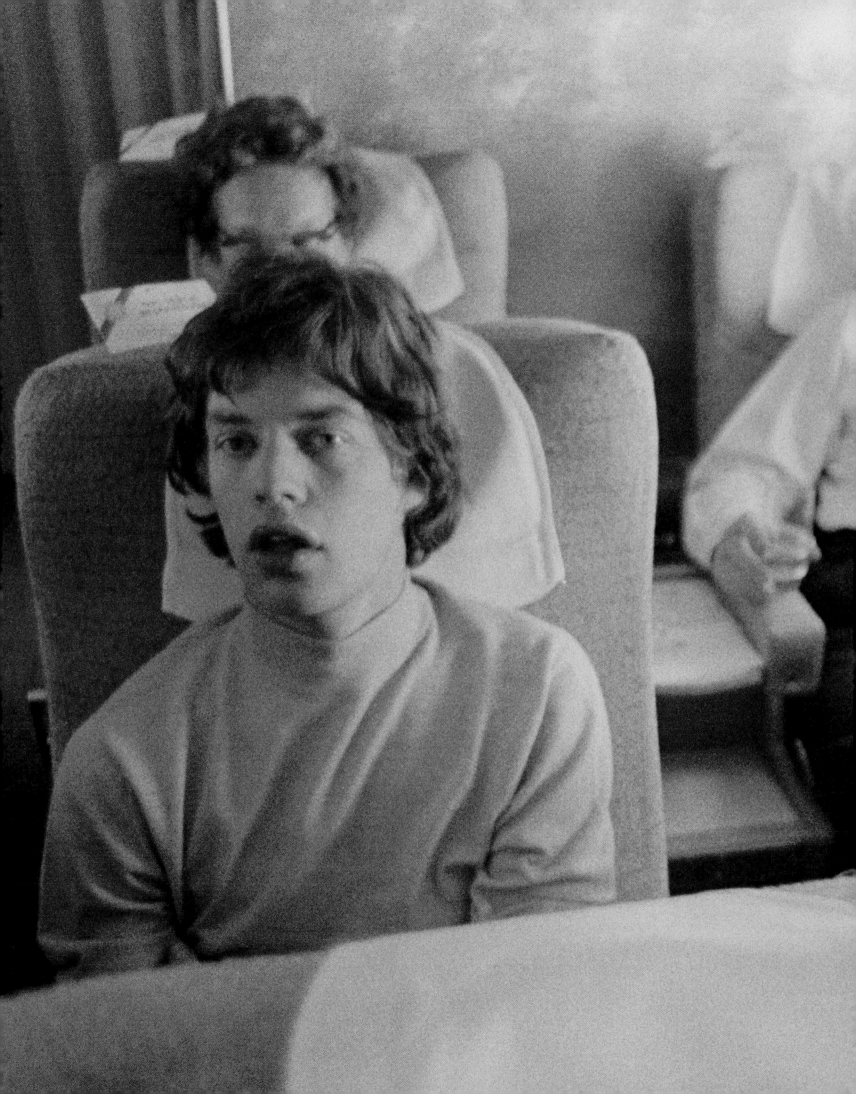

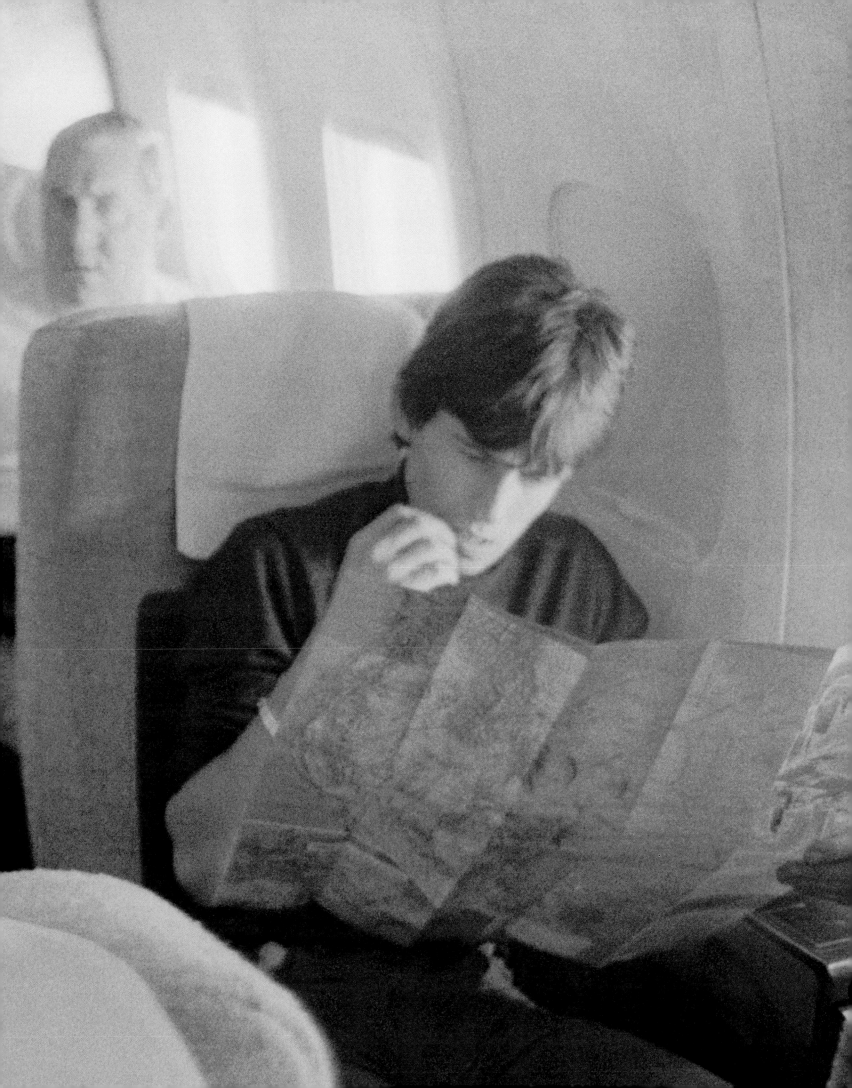

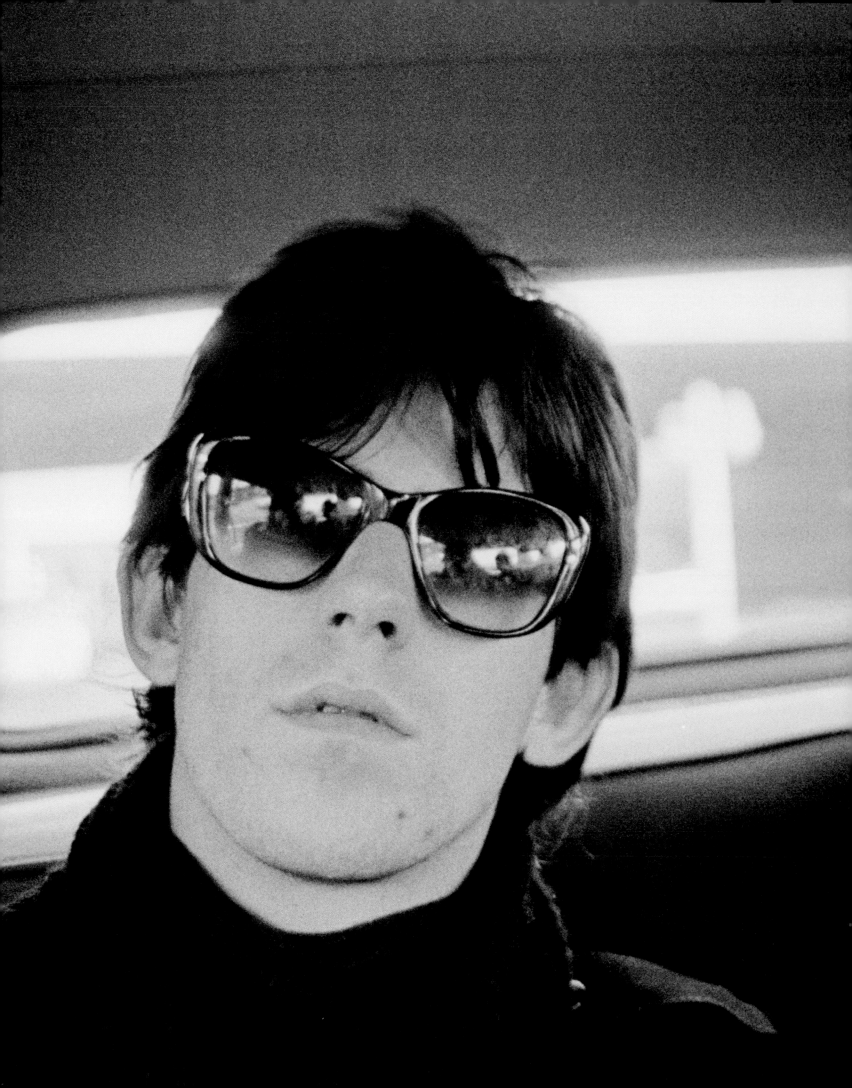

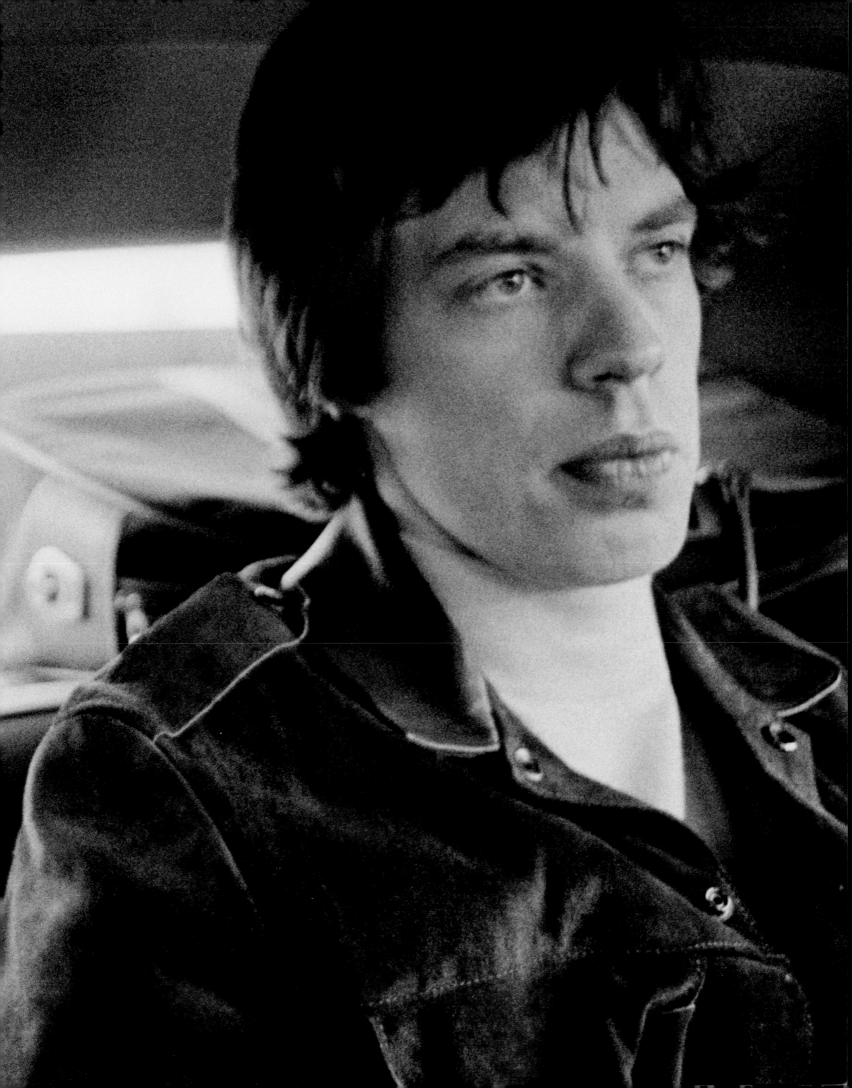

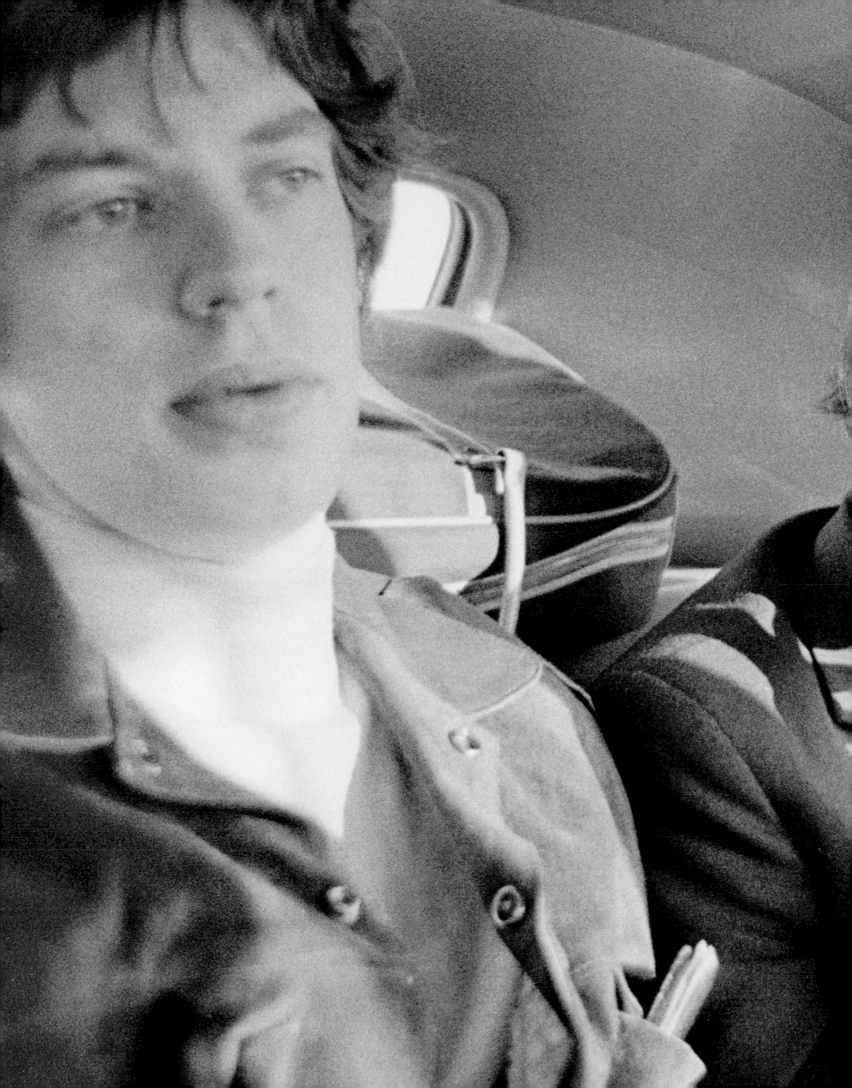

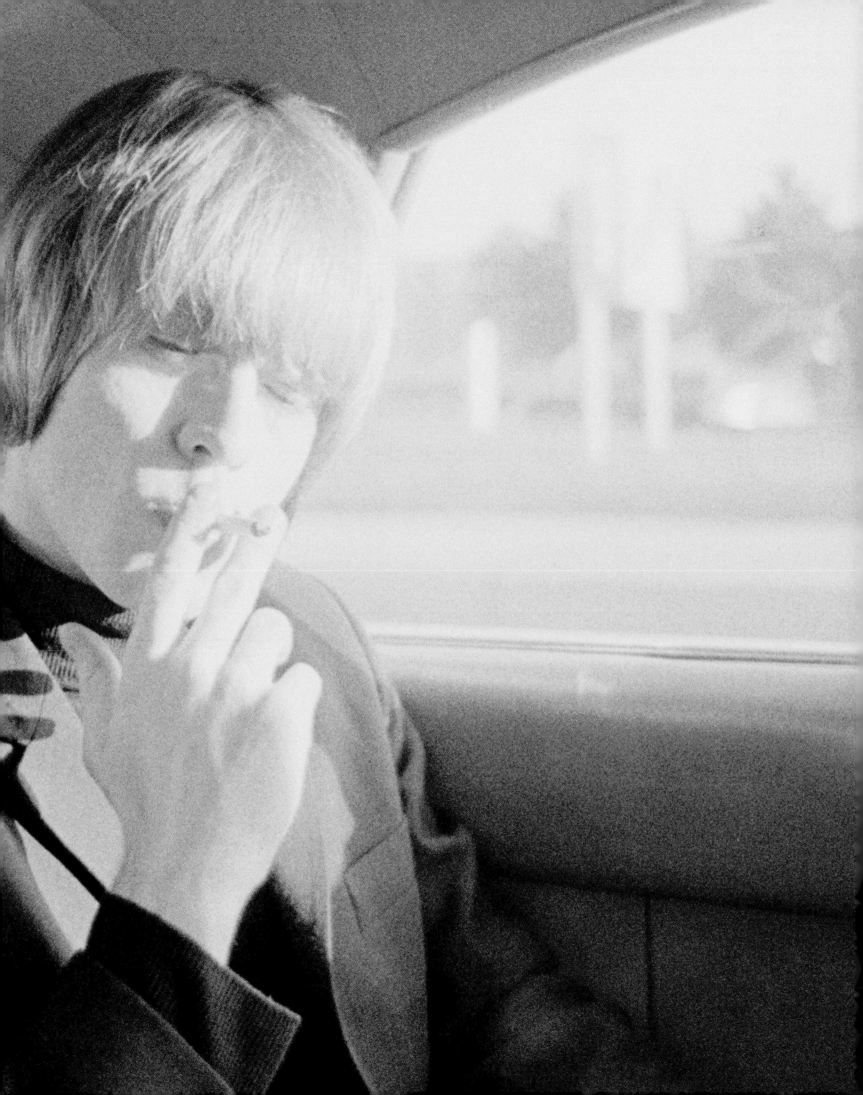

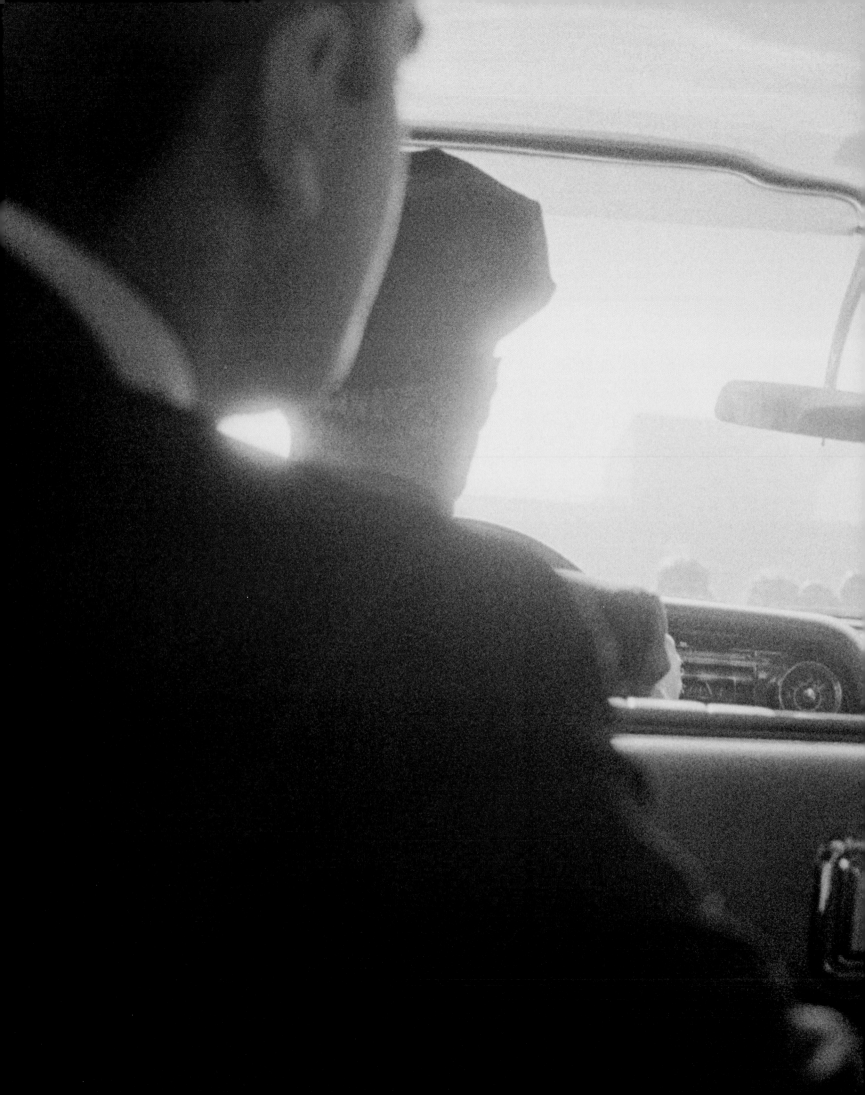

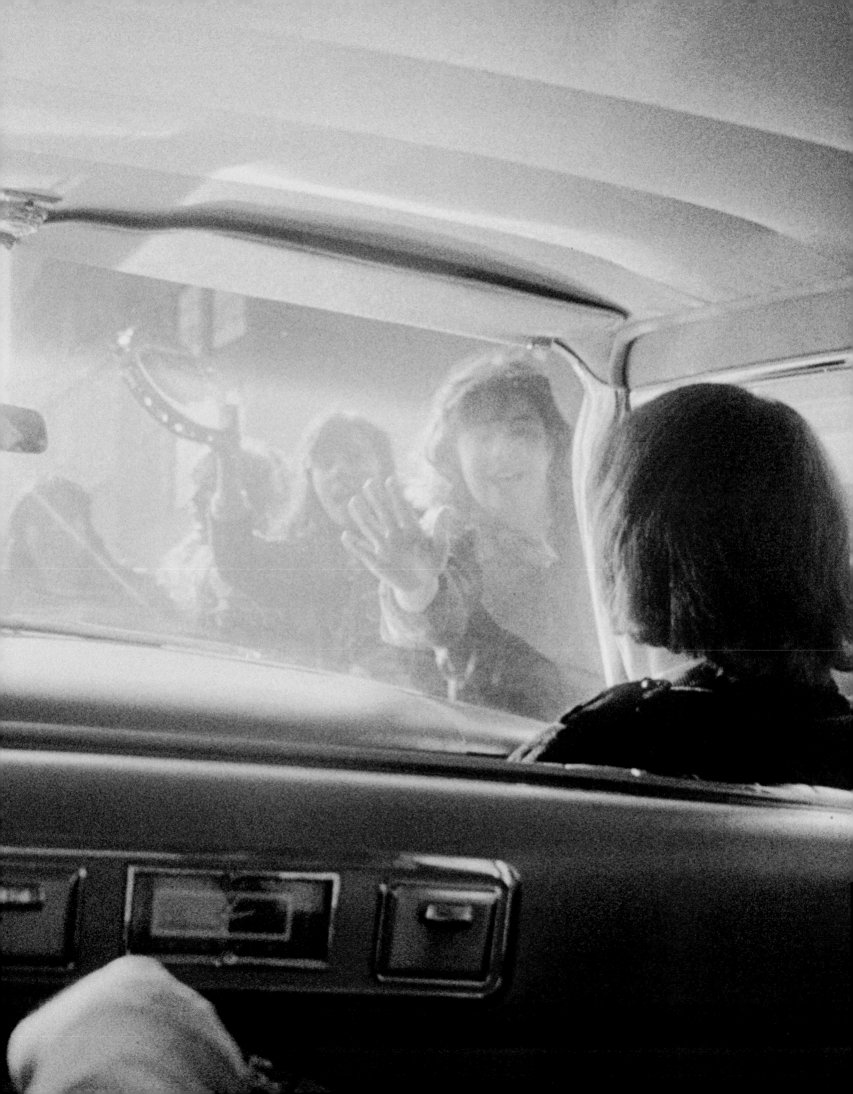

When we landed at Kennedy, Andrew Oldham and Alan Klein met us, and we were whisked into New York in Cadillac limousines. There was a huge crowd outside the hotel, The City Squire, on Broadway, and the drivers didn't really know how to deal with it. The police outside were exasperated and we couldn't get into the underground car park, so the drivers stopped, and the girls just swamped the car, and crawled all over it, and the roof started to cave in. We had to hold the roof up. And all the time we were doing this, Bill, who was sitting in the front, was chatting up girls through the window. It was pandemonium.

There was a dent left in the roof of the car but I didn't photograph that. I was too immersed in what was going on.

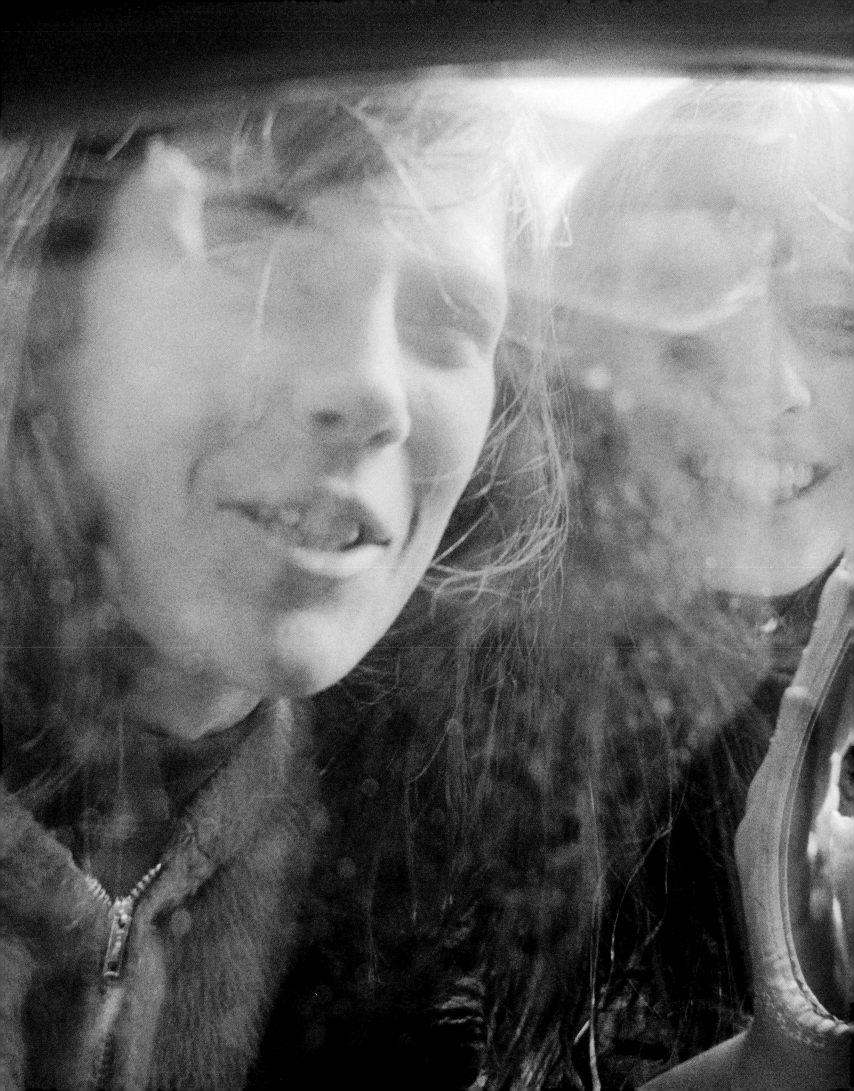

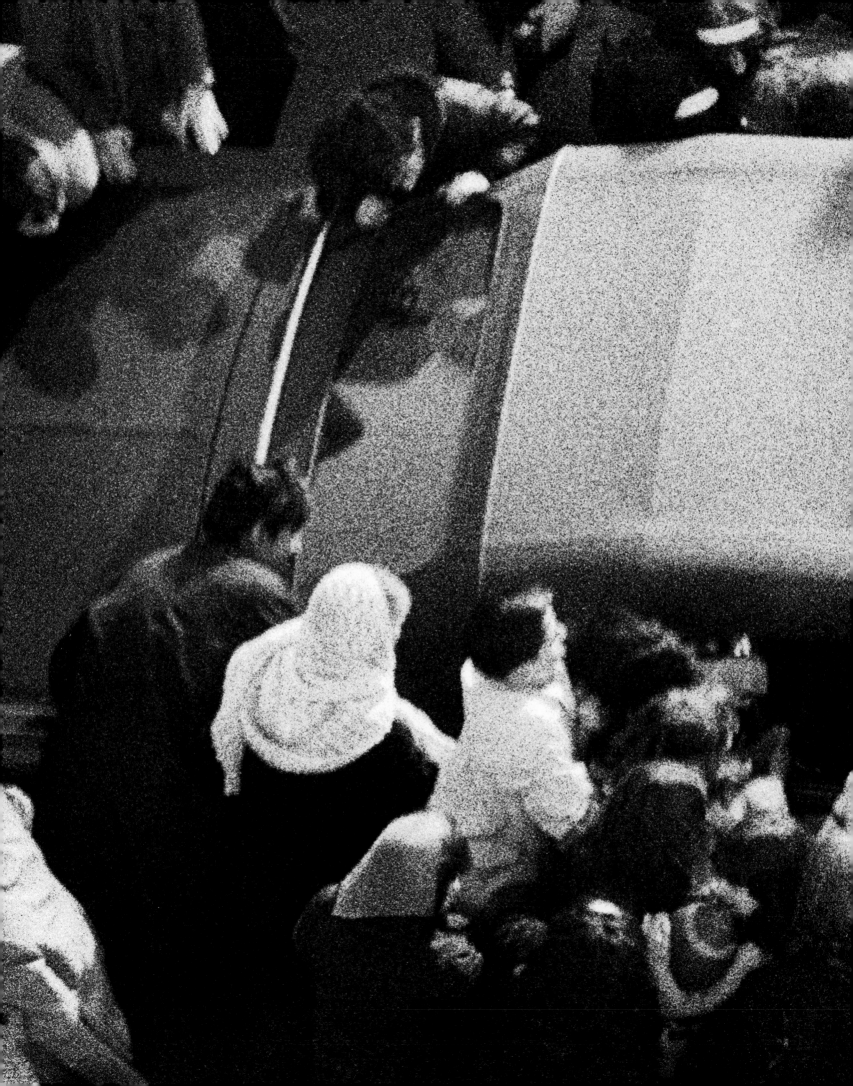

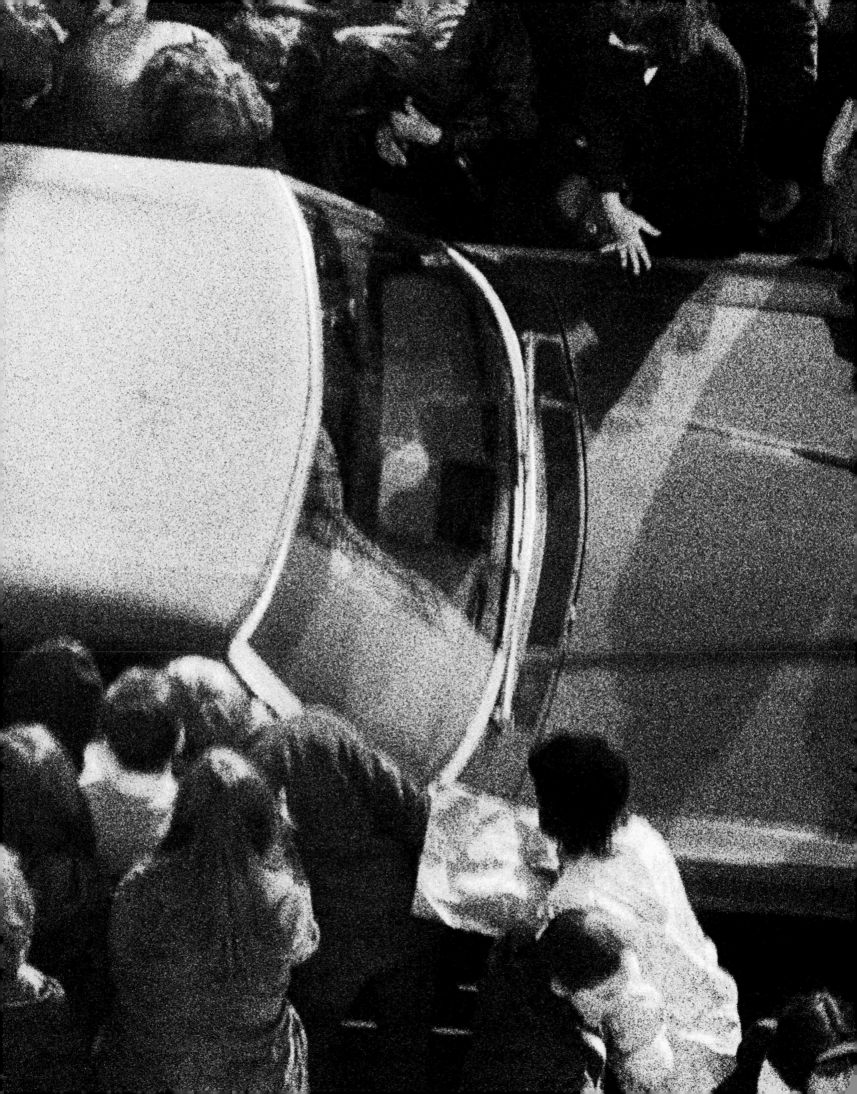

Pete Bennett was the greatest record plugger of all time, and he was Alan Klein's record plugger. He was famous and he was a fantastic character and as you can see he looked like someone out of a Martin Scorsese film.

One of the things I like about looking back at him is that his look was typical of the time. He was immaculate and buffed and manicured and the antithesis of the rebellious, grubby, student-y thing that we were part of. He also had his initials on everything, on his shirts and ties, and on his socks as well. On everything.

I shared a room with Pete Bennett a couple of times on the tour. He wore incredibly huge boxer shorts and suspenders for his socks, and spent a great deal of time on his hair. But the real point about Pete Bennett was that through-out that tour, "Get Off My Cloud" was exactly where it was meant to be in the charts. I've no idea how he did it. But one had tremendous respect for this guy. He was incredibly well connected. He had photos of himself with Nixon, Elvis, the Kennedys, Tom Parker, everyone.

65 –
He was incredibly
well connected.
He had photos of
himself with Nixon,
Elvis, the Kennedys,
Tom Parker, everyone

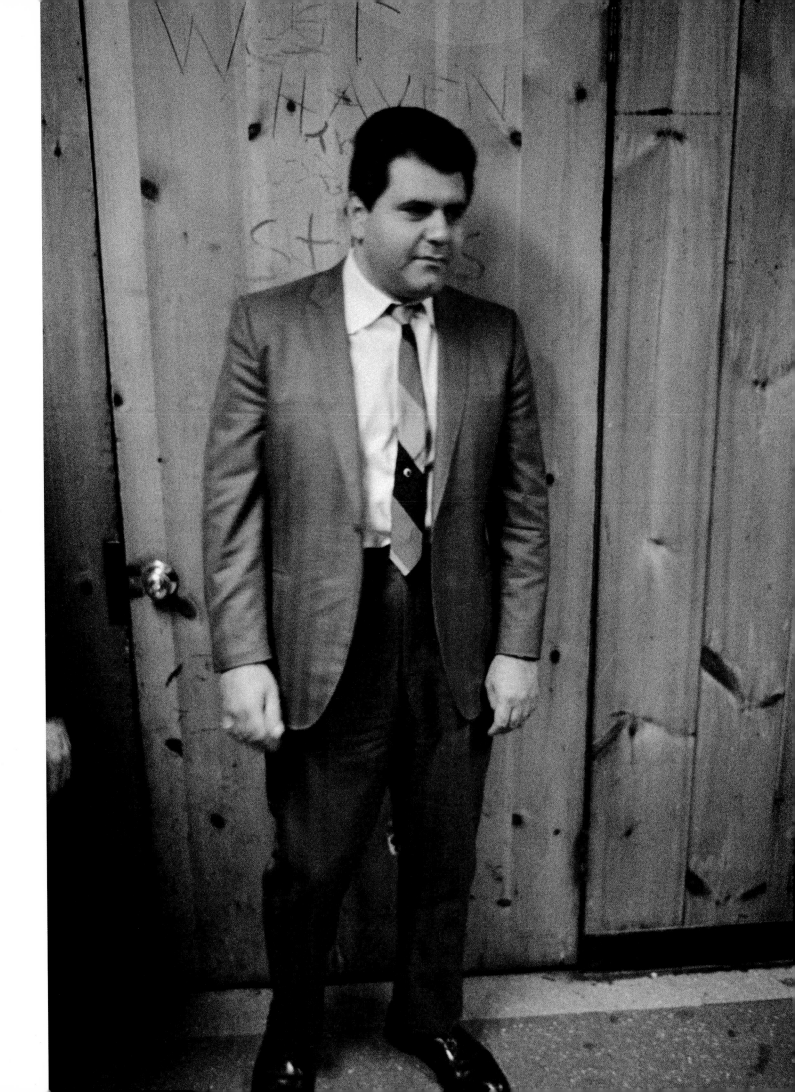

The venues were very mixed. A lot of them were auditoriums, sports halls really. Some of them were places where there had been rodeos, and stank of cows and horses, and the dressing room facilities were very basic. There were tables and chairs if you were lucky and as you can see, Charlie's pissing in the sink, I guess because the toilets were a long way down the hall, or we were trapped. There were no en-suite facilities, and no plentiful supplies of drink or willing maidens. It was far removed from the fantasy vision of rock'n'roll touring.

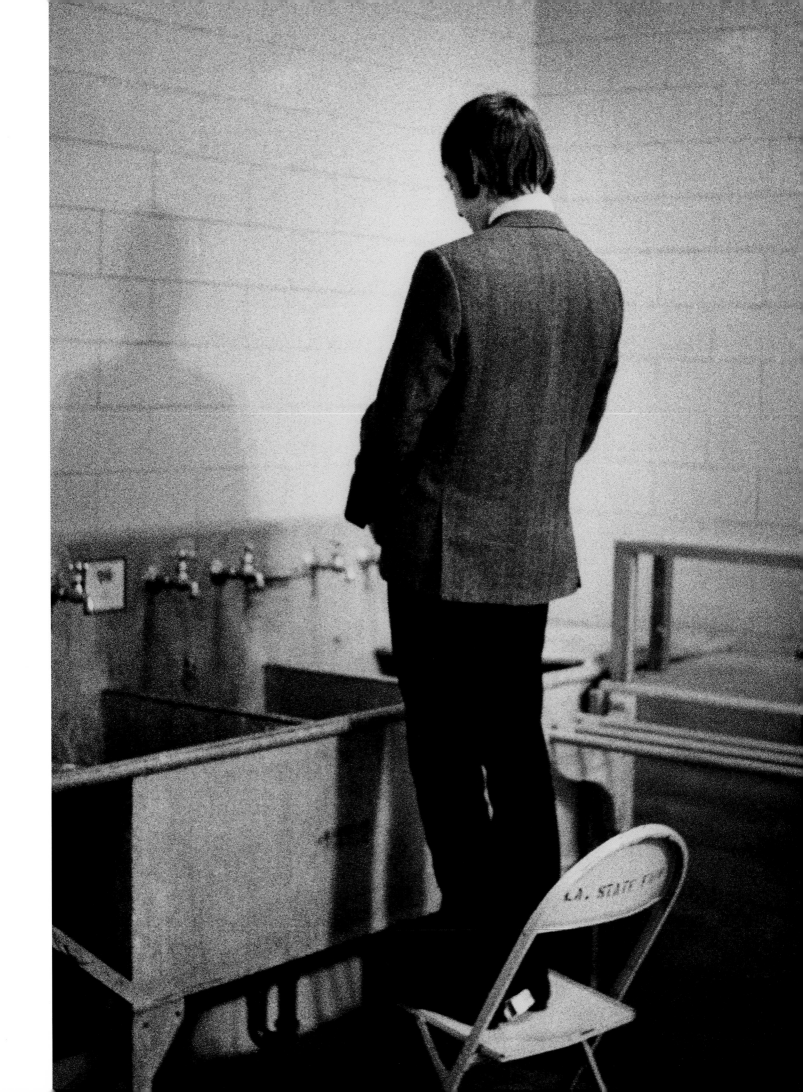

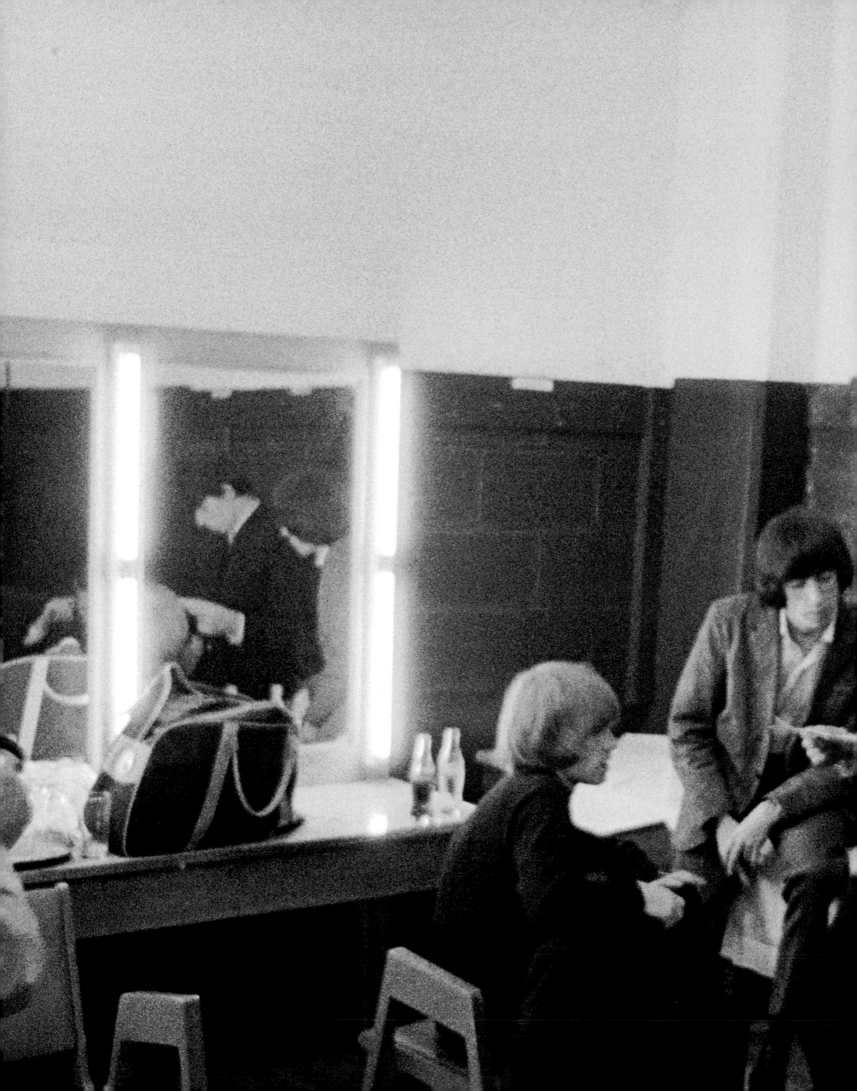

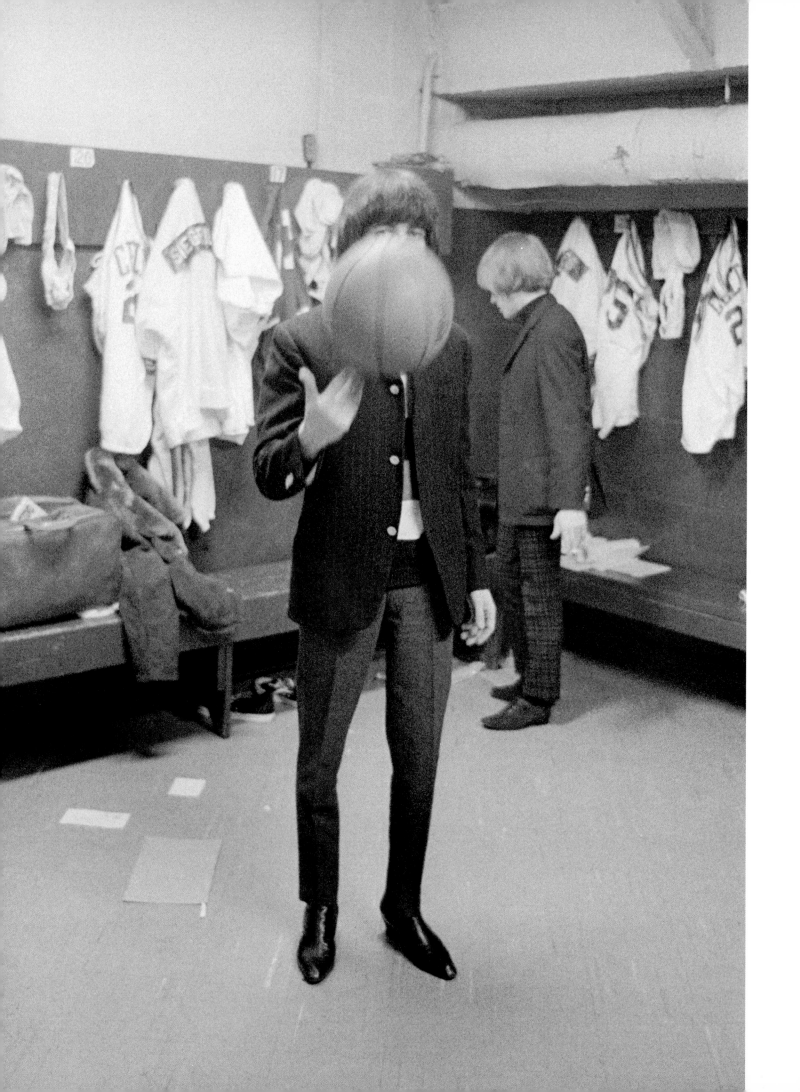

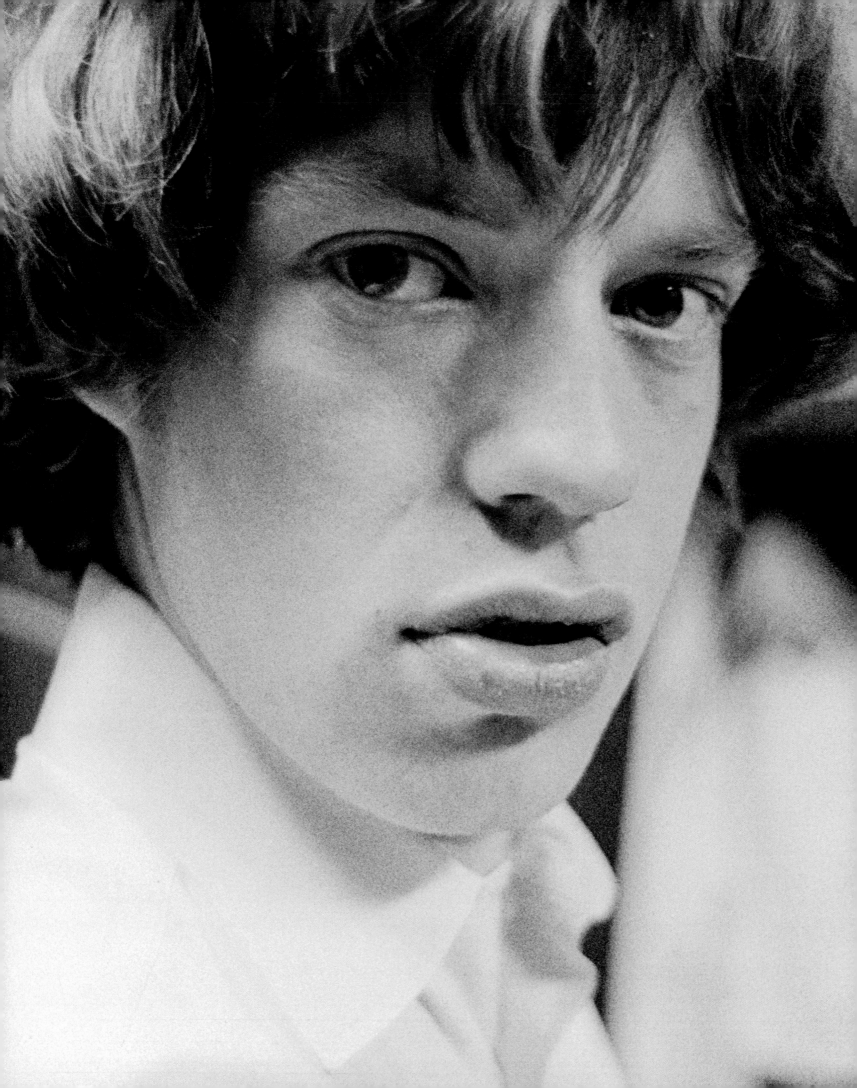

Their hair was considered very long. One time in a coffee shop somewhere in the South, Charlie and I were going to have some breakfast and a little old lady berated us for being long-haired and filthy. If you were long-haired you were filthy. This funny little granny almost attacked us with her duck-handled umbrella.

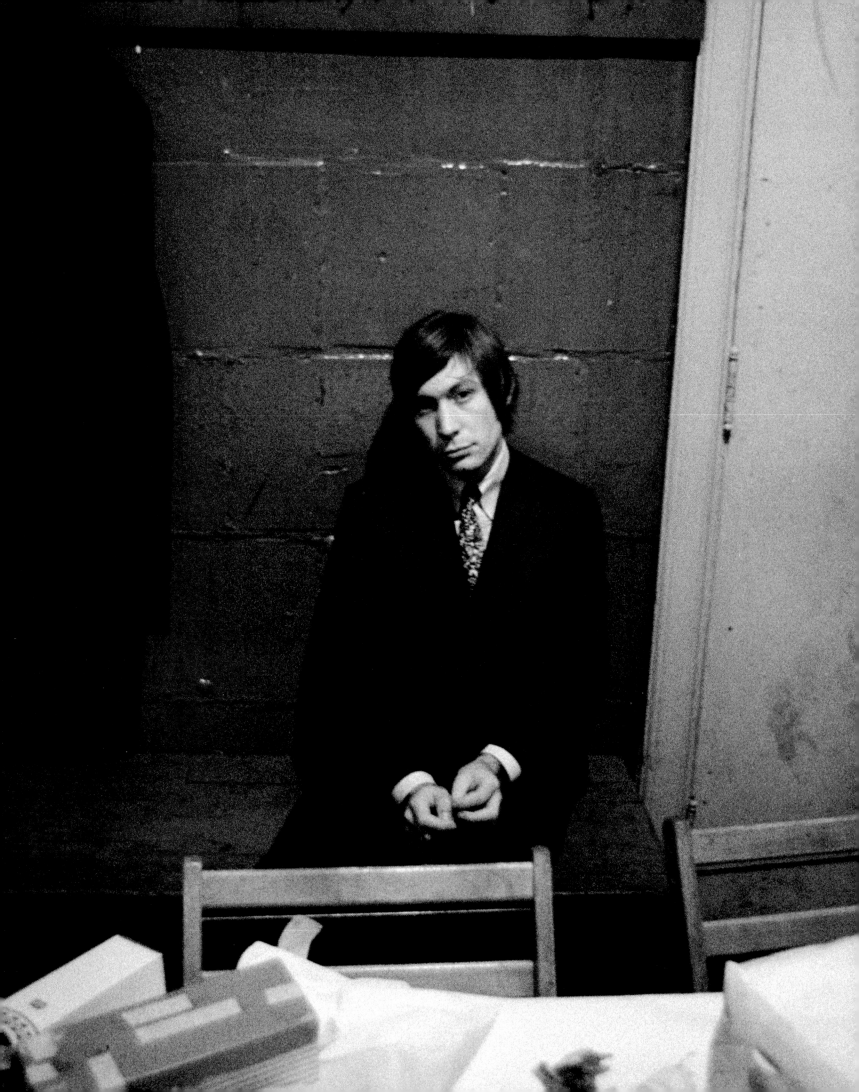

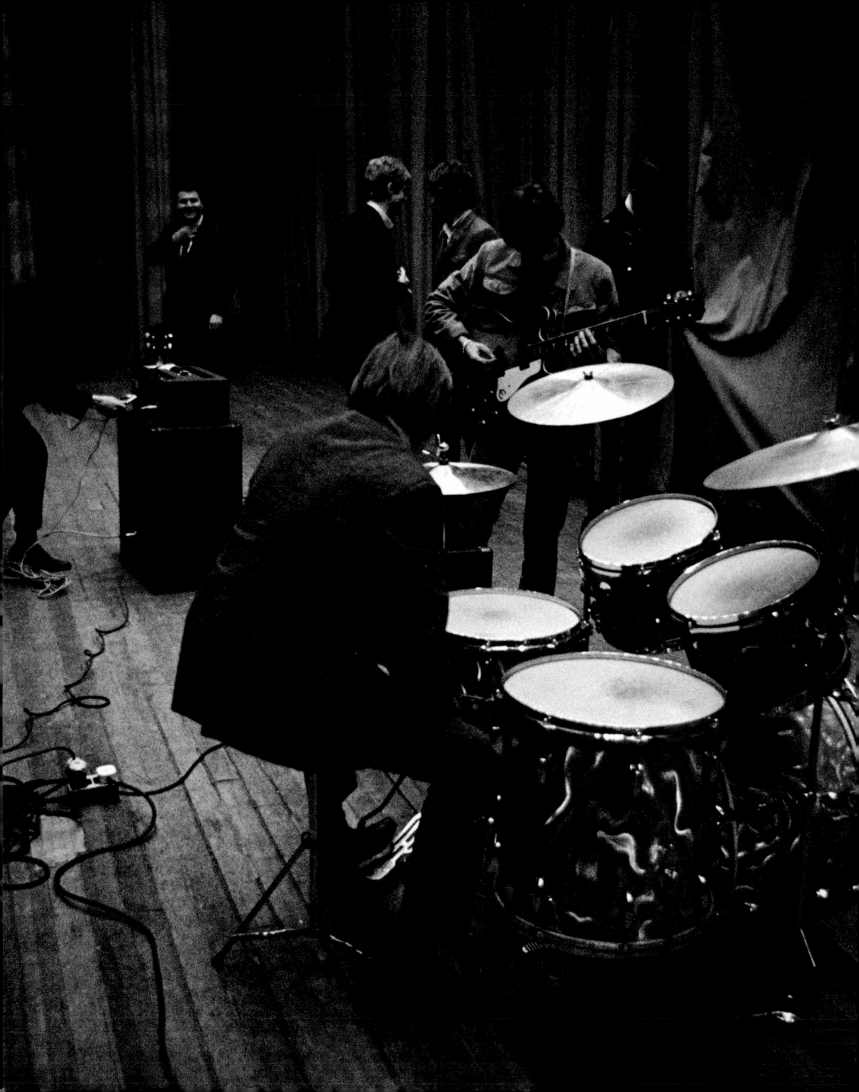

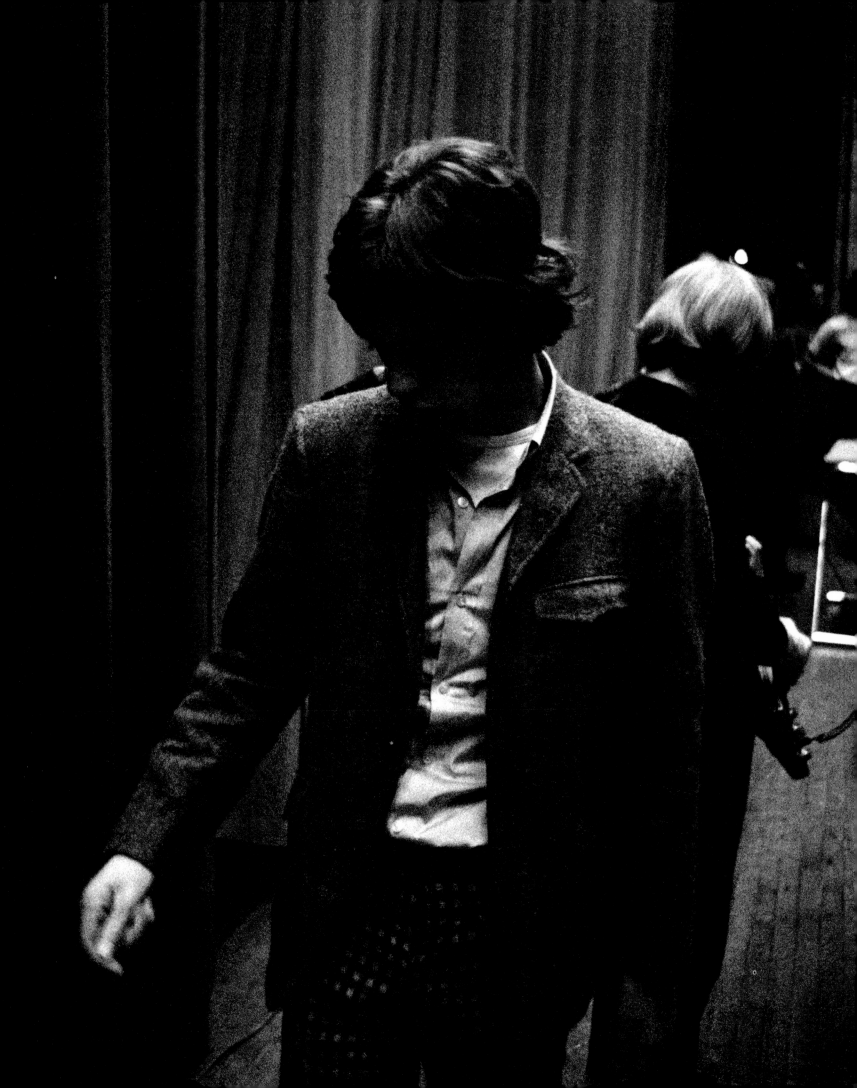

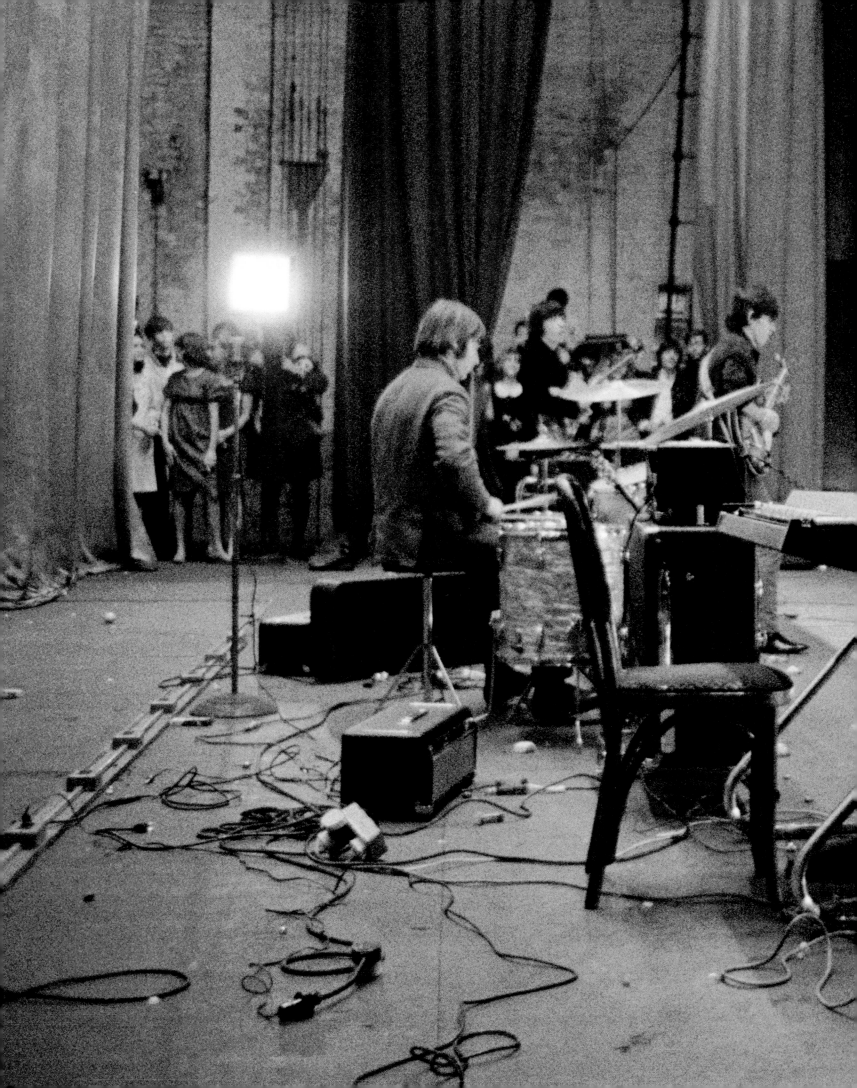

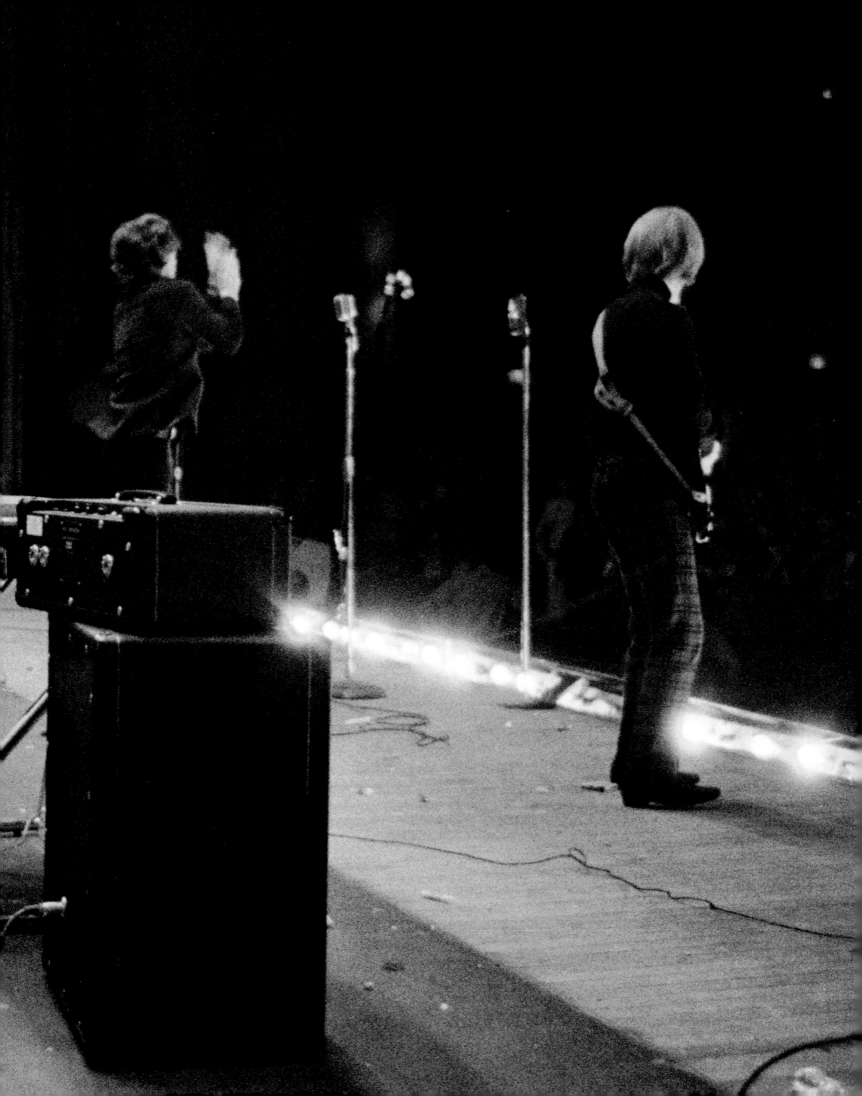

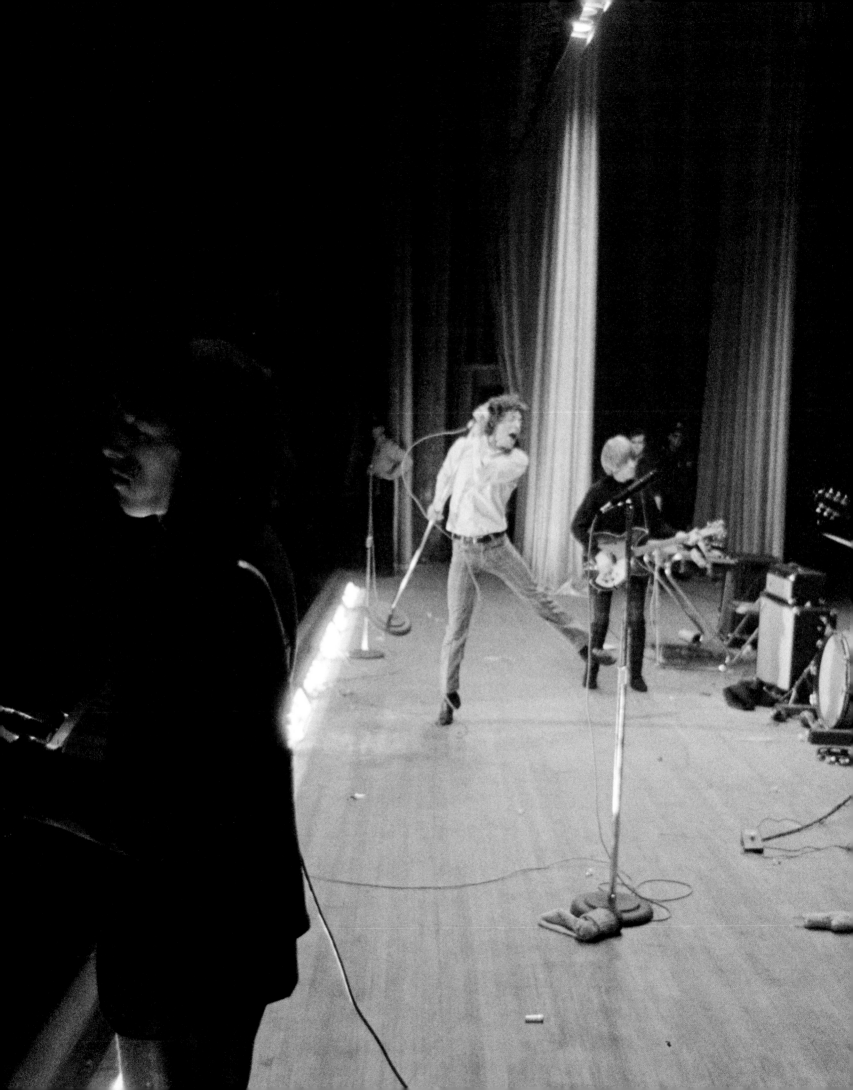

From a practical point of view, taking photographs from the side of the stage was the only way to do it. Frequently there was no pit and I couldn't get into the audience. In most places I had to work from the wings or behind them, or I could just sneak up on the edges.

Generally, the lighting was appalling. Backstage there'd be two or three working lights thirty feet up in the air, and I pushed my film to the very limits to get an image. I had a flash with me but I used it very rarely, because they didn't like flash, and I didn't like the quality of flash.

At some gigs I just didn't take my cameras out because it was so awful. I could get more out of the atmosphere by shooting into the light, so there's quite a lot of that. If there were follow spots, it gave me these lovely silhouetted figures which I liked very much. But it wasn't conducive to photography.

There's a professionalism at almost every level of music presentation now, but it wasn't like that then. The backstage was chaos, the equipment was basic and dangerous, there was no soundcheck, Mick was almost certainly going through the house PA system, and there were no monitors and no sound desk. It was really basic, but that's how it was done. Of course something like The Beatles in Shea Stadium was huge, but everybody knows that you couldn't hear a thing.

I don't recall girls falling off the balconies, but it's perfectly possible that it could have happened without people knowing. There was an incredible pandemonium. We didn't have backstage passes and we didn't have badges. The tour manger, Bob Bonus, was very experienced, but I had nothing on me that said I was part of The Rolling Stones' team. In one photograph, a motorcycle cop is about to try to stop me taking pictures because he hasn't realised I'm with the band.

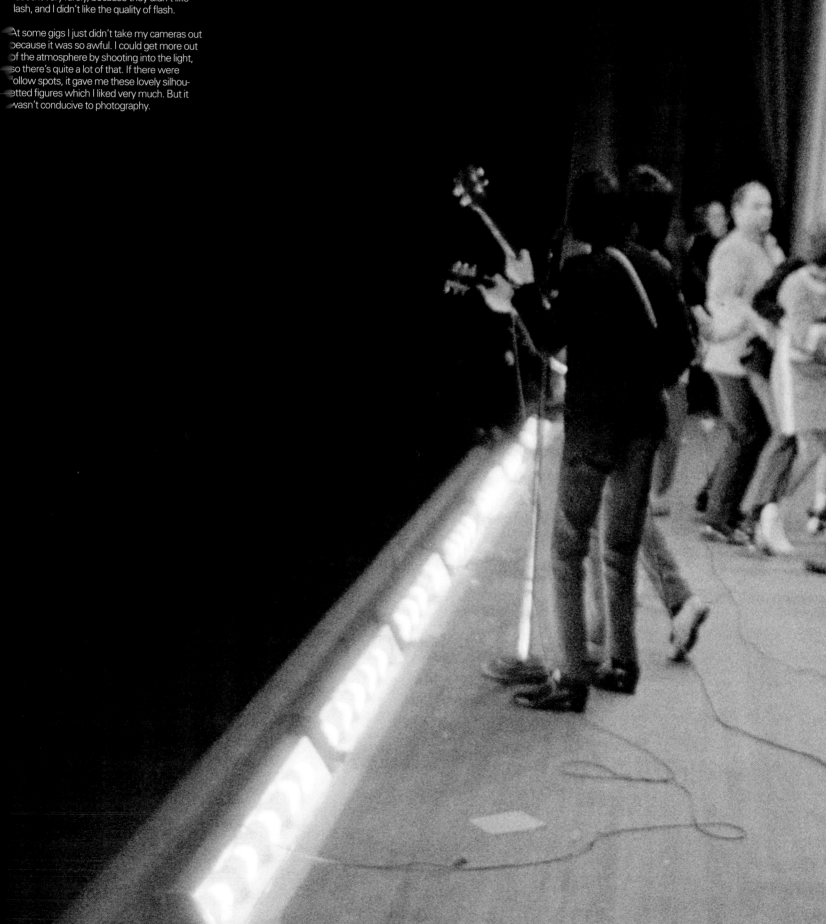

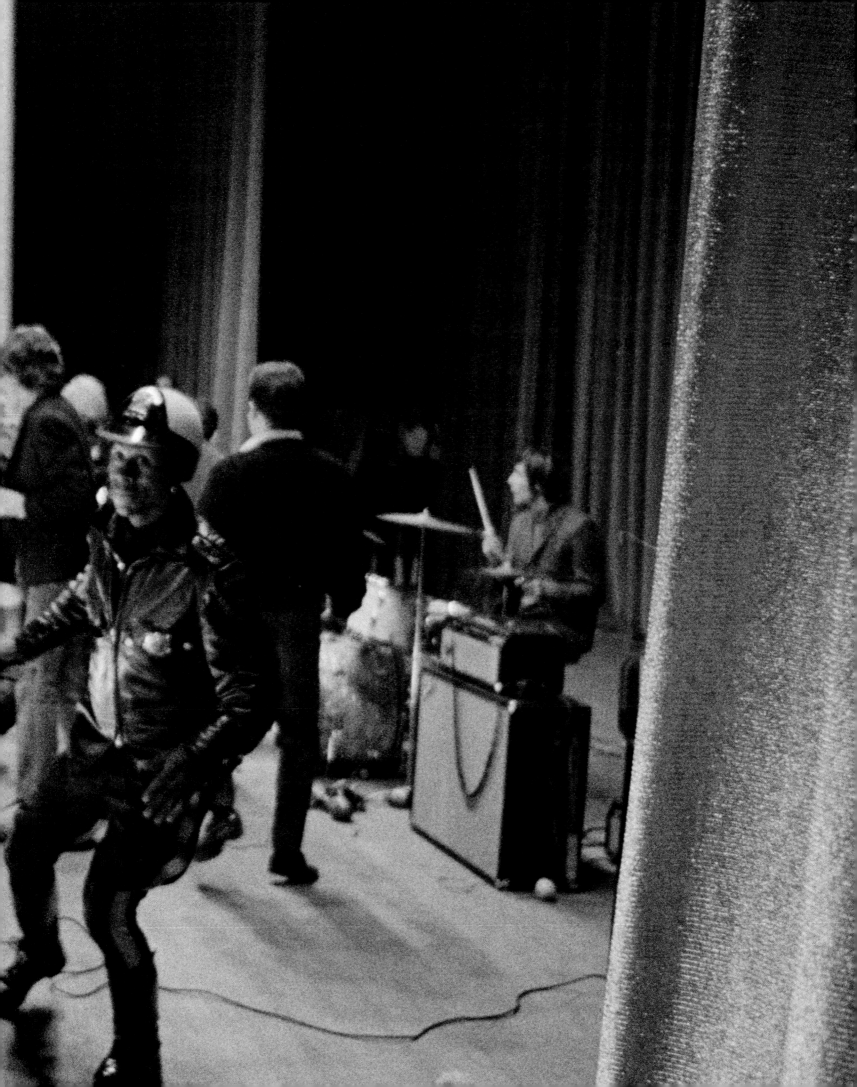

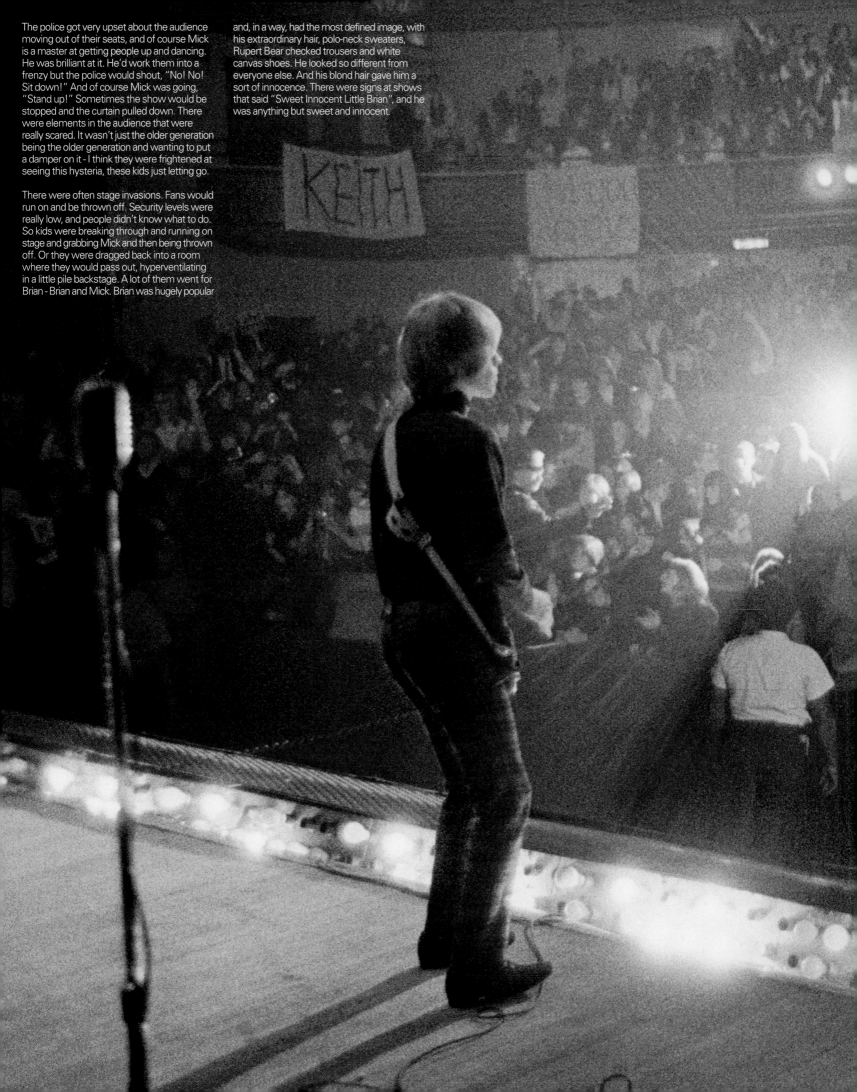

The police got very upset about the audience moving out of their seats, and of course Mick is a master at getting people up and dancing. He was brilliant at it. He'd work them into a frenzy but the police would shout, "No! No! Sit down!" And of course Mick was going, "Stand up!" Sometimes the show would be stopped and the curtain pulled down. There were elements in the audience that were really scared. It wasn't just the older generation being the older generation and wanting to put a damper on it - I think they were frightened at seeing this hysteria, these kids just letting go.

There were often stage invasions. Fans would run on and be thrown off. Security levels were really low, and people didn't know what to do. So kids were breaking through and running on stage and grabbing Mick and then being thrown off. Or they were dragged back into a room where they would pass out, hyperventilating in a little pile backstage. A lot of them went for Brian - Brian and Mick. Brian was hugely popular and, in a way, had the most defined image, with his extraordinary hair, polo-neck sweaters, Rupert Bear checked trousers and white canvas shoes. He looked so different from everyone else. And his blond hair gave him a sort of innocence. There were signs at shows that said "Sweet Innocent Little Brian", and he was anything but sweet and innocent.

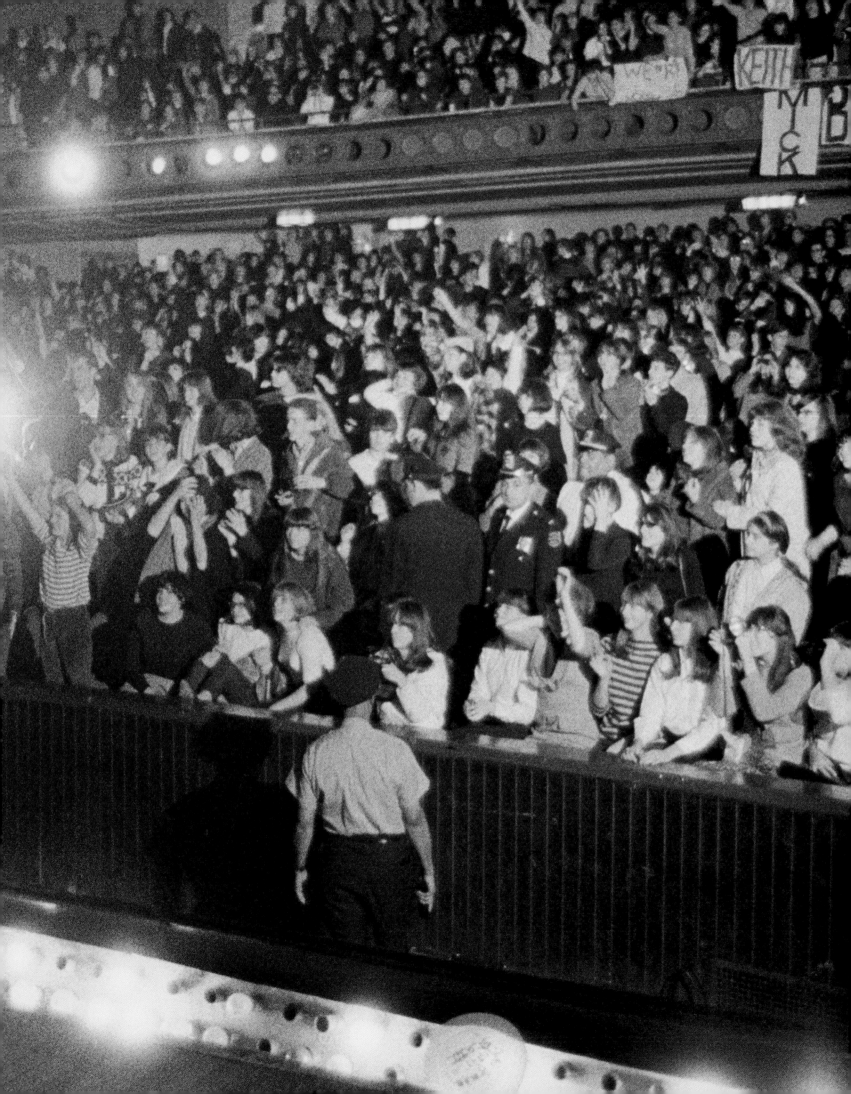

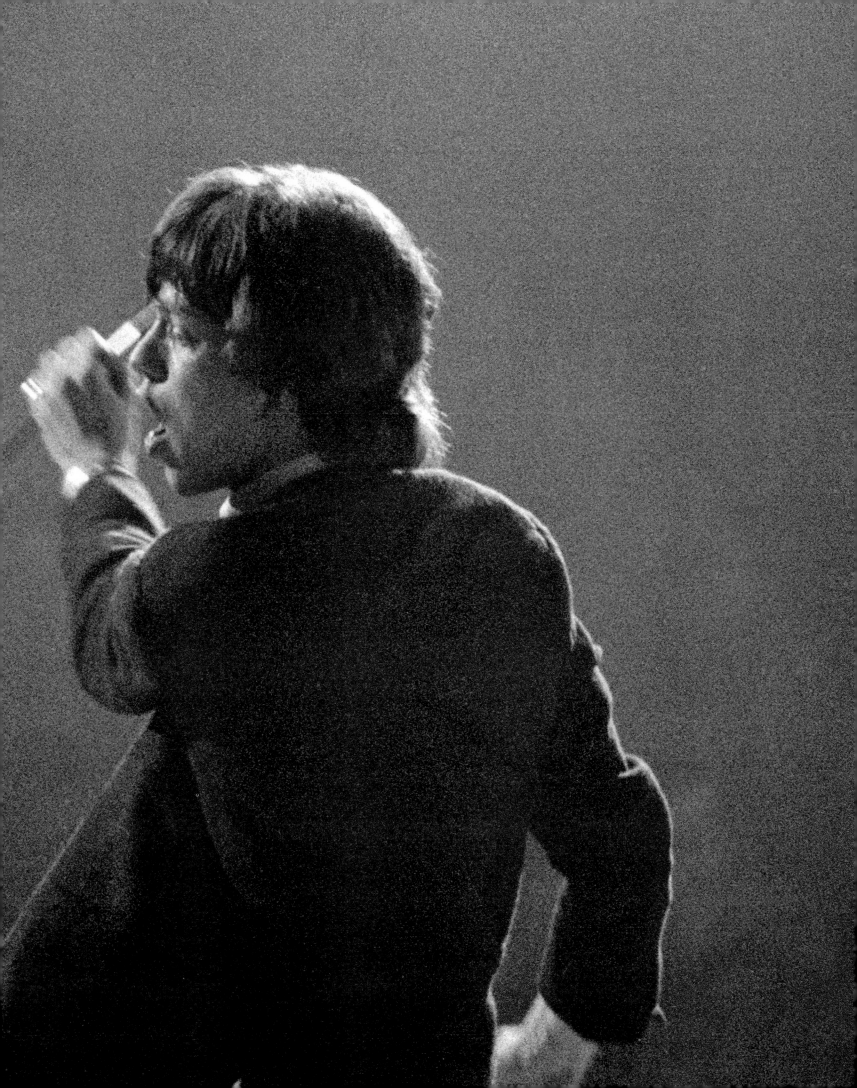

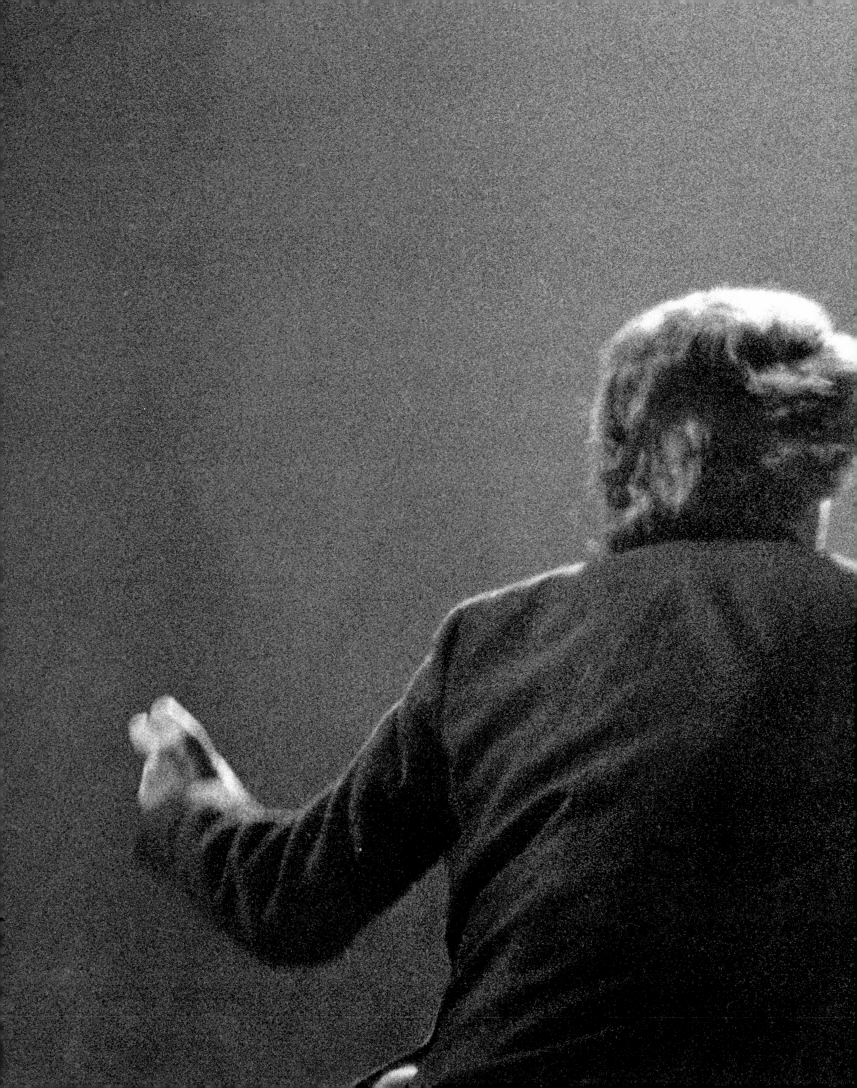

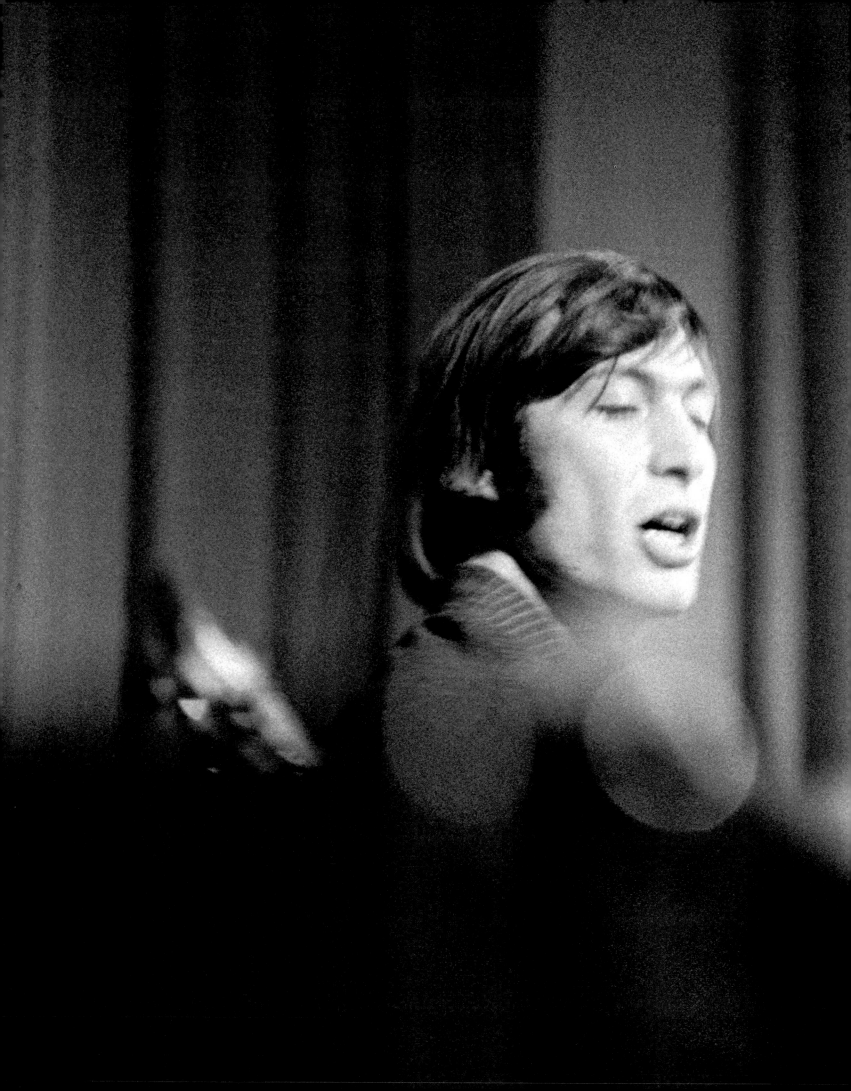

The support acts were Patti LaBelle and The Blue-Belles, who were wonderful, and there was a band called The Rocking Ramrods, who opened for everyone and backed Patti, and another black band called The New Vibrations, who were fabulous, a bit like The Platters, a doo-wop band. Patti sang "Somewhere Over The Rainbow", which seemed bizarre to have before The Rolling Stones. I think they [the Stones] were pushing it by having two black acts and taking the tour into Southern states. In certain places the black acts had to stay in an exclusively black hotel and we couldn't mix. I think on one date Mick and Keith were smuggled in and had a night with The Vibrations and Patti LaBelle and some other local black musicians, and had a great, wild time.

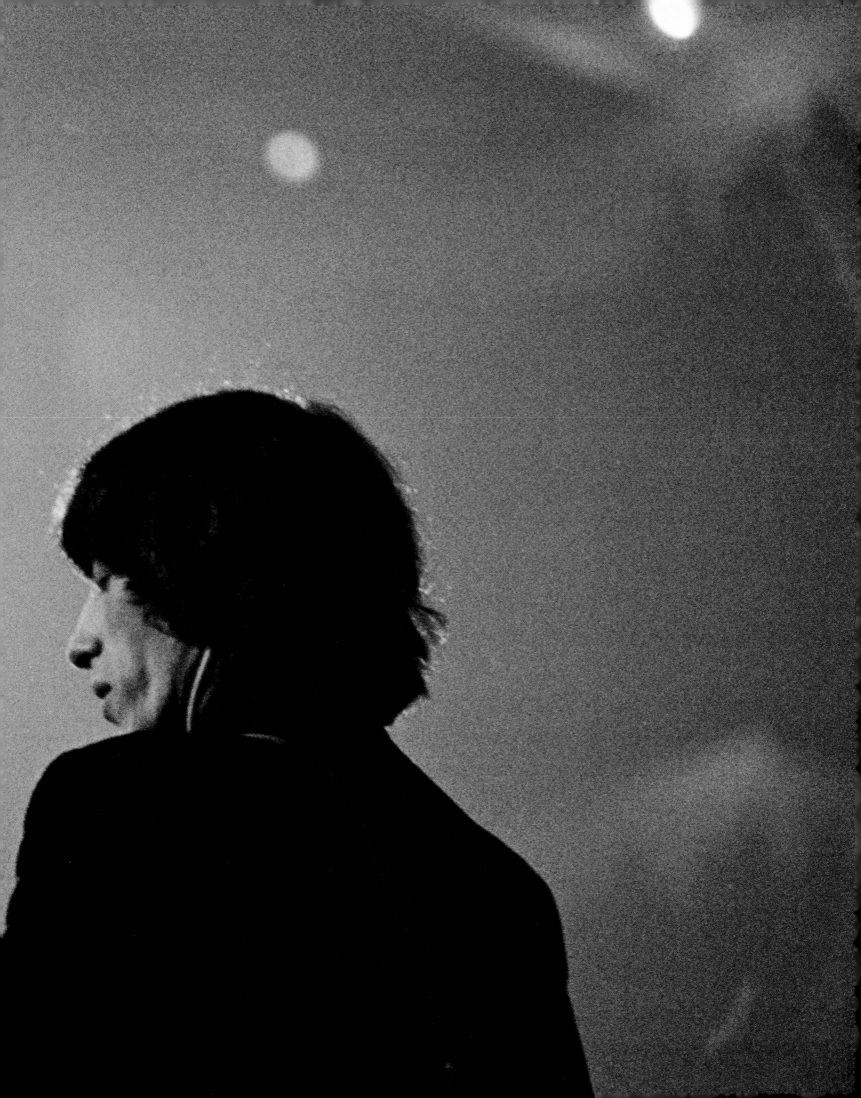

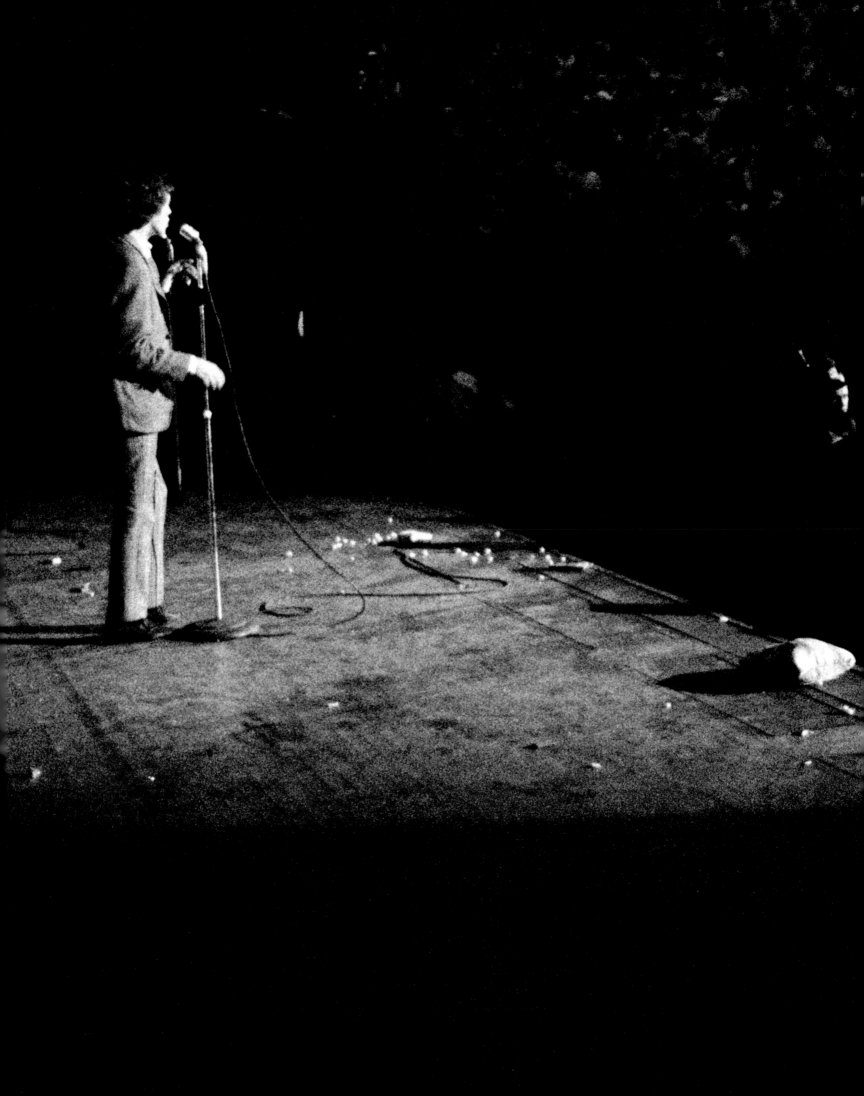

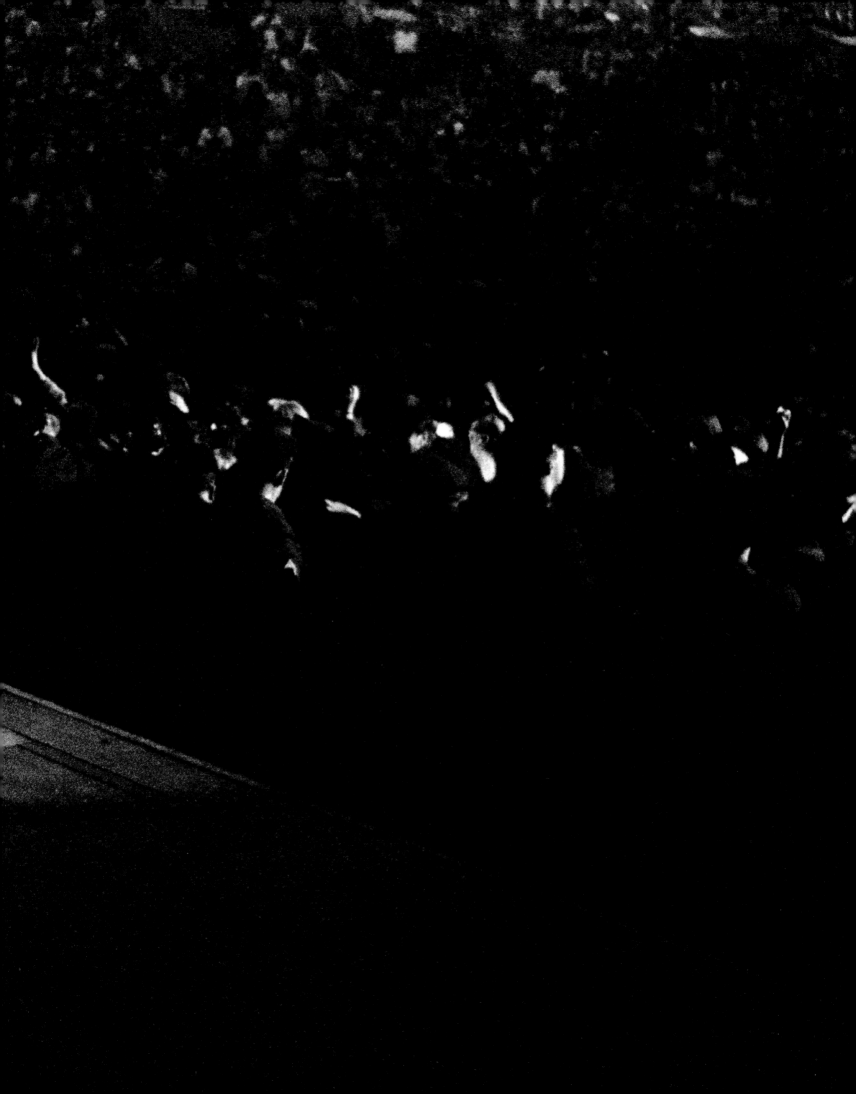

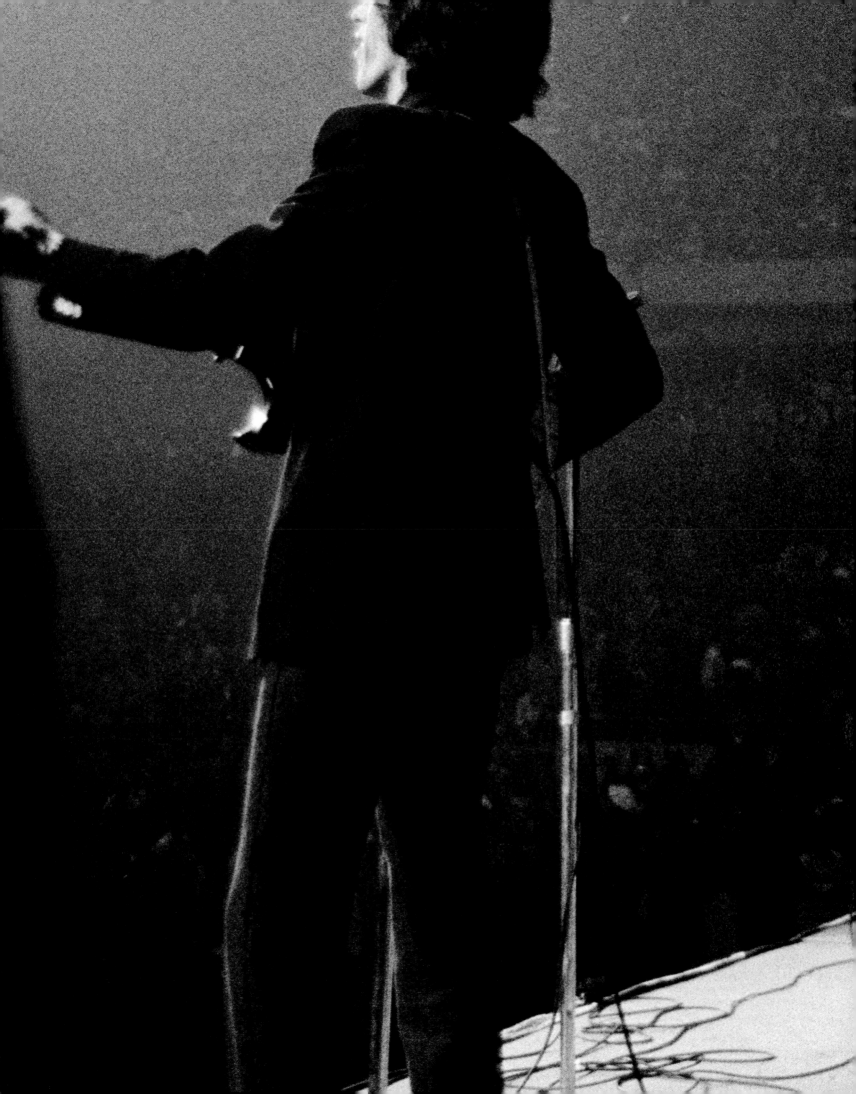

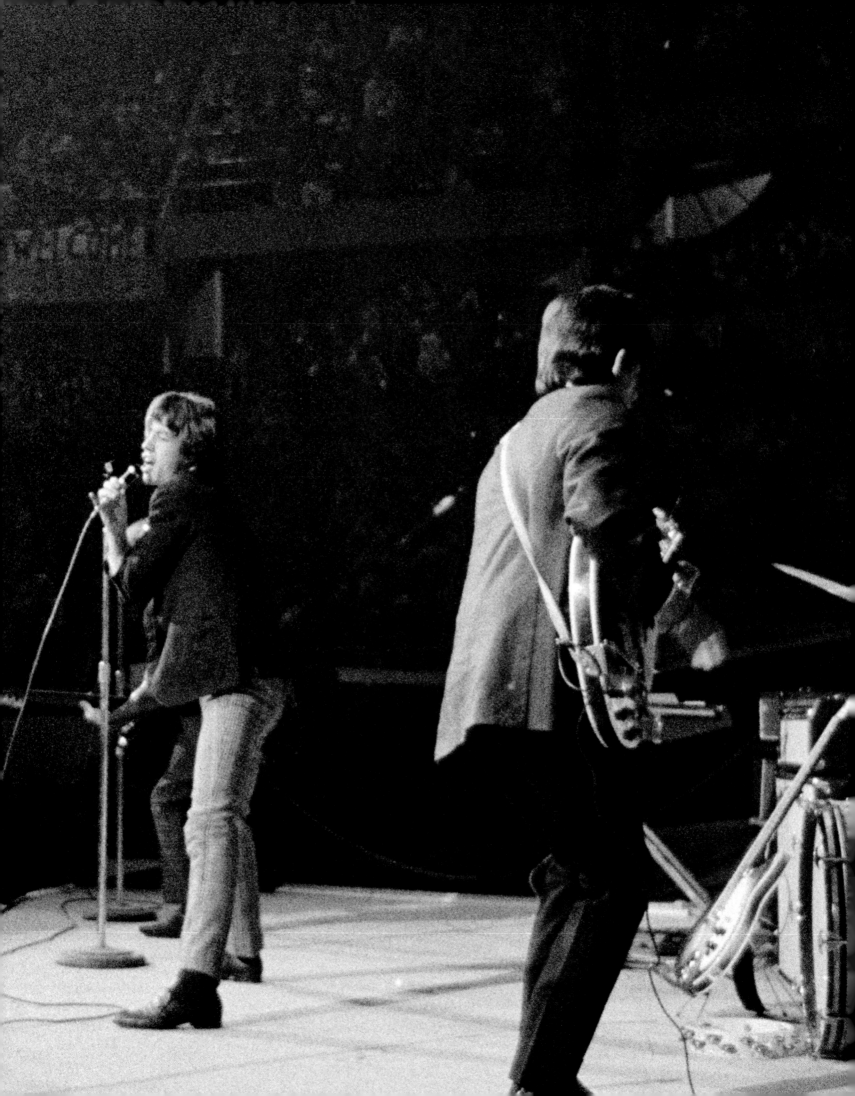

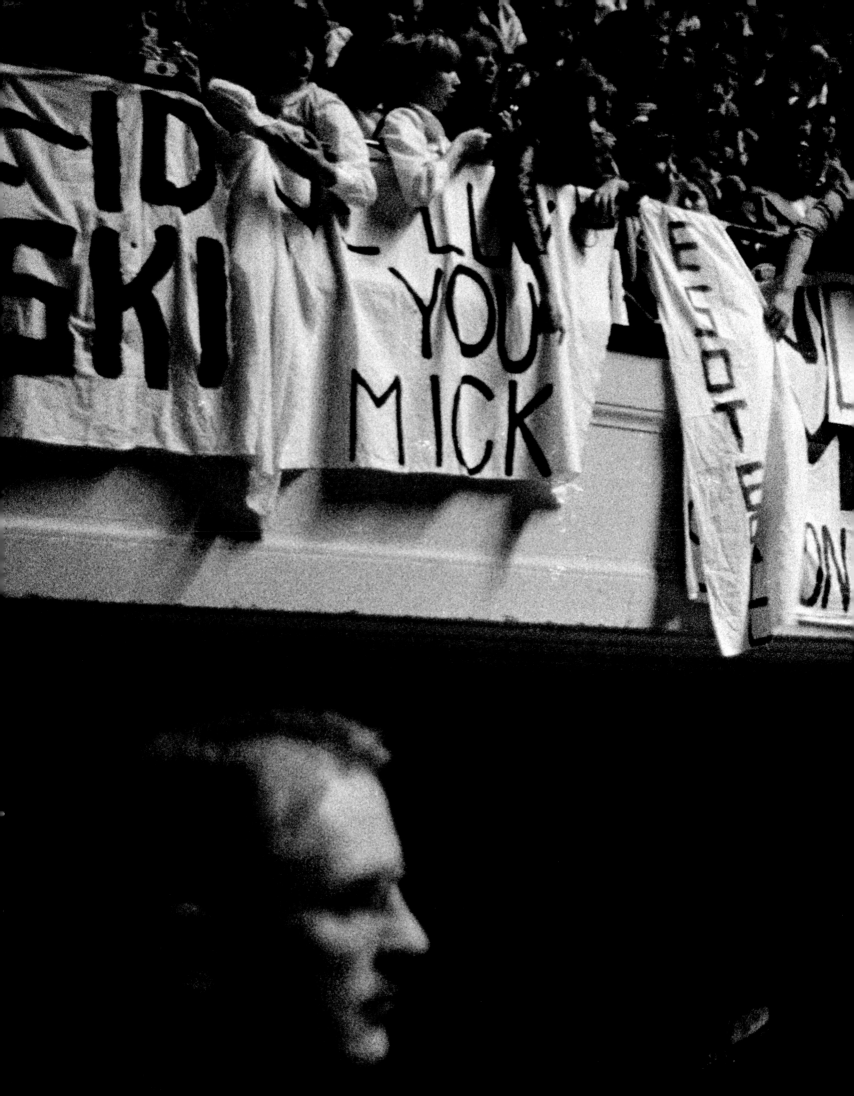

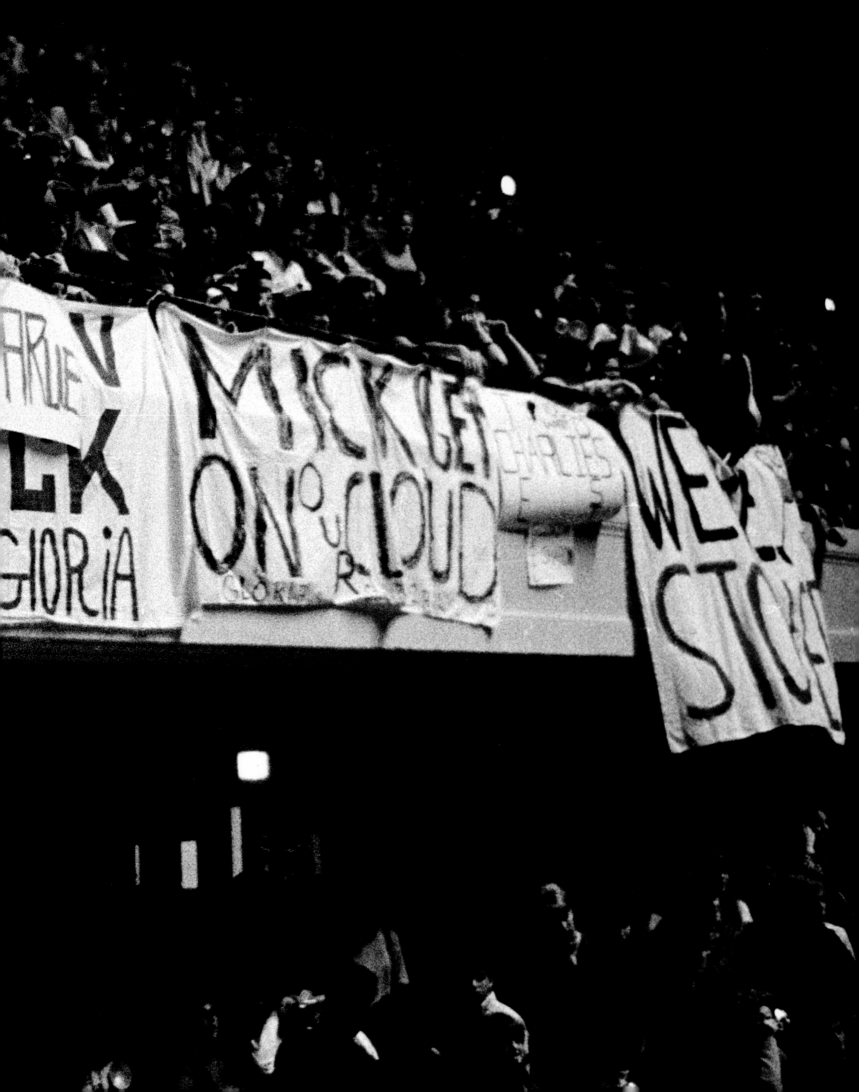

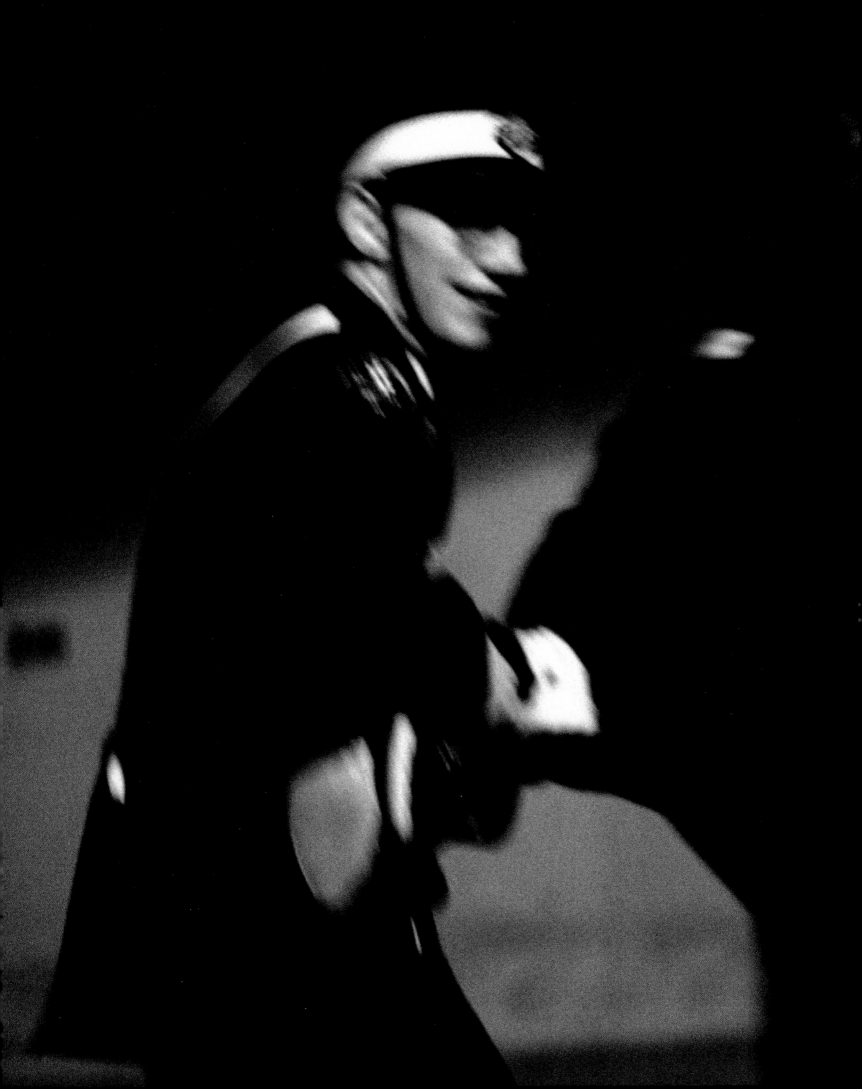

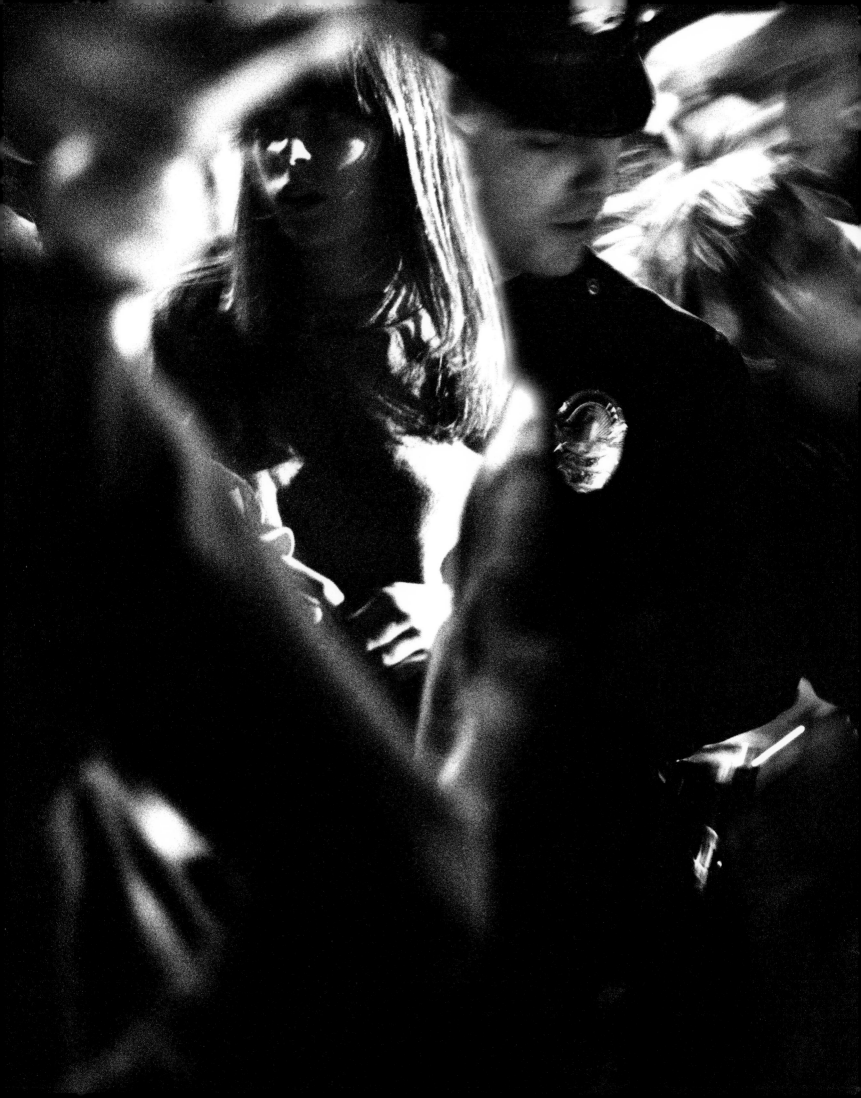

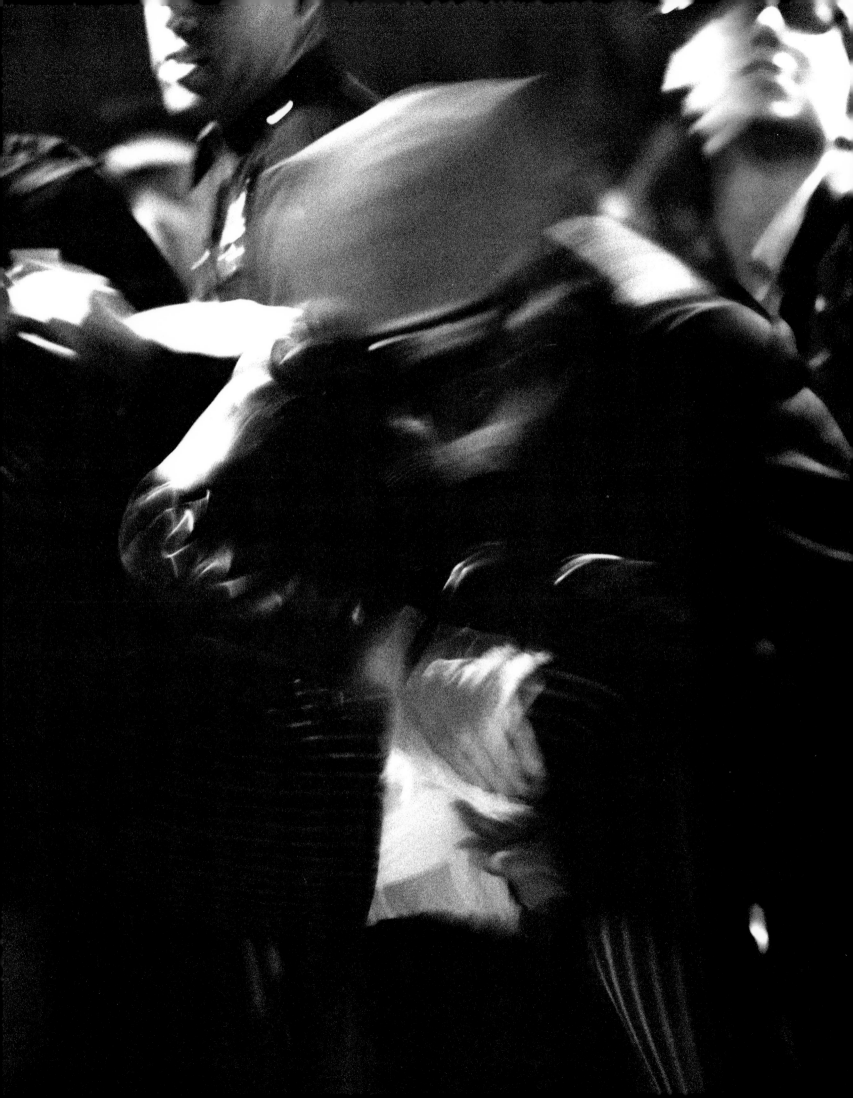

Brian had a manipulative quality to him that could be quite unpleasant, and the other side was that he was capable of being charming and funny and an incredibly important part of the band. But this seesaw effect was already becoming quite apparent, and if you spent a few days on the road with him it became clear that sometimes he was just bonkers.

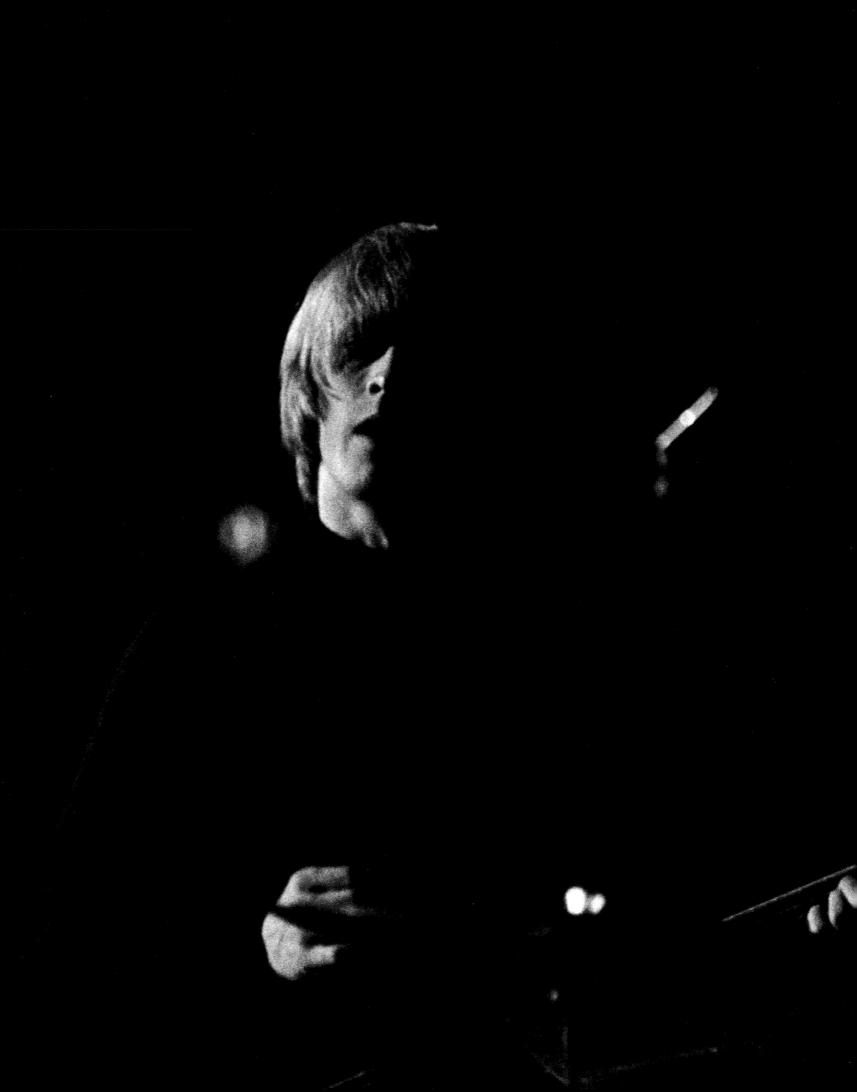

At the start of the tour they appeared on a show called *Hullabaloo* to play "Get Off My Cloud". The style of those shows was incredibly poppy and I think they found it a bit sterile, but at the same time they were highly professional and just got on with the job. But the show had these go-go dancing girls which The Stones thought were very humourous and inappropriate for their style of music. You can see Brian laughing at them in one photograph, which pretty much sums it up. He thought they were hysterical.

The photographs where Brian's getting his hair cut are from the same TV show, in the make-up department, and there's a huge contrast between Brian's look and the look of the hair-dresser, who had this very groomed, short, Paul Anka-ish style that was pretty prevalent.

I don't recall him worrying that much about his hair but I guess it must have been of concern. He definitely had the most defined look of the three foremost members. For that period he looked extraordinary and it gave him a sort of innocence that was completely inappropriate.

There were a few times when he went missing on that tour. I have a rather confused memory of Brian literally walking out of a limo in a traffic jam, and then disappearing for two or three concerts. I think it was announced that Brian had flu. There was an erratic quality to Brian even then.

65 –
It gave him a sort of
innocence that was
completely inappropriate

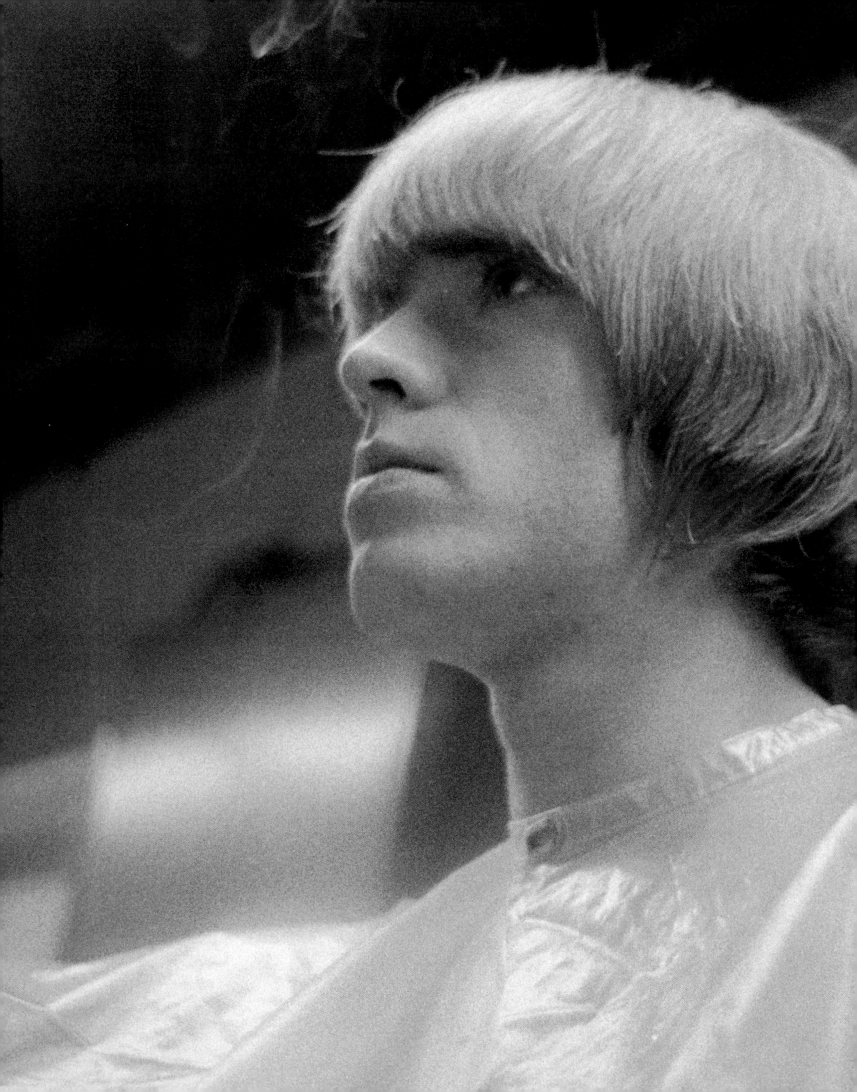

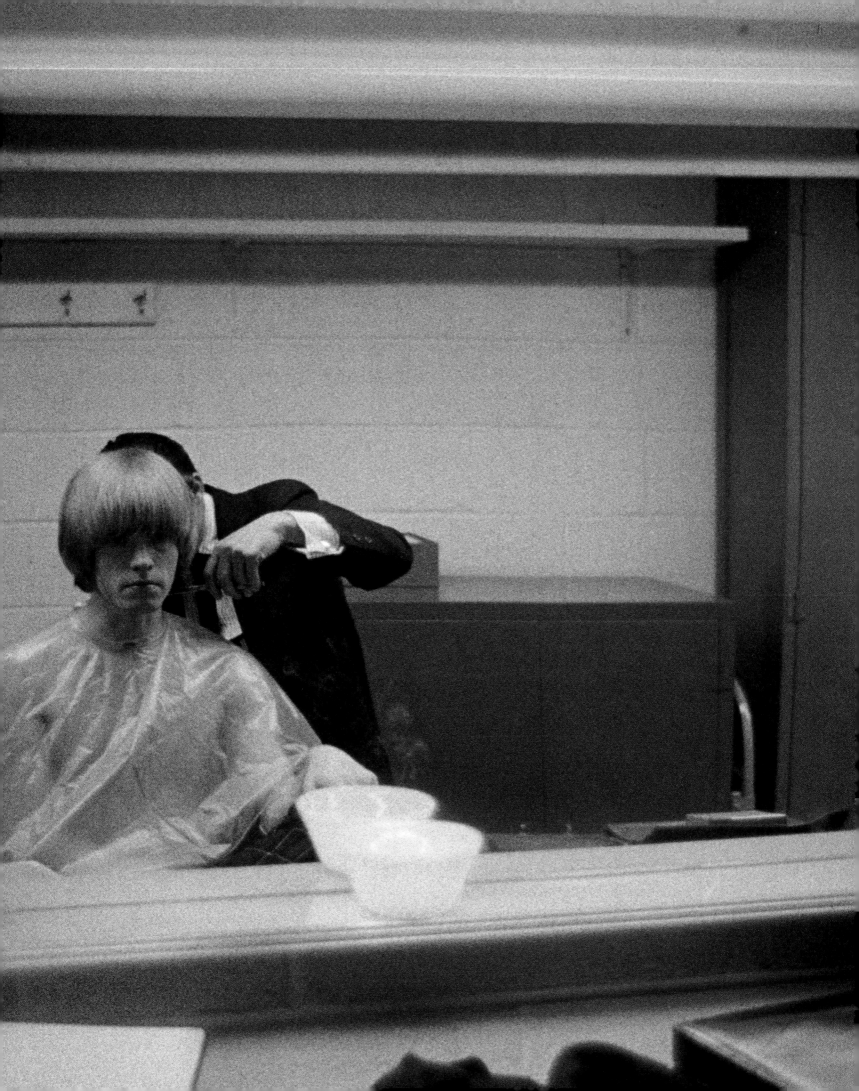

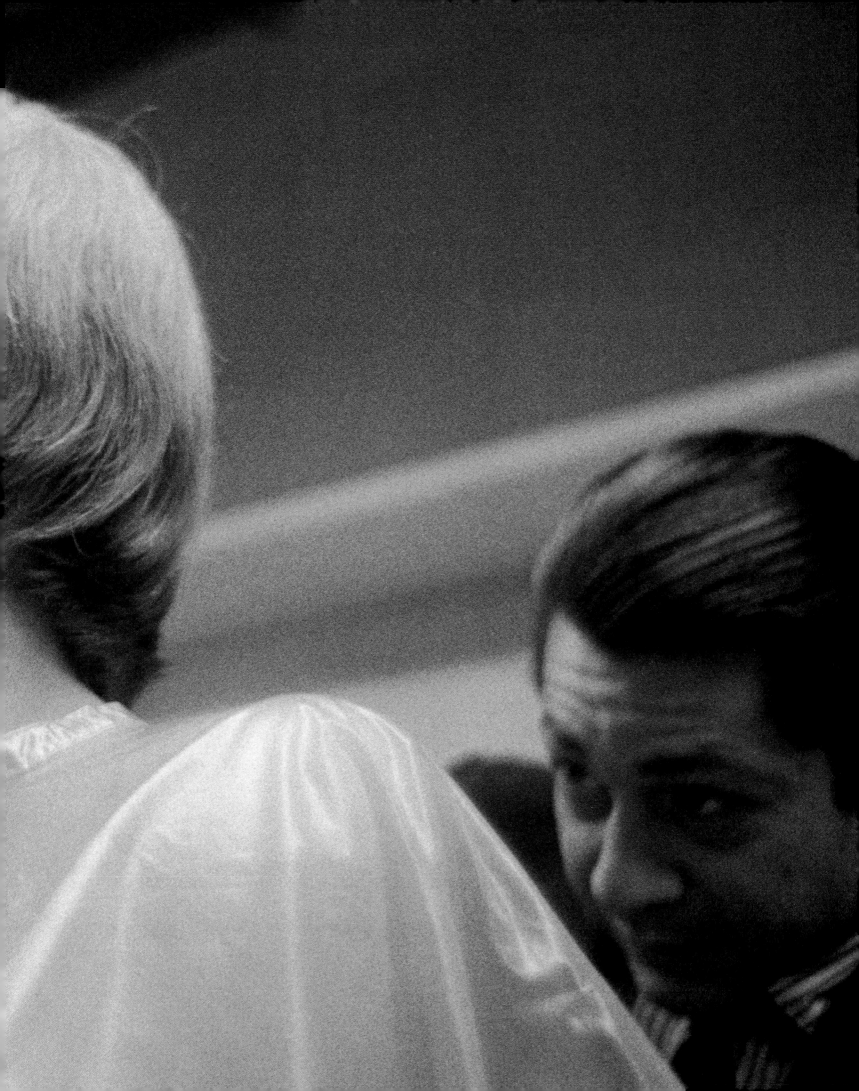

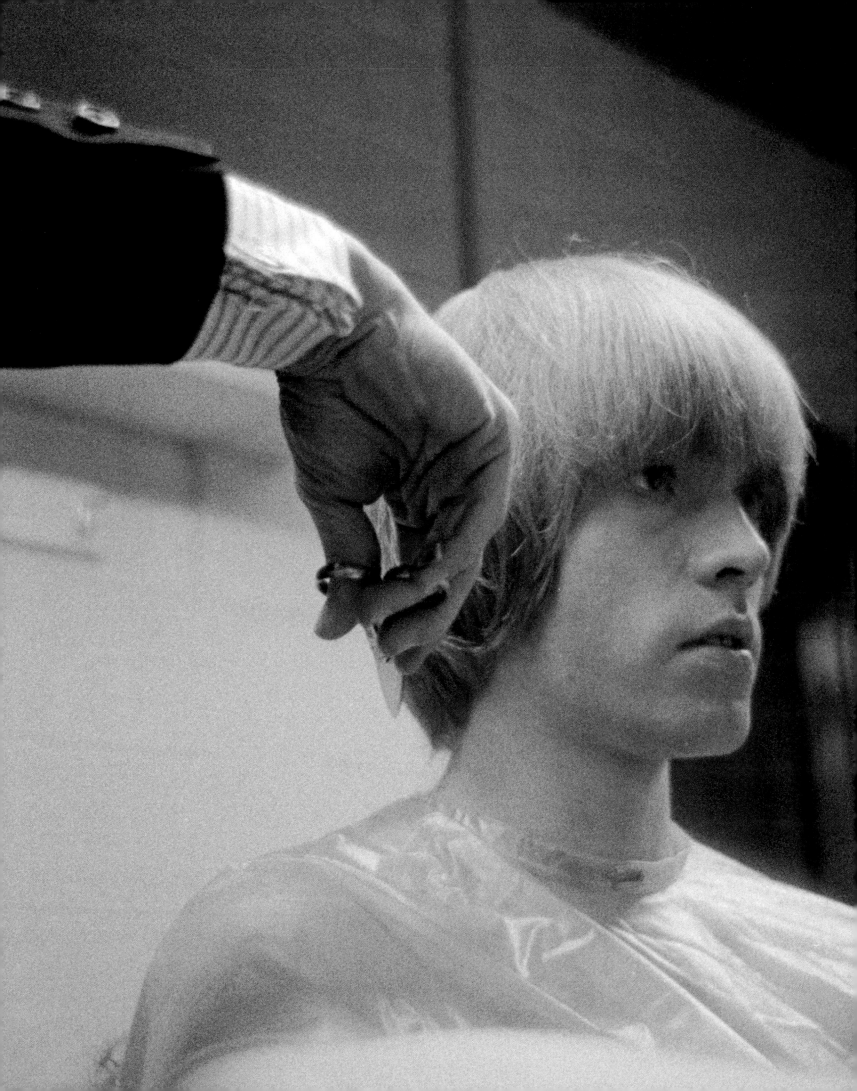

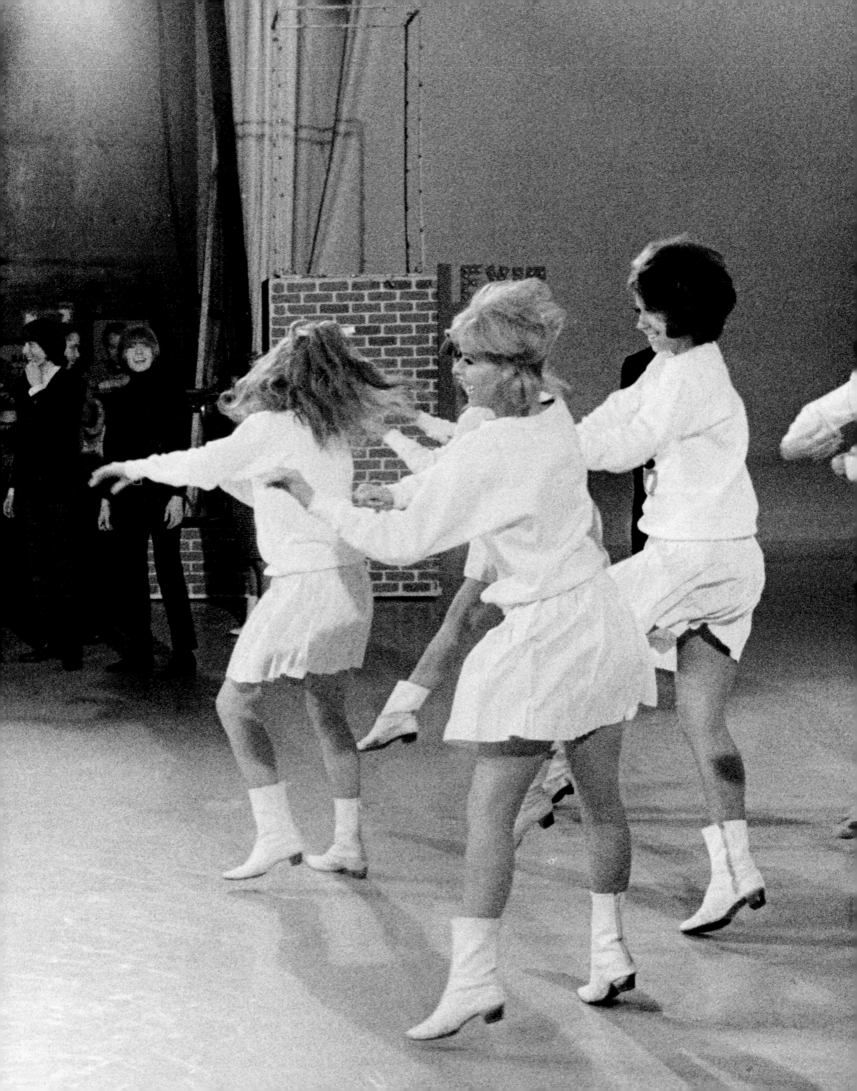

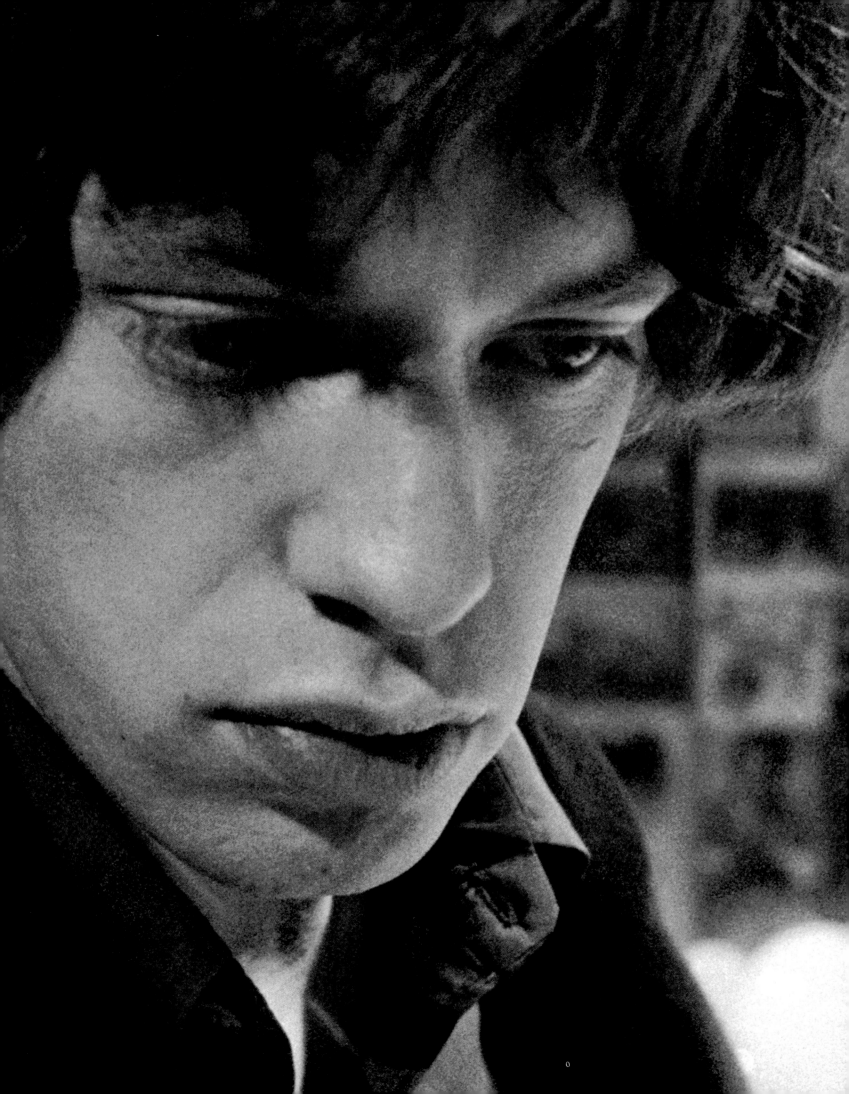

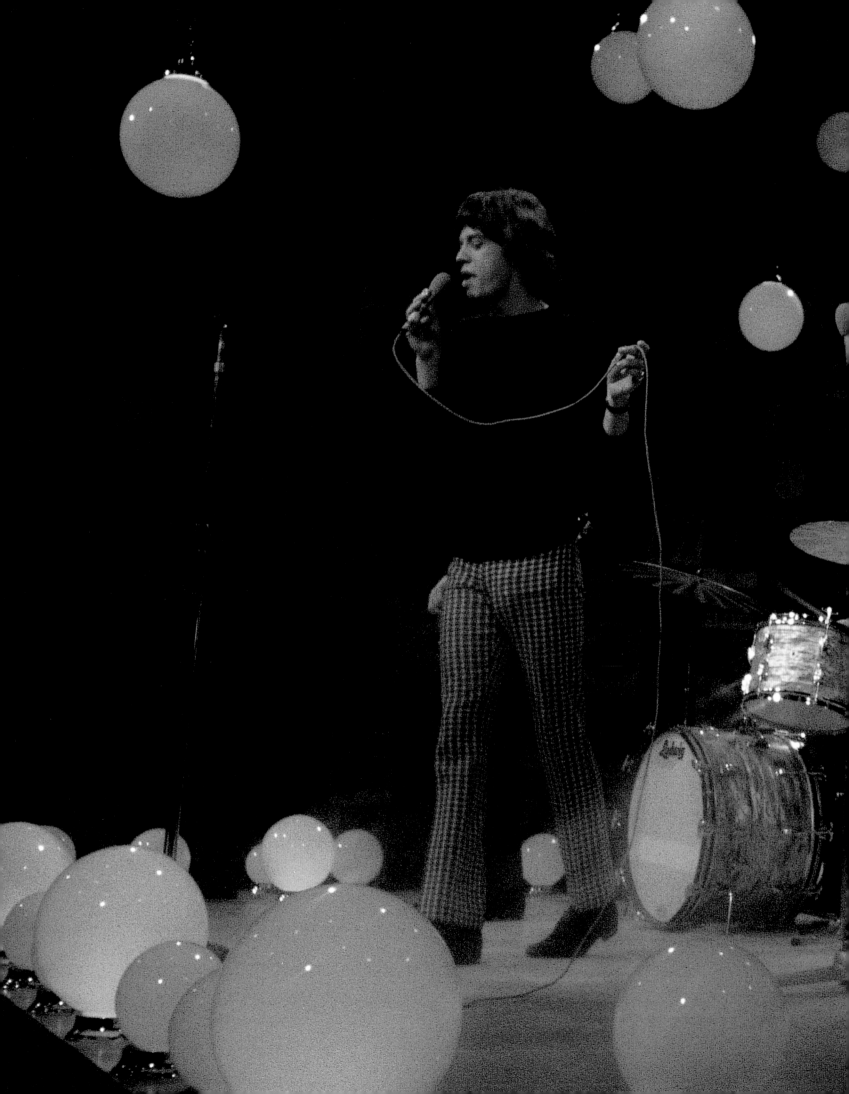

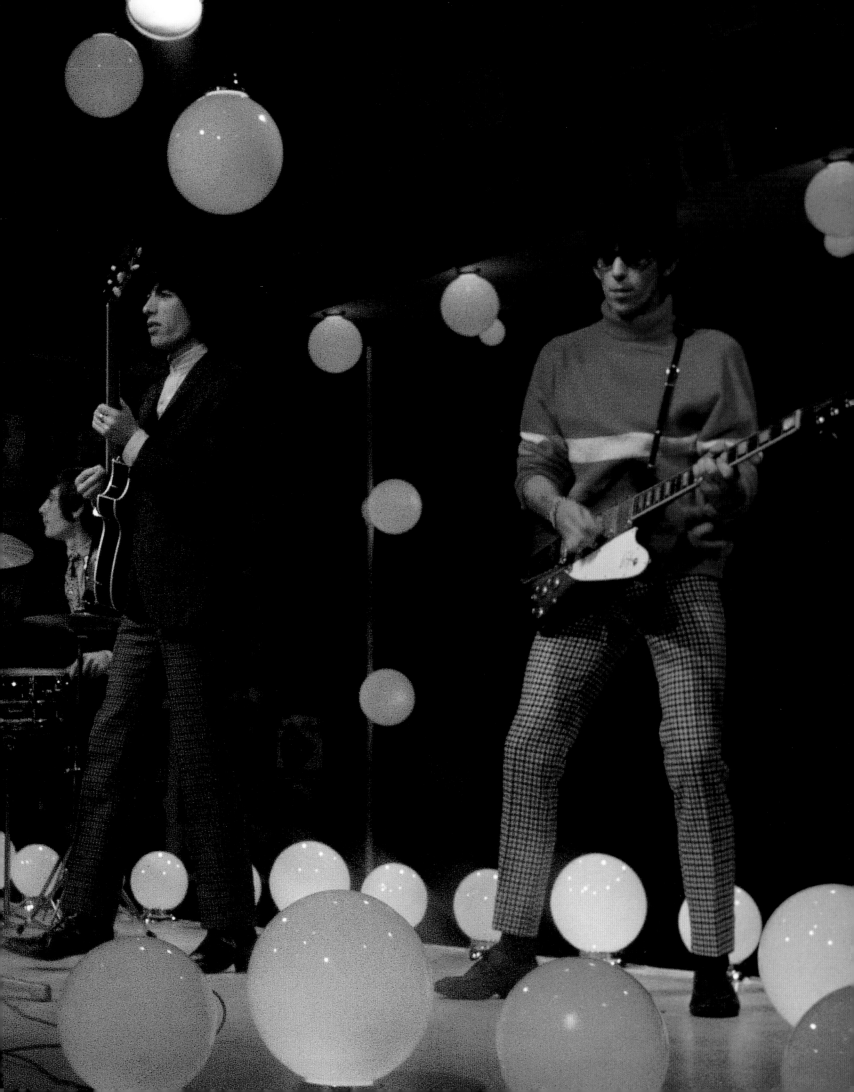

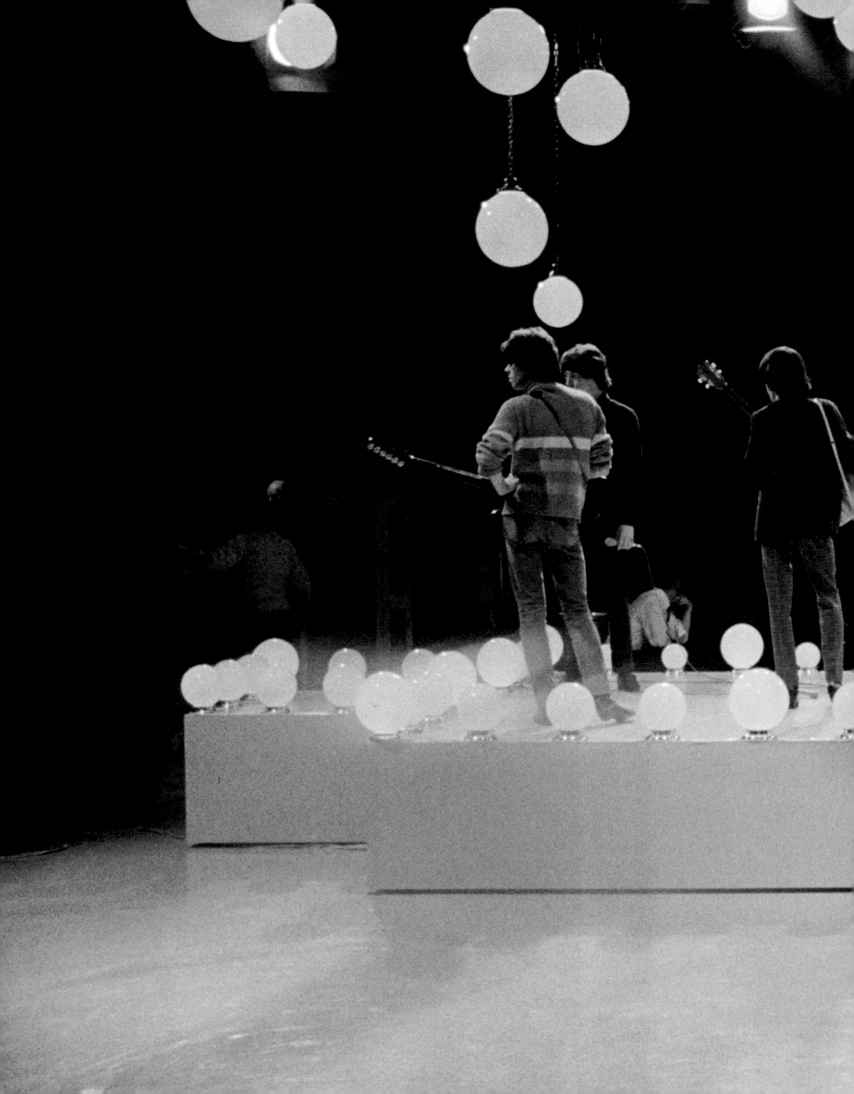

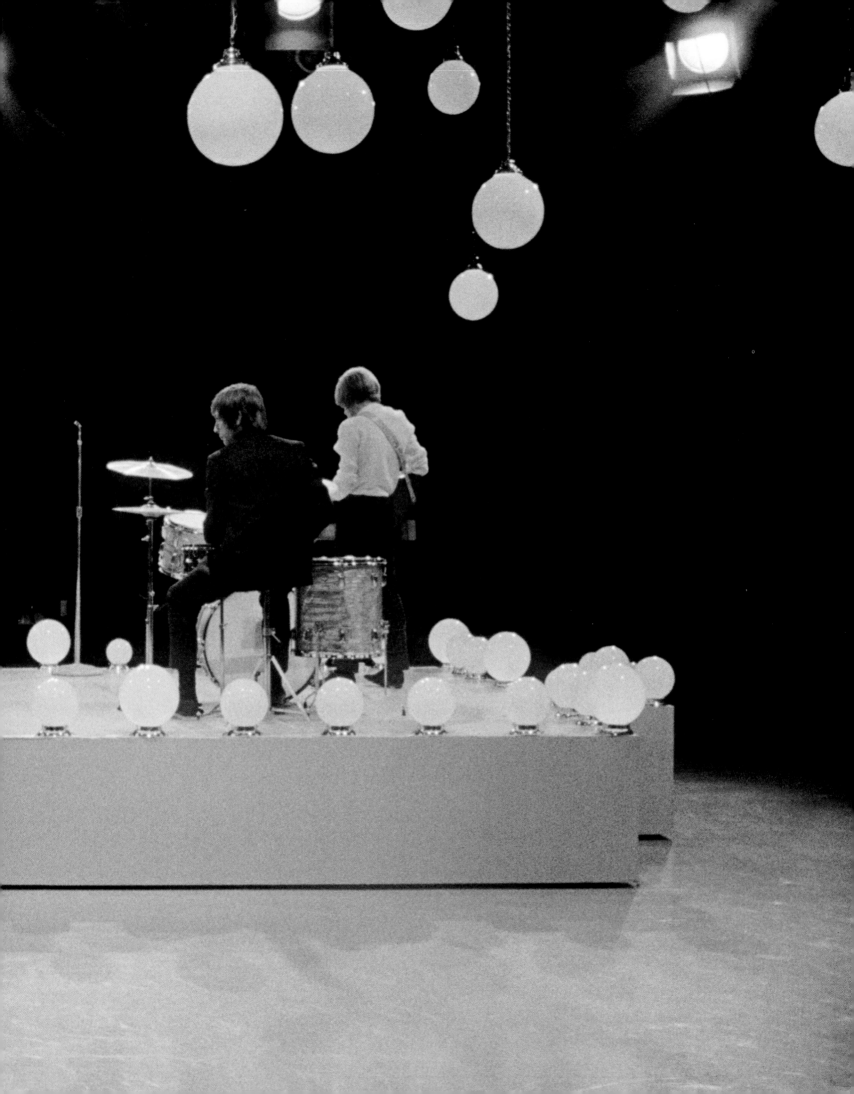

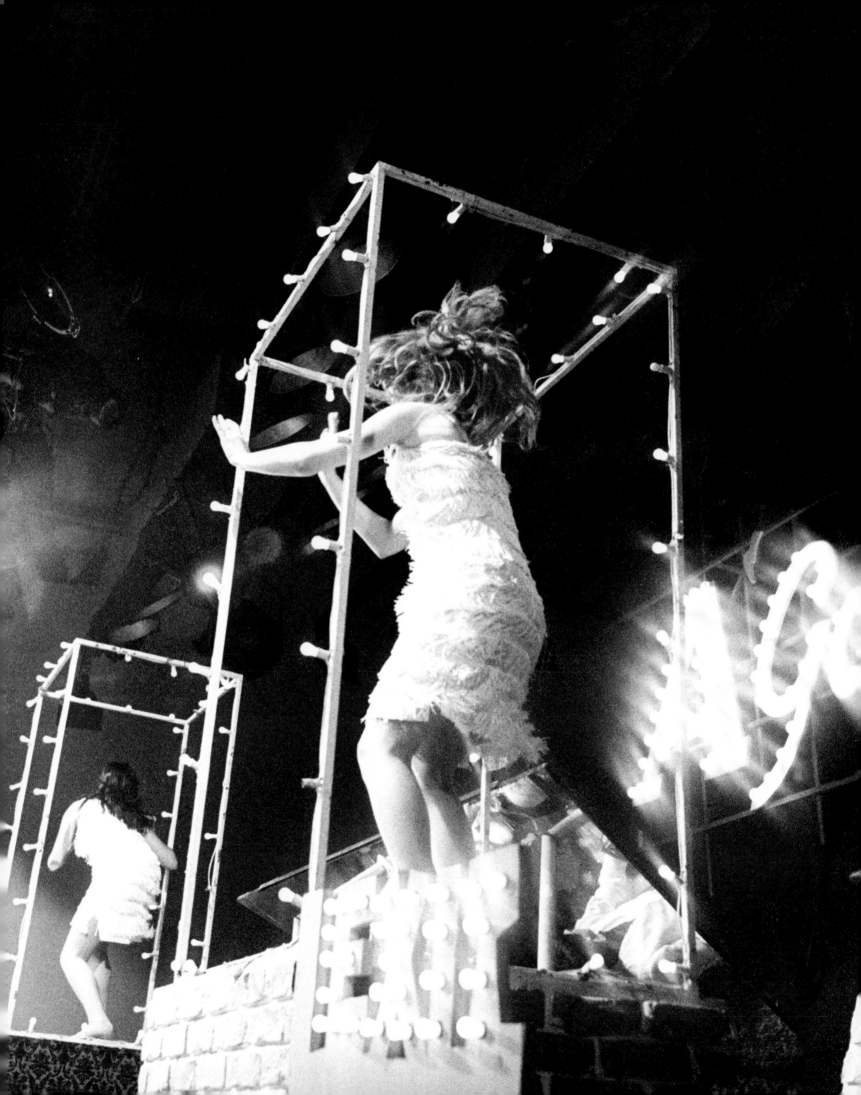

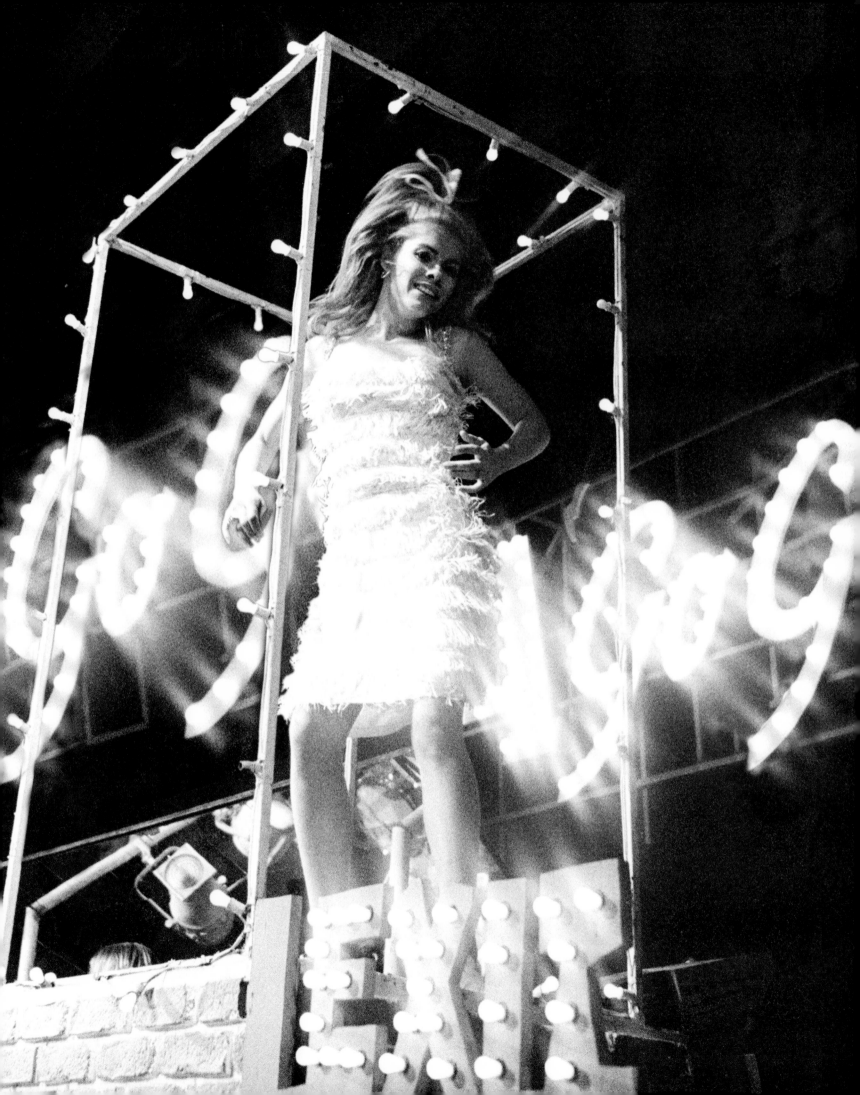

I did go into the audience whenever I could because I was very interested in the crowds. I wanted to capture the phenomenon, because it was extraordinary. We'd all heard about Beatle-mania but very few of us had actually experienced it. And I thought this was amazing. Occasionally, where there was access, I got down into the audience and photographed the fans.

There was a curious fashion at that time where quite a lot of kids would come with friends and they'd dress virtually identically or very similarly. In those days, 14-year-olds wouldn't be allowed to go to a concert by themselves, so their mums and dads had to come.

So there was a vibe within the audience of disapproval, from quite a large percentage. And there was also a horror that I think both the security and the older generation felt at seeing this uninhibited outpouring of energy and enthusiasm and excitement in their children. It created an interesting cocktail of vibrations.

But the general fan behaviour was extraordinary. People would throw things on stage: great big dolls, and sweets, and knickers with notes safety-pinned to them, and gifts. I tried to catch the pandemonium of the crowd and the police and paramedics.

I always felt that there was a certain amount of opportunism in a lot of the police, who had an opportunity to fondle young girls. There was a bit of that anyway.

65 –
There was a vibe
within the audience
of disapproval

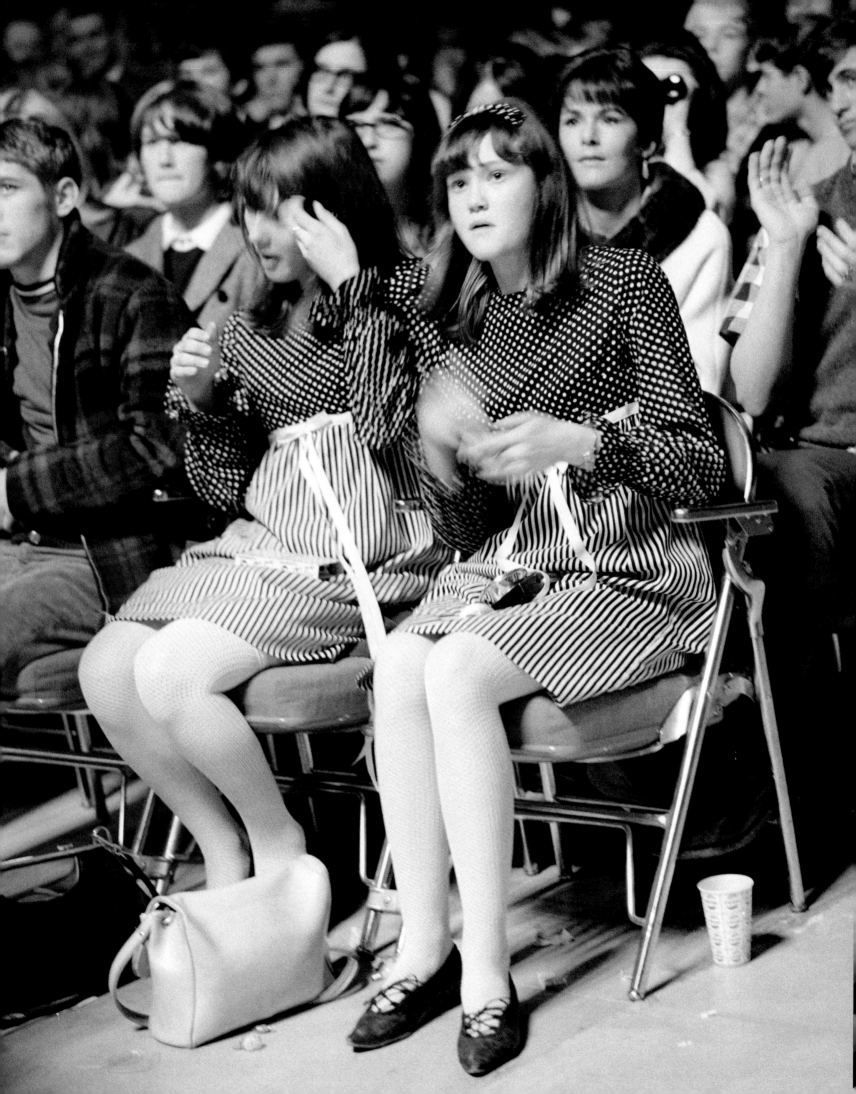

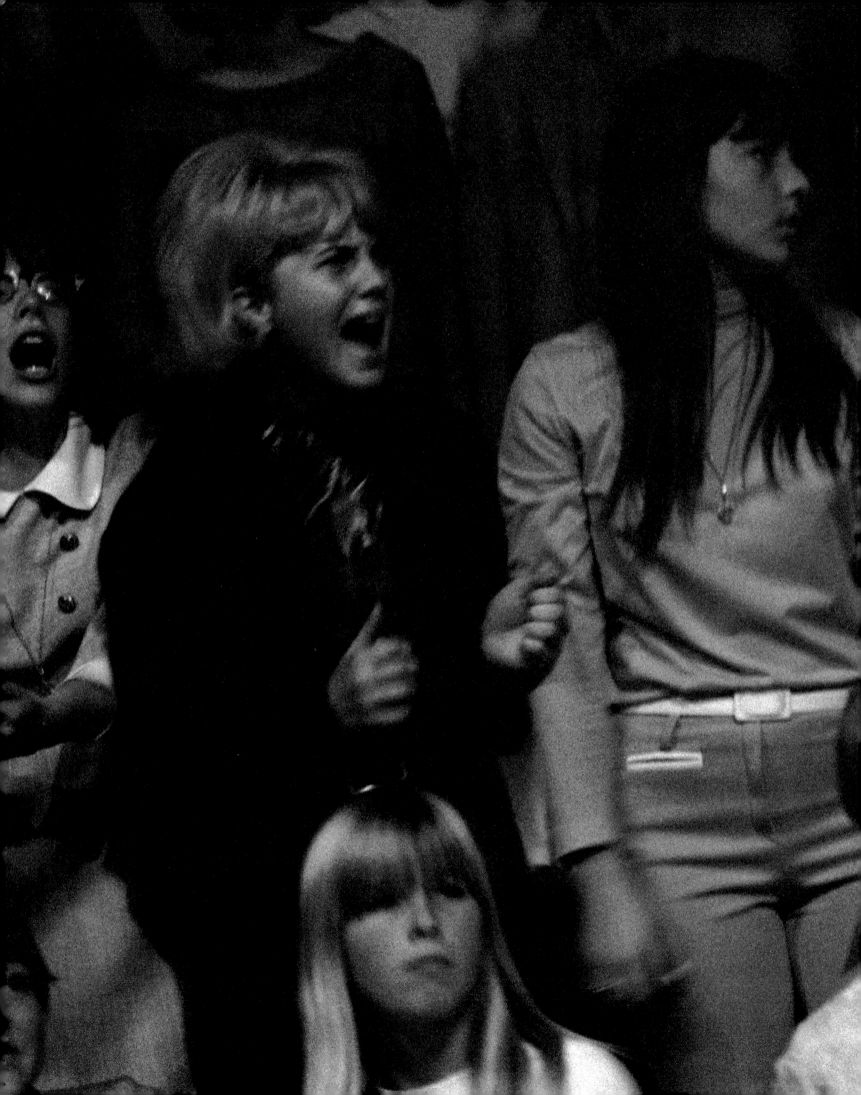

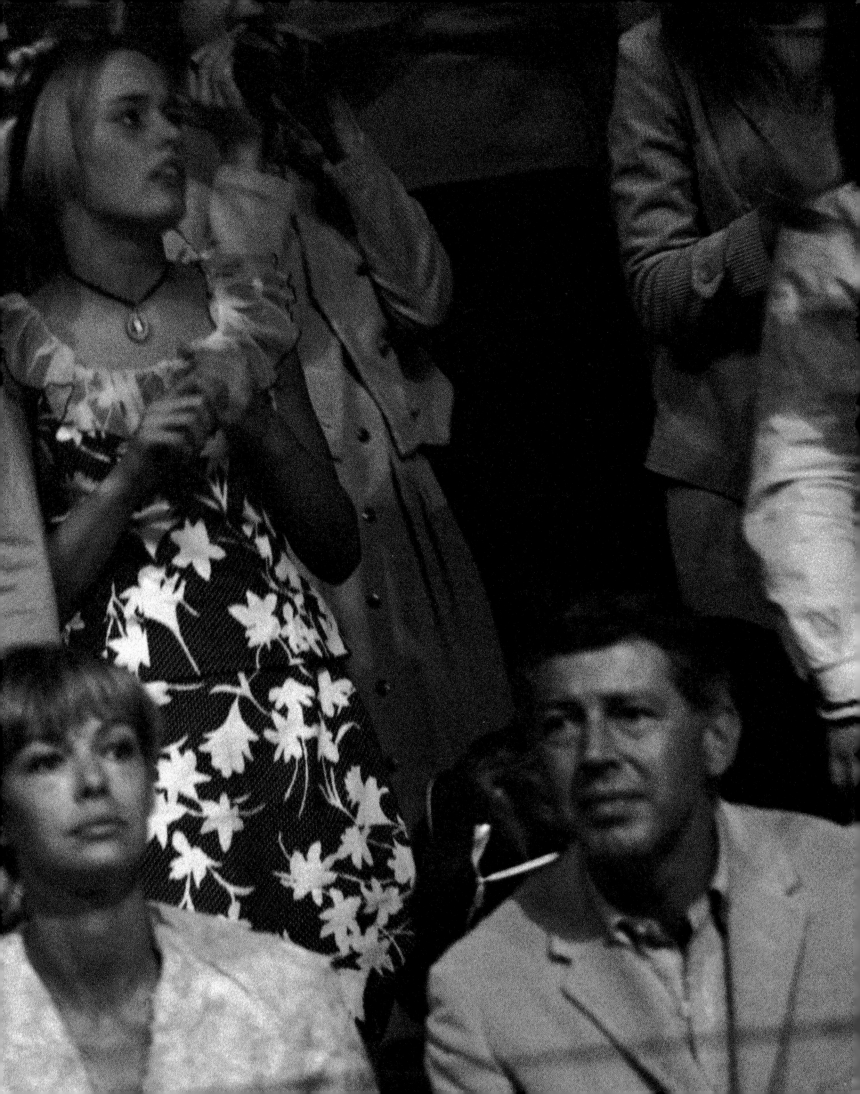

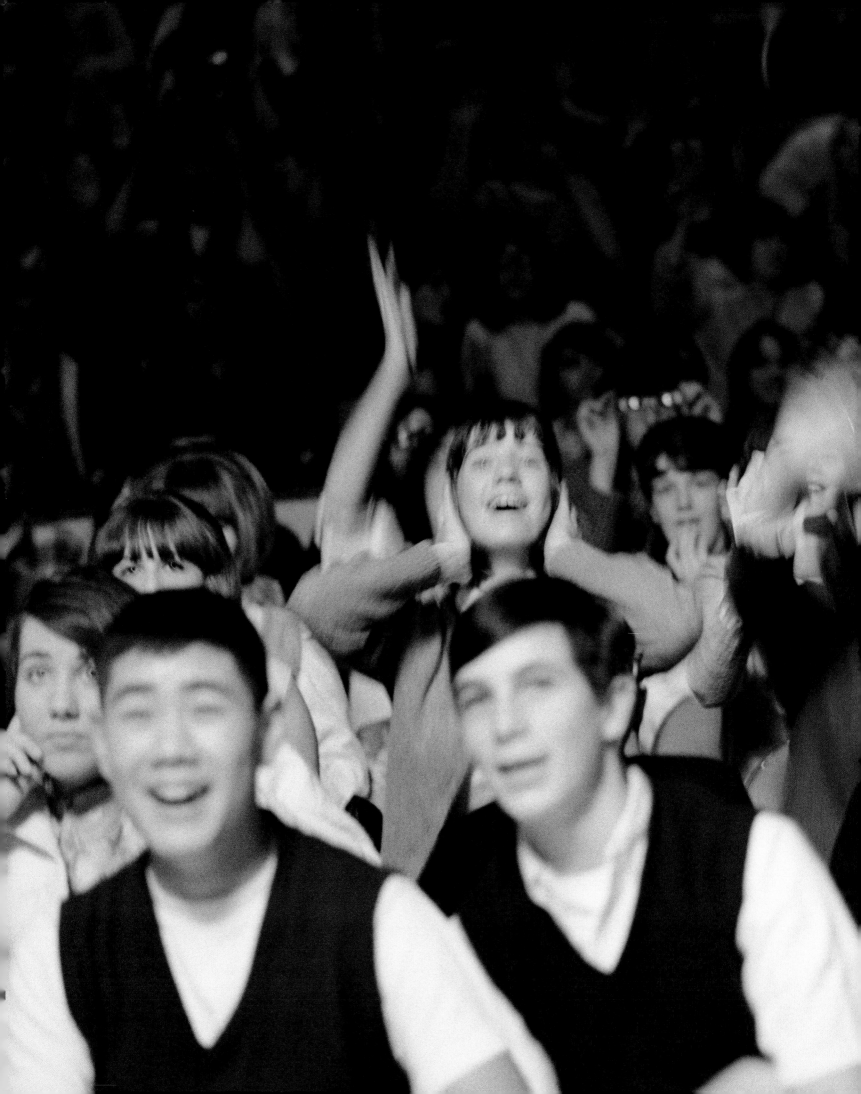

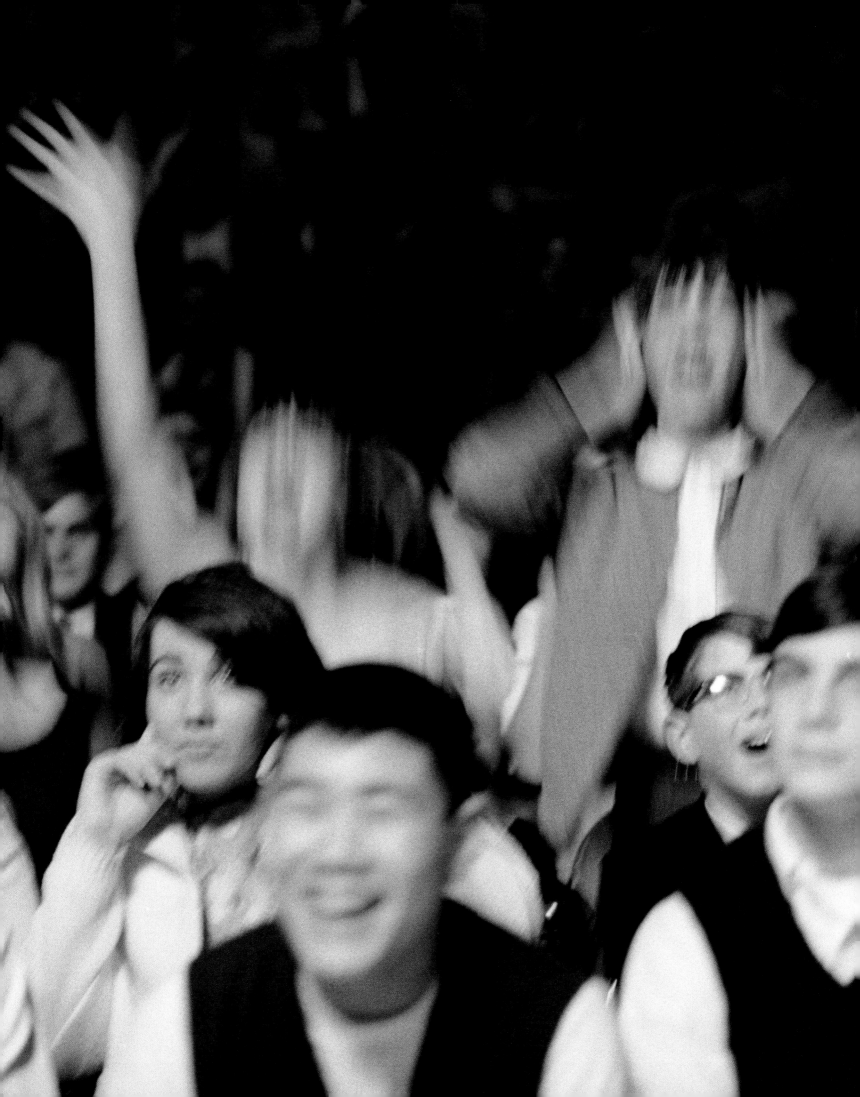

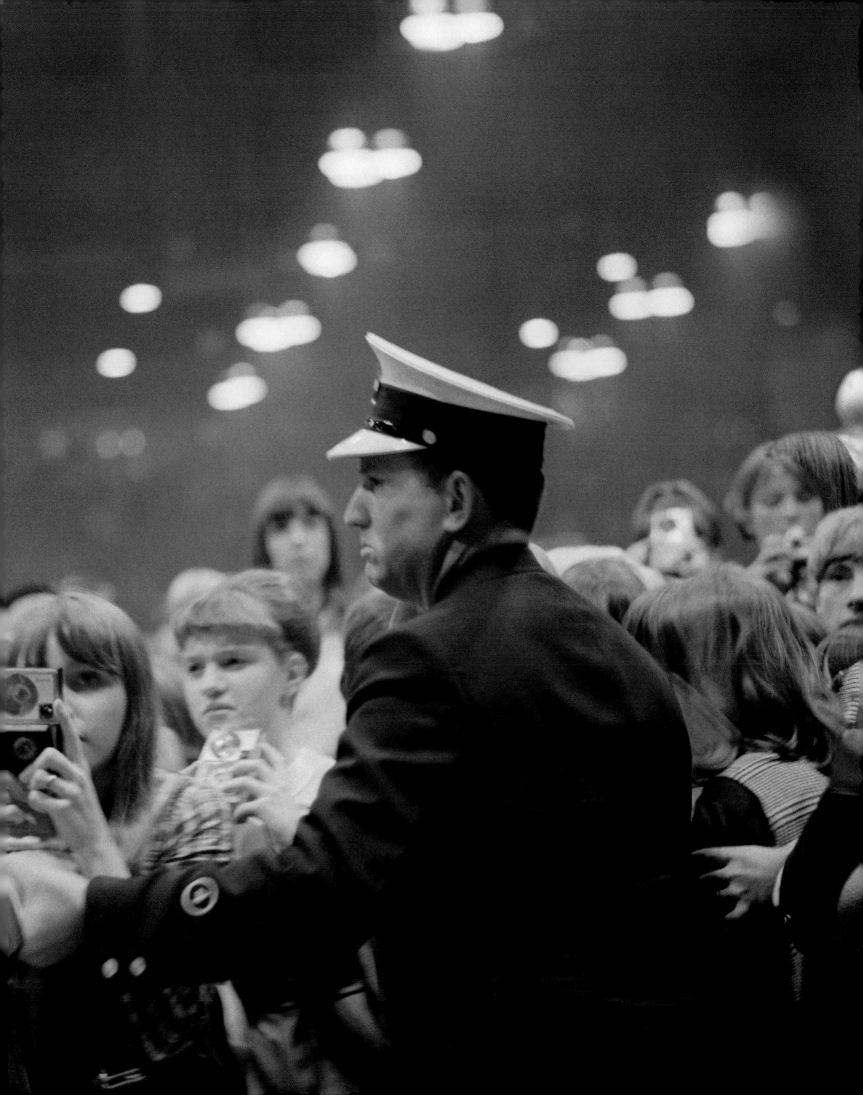

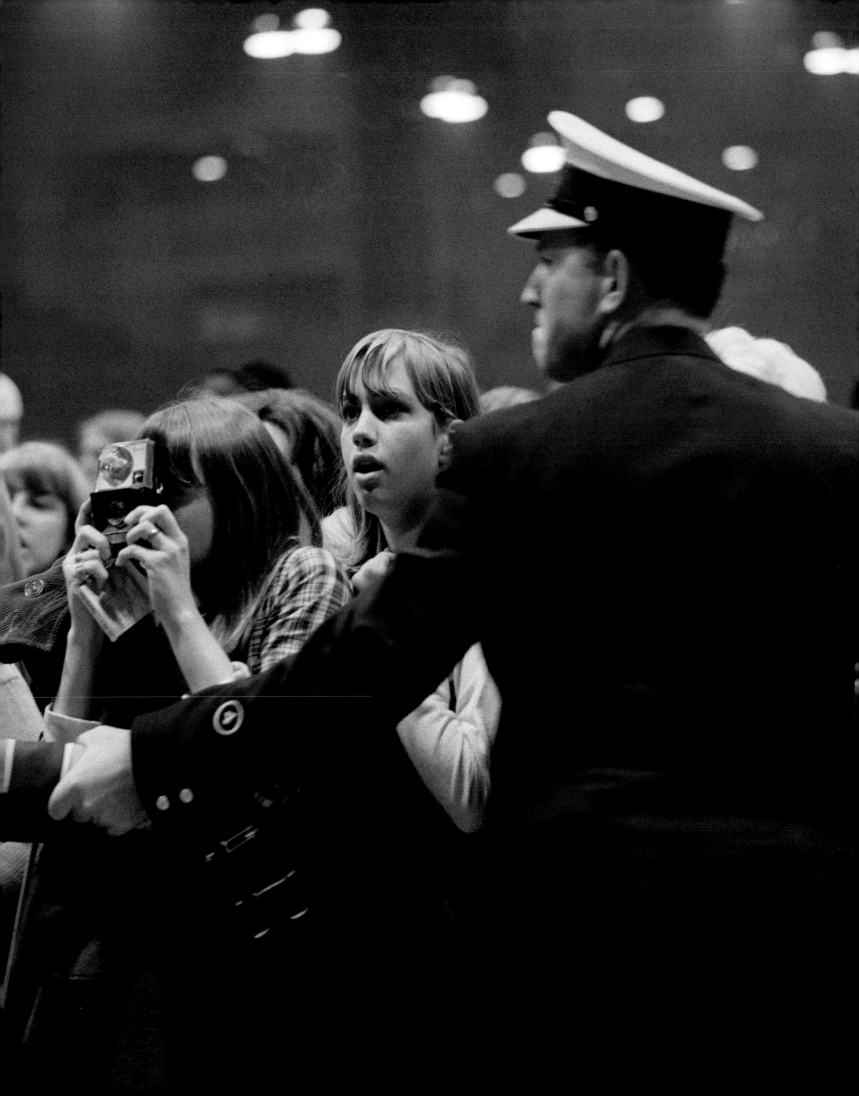

The Stones really disliked the idea of having a stranger photograph them at home, and they didn't want to conform to the sort of generally accepted style of the domestic photograph. They wanted to be a bit wackier. They recognised that they had an obligation to the magazines who wanted pictures at home, so they asked me to do it, and I supplied them, but they were wacky, piss-taking things. They didn't have a huge amount of time at home, because they were on the road an awful lot and recording and working pretty much nonstop.

Charlie was very into antiques and had excellent taste. I think they all had pretty good taste. Brian's was a bit gothic. Bill's was very suburban, family-oriented. Keith and Mick were both in the process of buying these incredibly lovely houses. Mick's apartment in Harley House in Marylebone Road was fantastic, and it was being done with incredible style and taste. He drove an Aston Martin at the time. And Keith had bought Redlands, which was a gorgeous half-timbered house in Sussex, and he had a beautiful Bentley. So they were getting into rock'n'roll style.

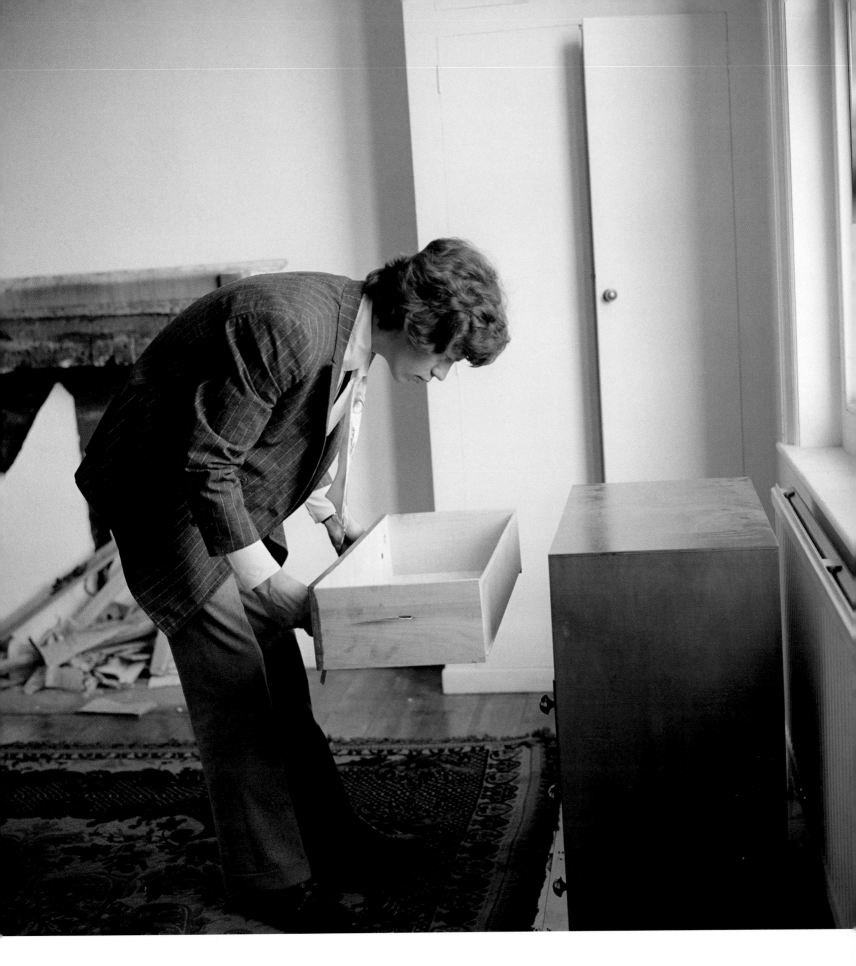

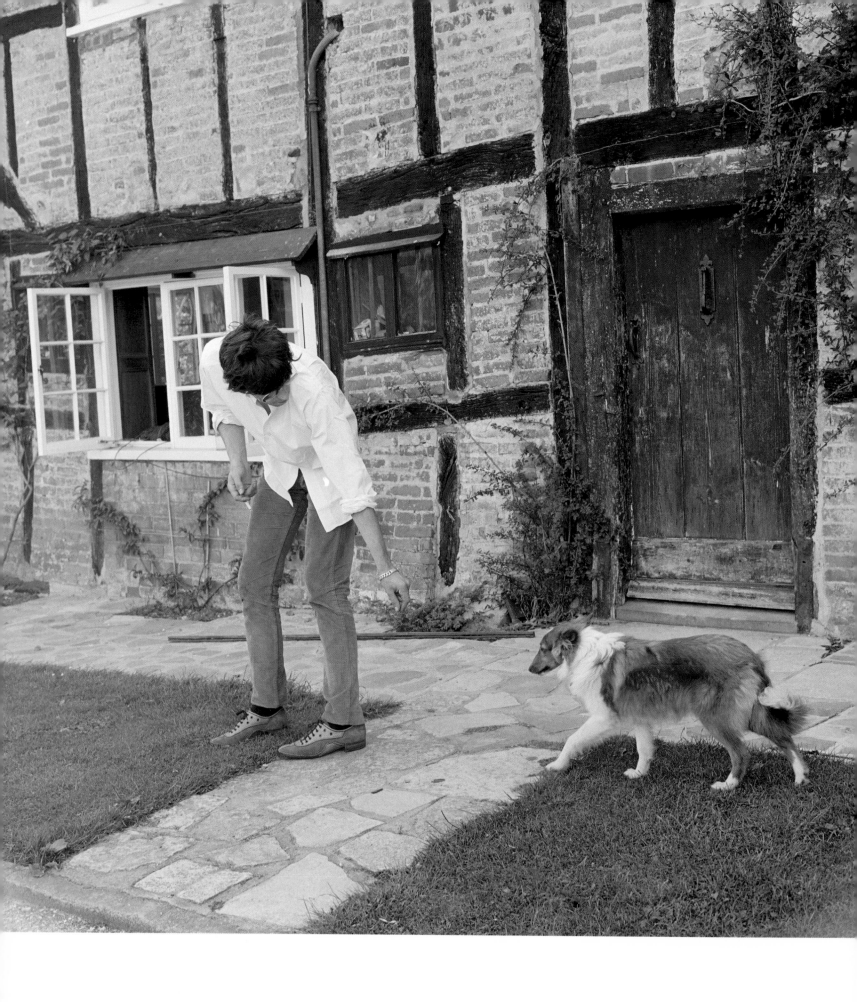

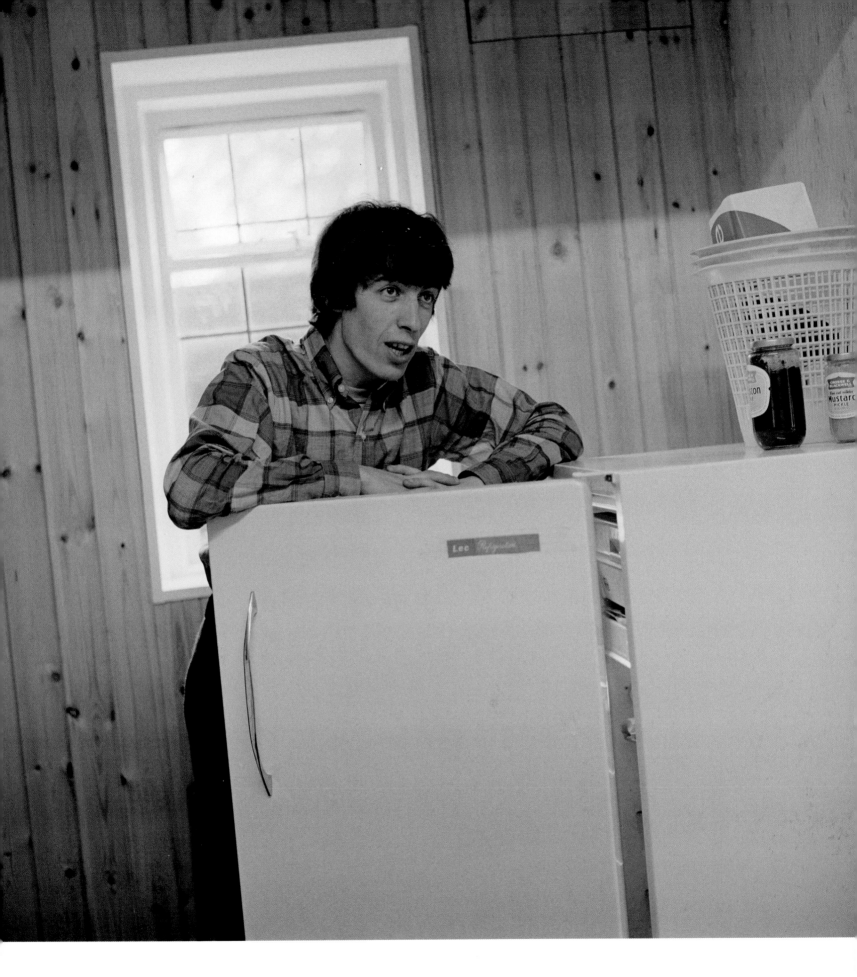

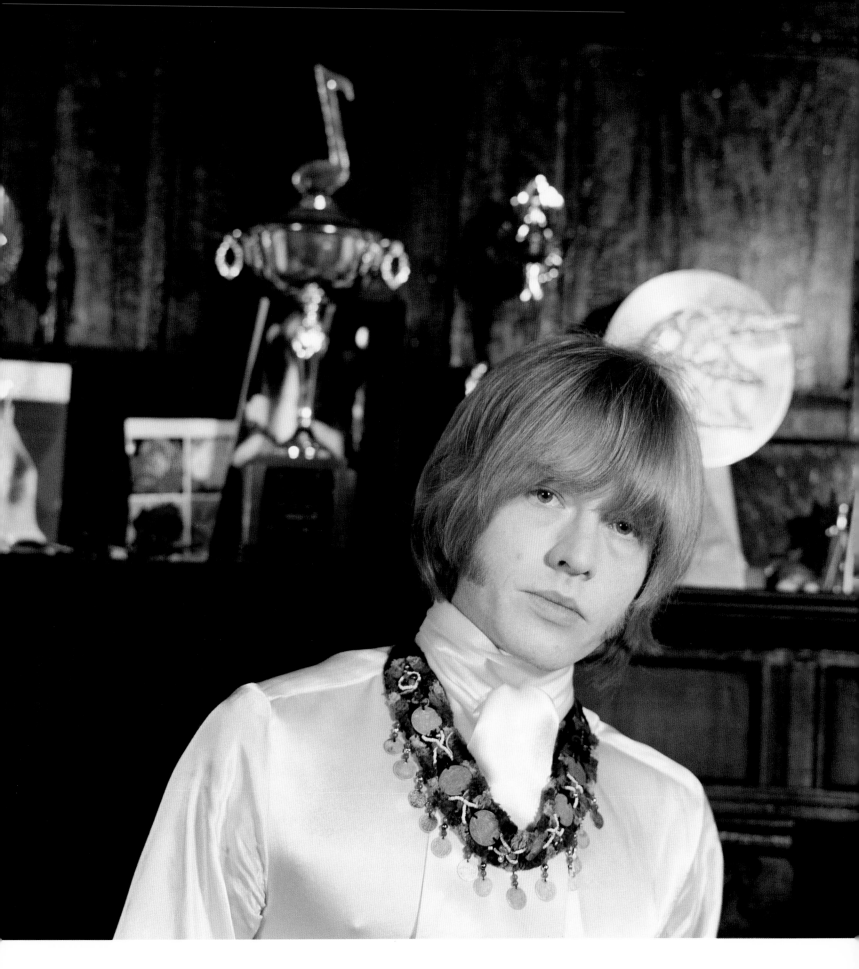

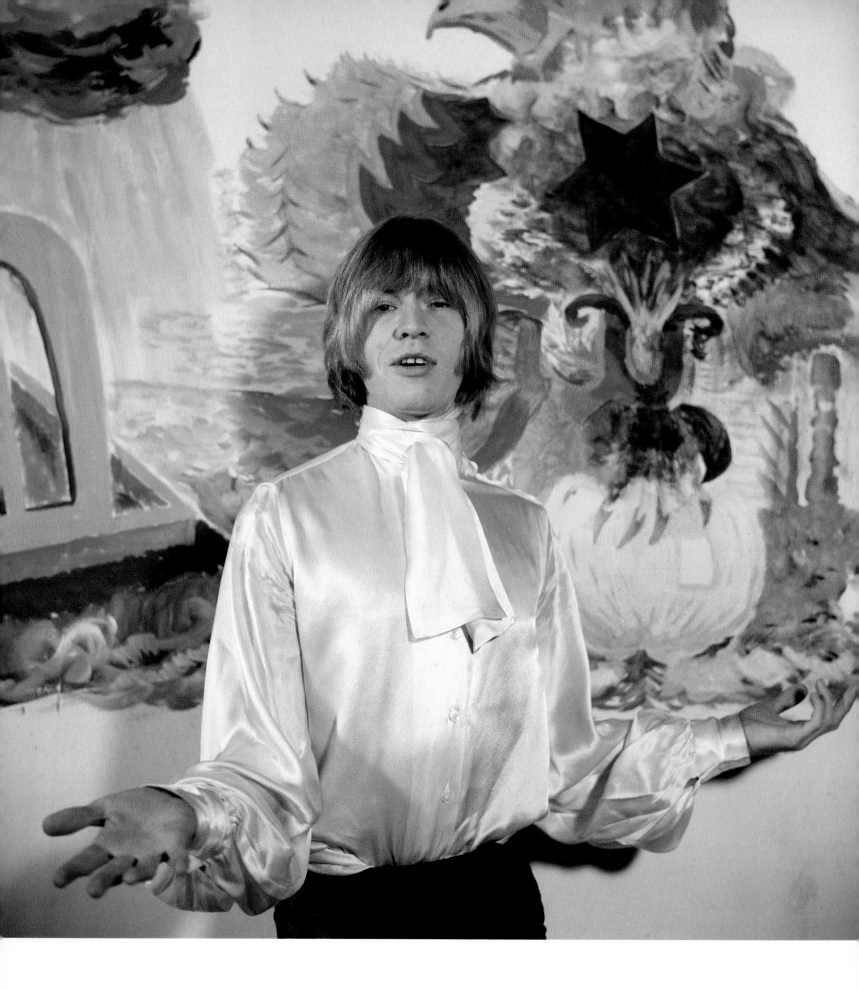

Brian's apartment in South Kensington was rather gothic and had a lot of dark wood, heavy fabrics and a minstrel's gallery. There was a sort of weird, gothic strangeness to him. He's standing in front of this rather ghastly mural that he had painted. In Marianne's book, she says about the mural, which has a tombstone without a name on it, that we all knew - everybody knew - that it was really his own tombstone.

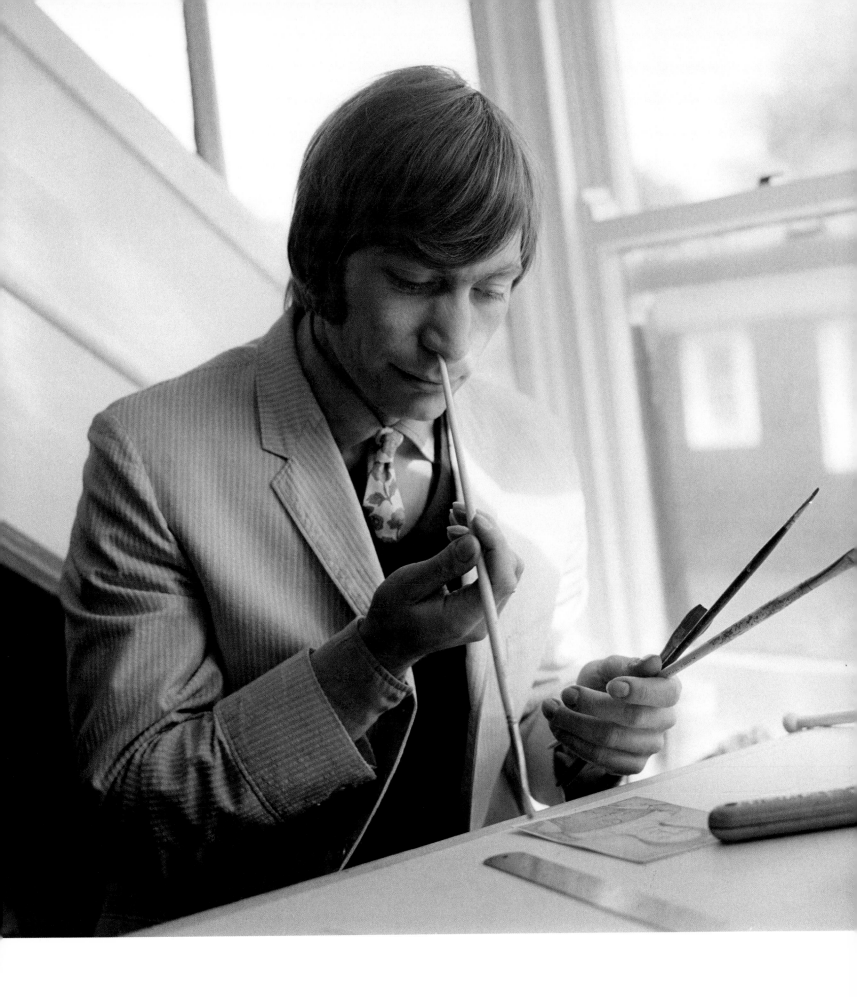

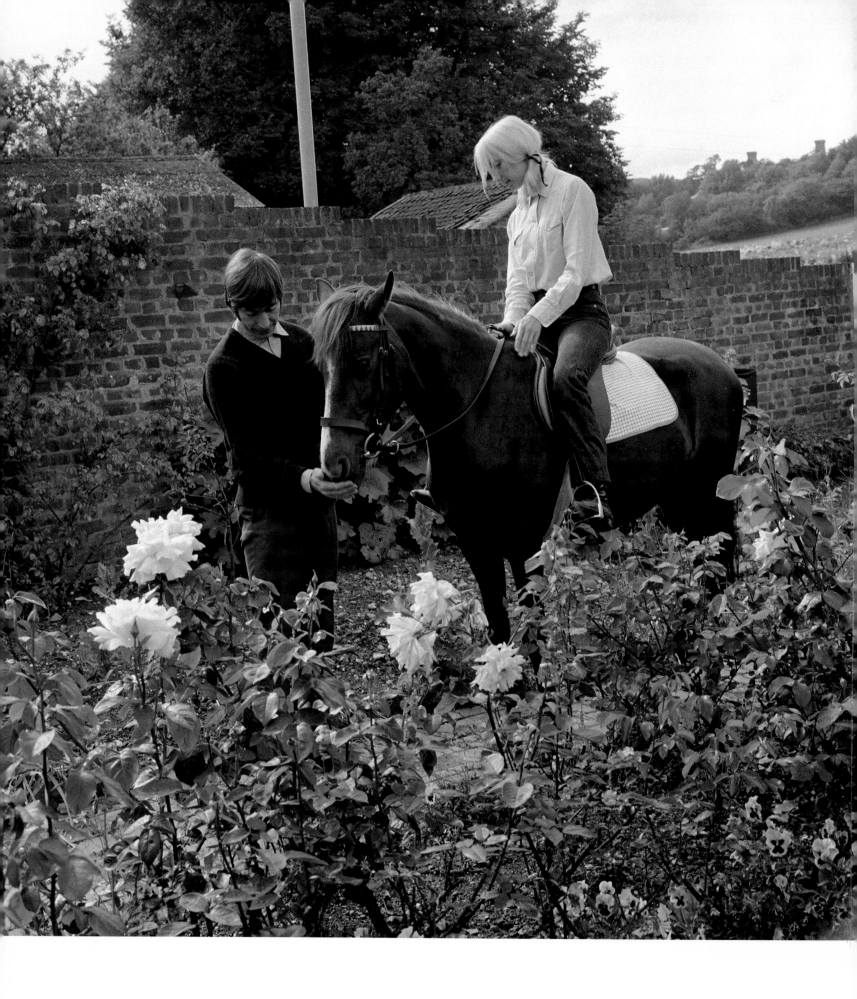

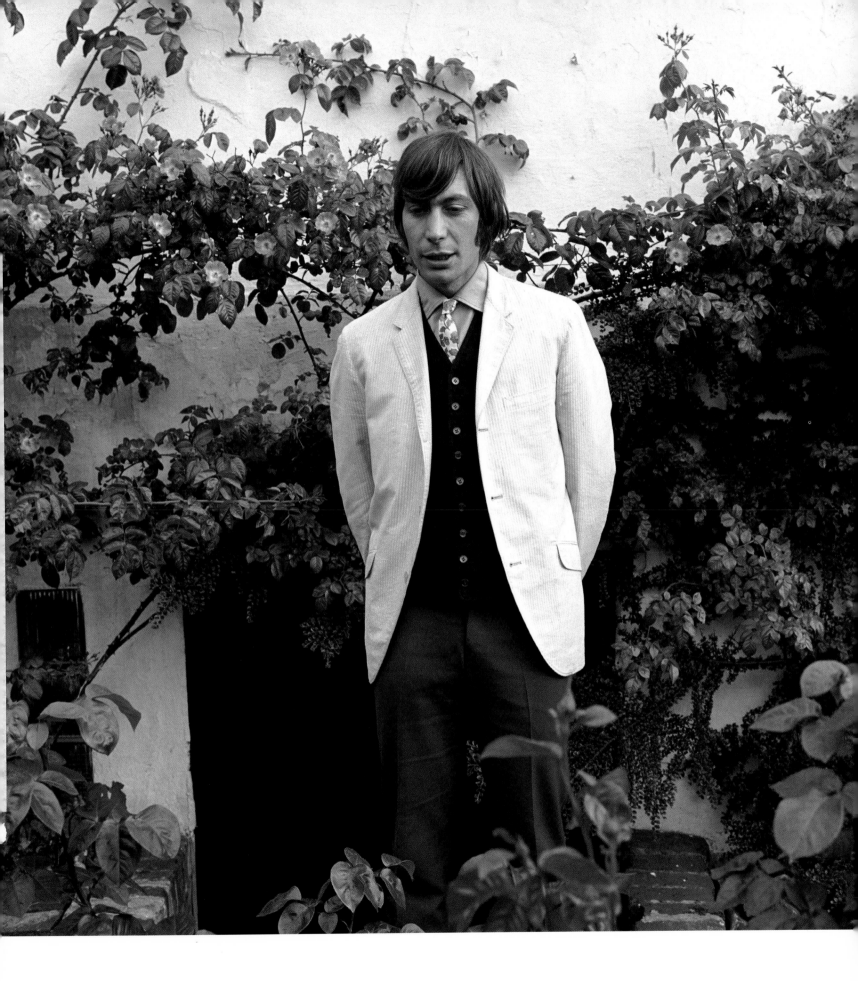

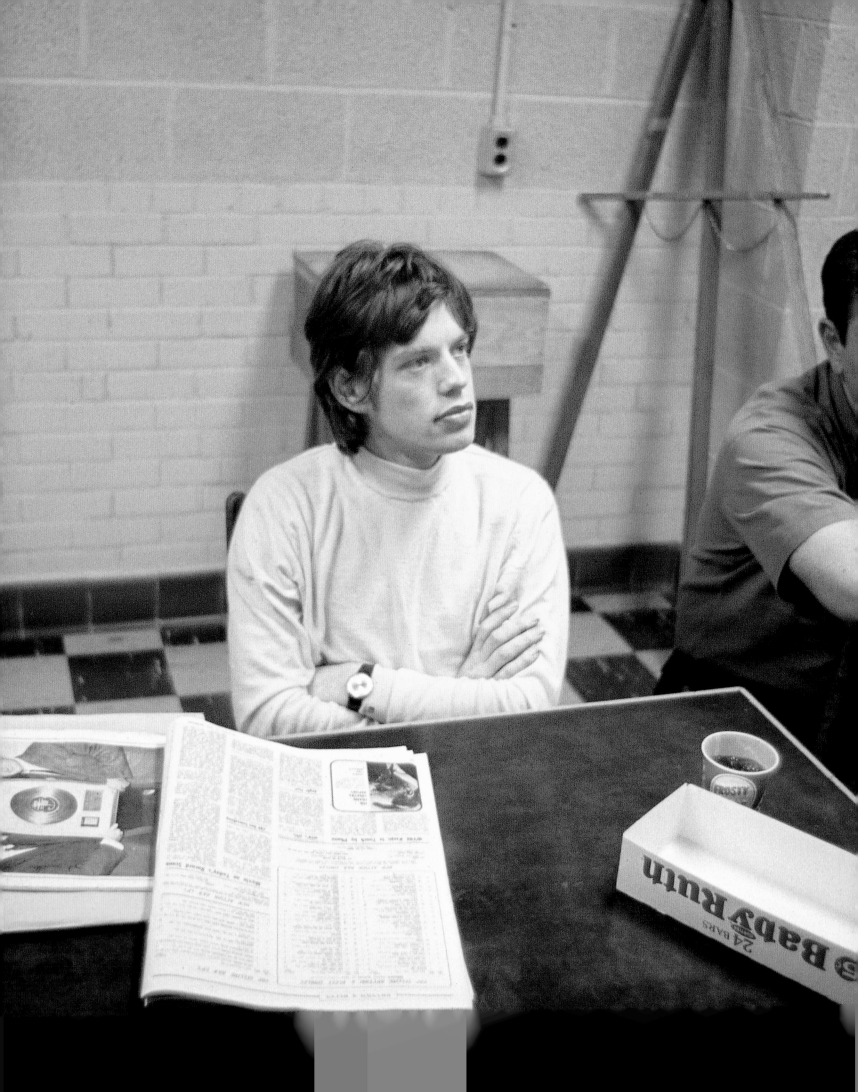

Backstage Mick's reading *Billboard*, and I think they're just monitoring the progress of "Get Off My Cloud". It was moving up the charts around this time and heading towards number one, which is where it was during the last week of the tour. Mick was the most conscientiously involved in the business aspects of the band. He seemed to have a better grasp of the big picture. He was clearly the spokesperson for the band and was coming across increasingly as the leader.

65 –
Mick was the most conscientiously involved in the business aspects of the band. He seemed to have a better grasp of the big picture

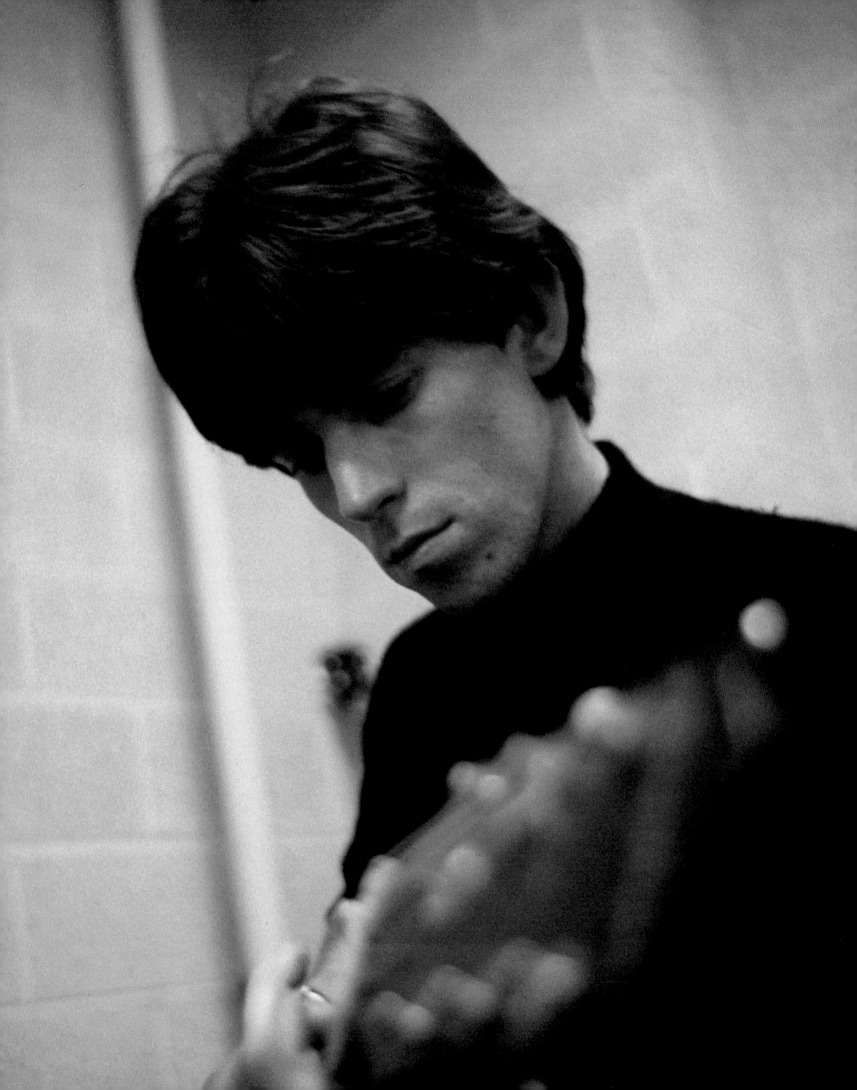

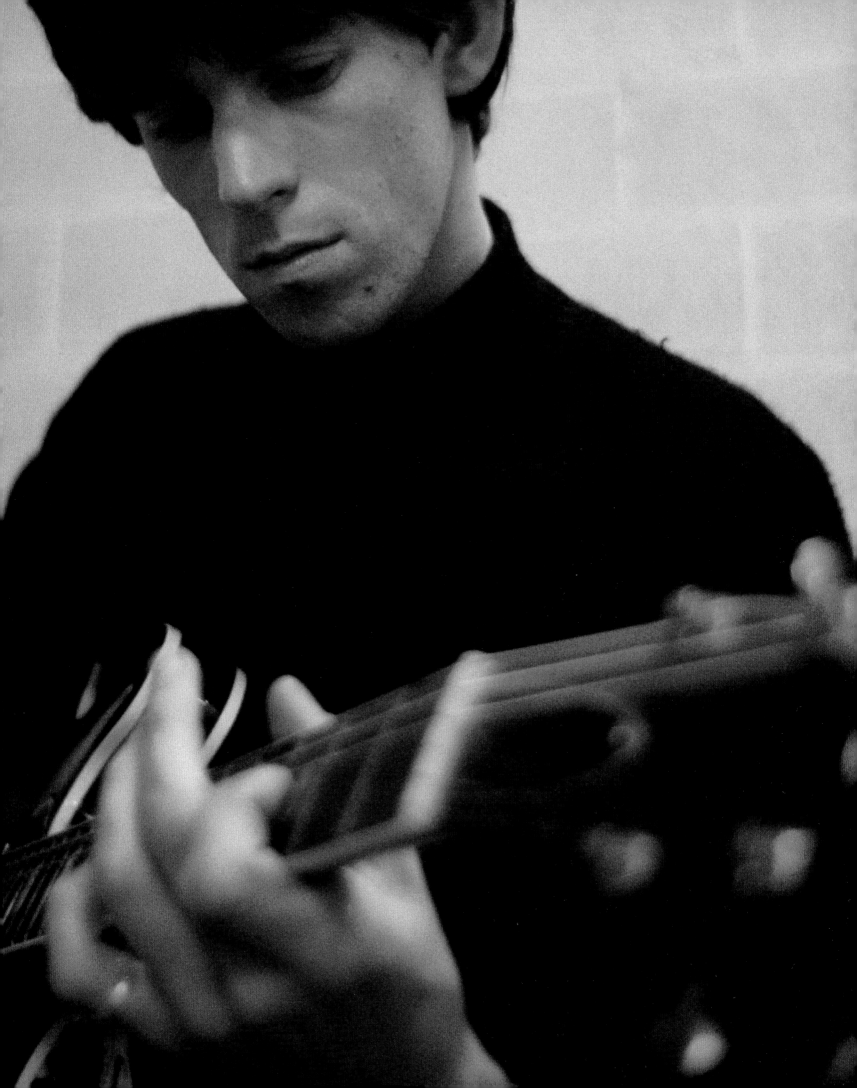

On tour in America they were very professional and very conscientious. There weren't huge amounts of drugs - there were great fallow periods where it was very workaday. There was a curious upside-down routine of flying out after each gig in this funny little prop-driven aeroplane called a Martin, getting into some country airport at two or three in the morning and being whisked off to a motel where nobody knew we were there. There weren't any girls waiting, and there wasn't anything to do. America wasn't a 24-hour country out in the countryside. It was dead, and it resulted in homesickness, missing girlfriends, pining.

So of those sixty days there were probably twenty when we did have a lot of fun and there were parties and clubs. We went to see Solomon Burke in a club in Miami, which was a fantastic night. He went on at two in the morning and we were all roaring drunk and having a great time. In New York there were some fantastic parties and girls all over the hotel and that was everything that you wanted and fantasised about.

I set my room on fire in the Lincoln Square Motor Inn in New York, on the night of the great power failure, when the whole of the east coast of America was blacked out. A night light exploded onto my bed and the whole thing went up, which was a bit scary for a moment. So the only person on this tour to ever trash their room was me.

LA was great, and we had a marvellous night in Nashville, a monstrous rock'n'roll night, got into a fight in a bar and people had to be separated. But at least two-thirds of the time, it was hard work, just laborious routine. And that affected everybody and it's why I would never tour again. I never did another complete tour after that, not with anybody.

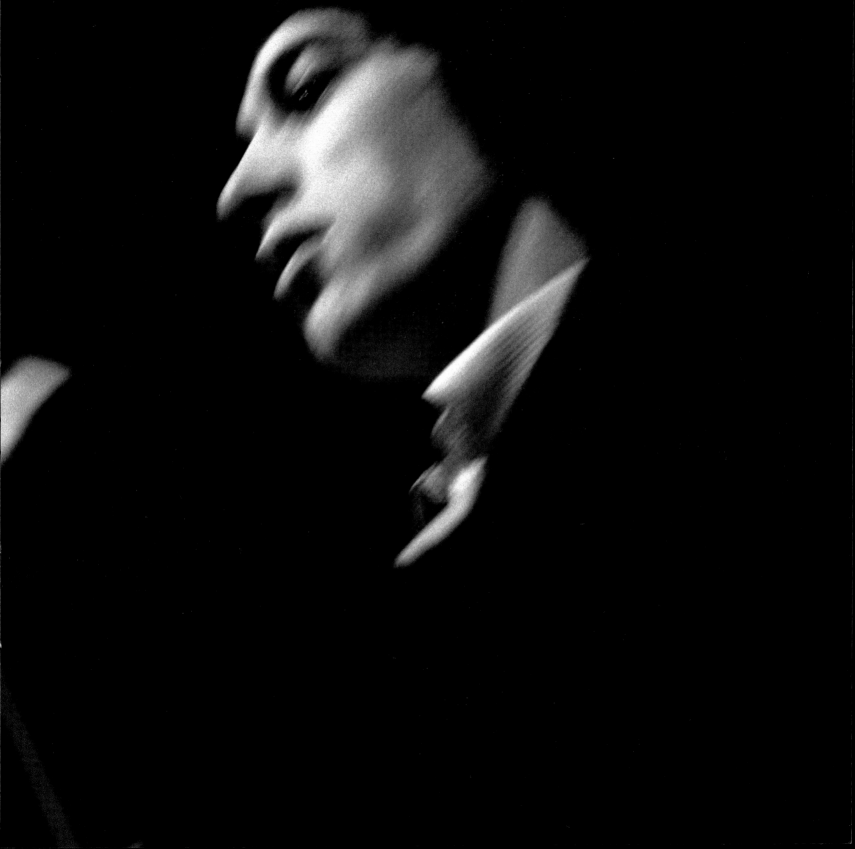

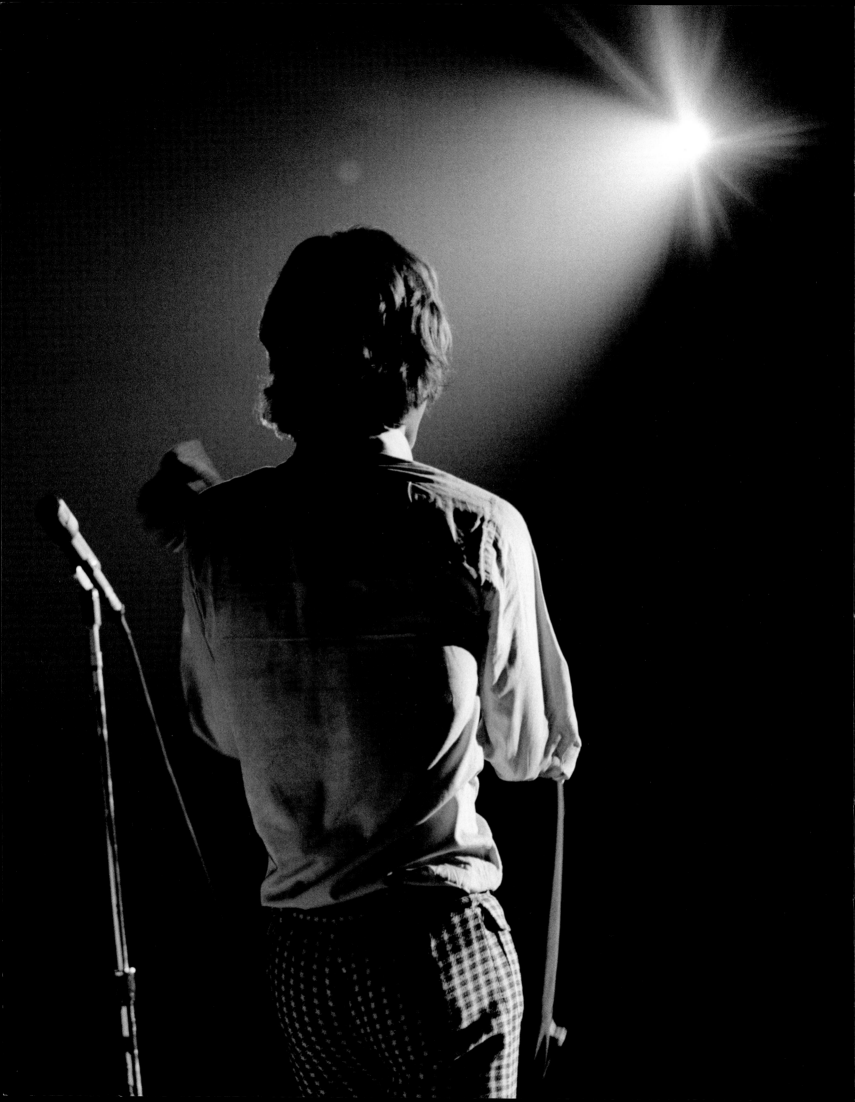

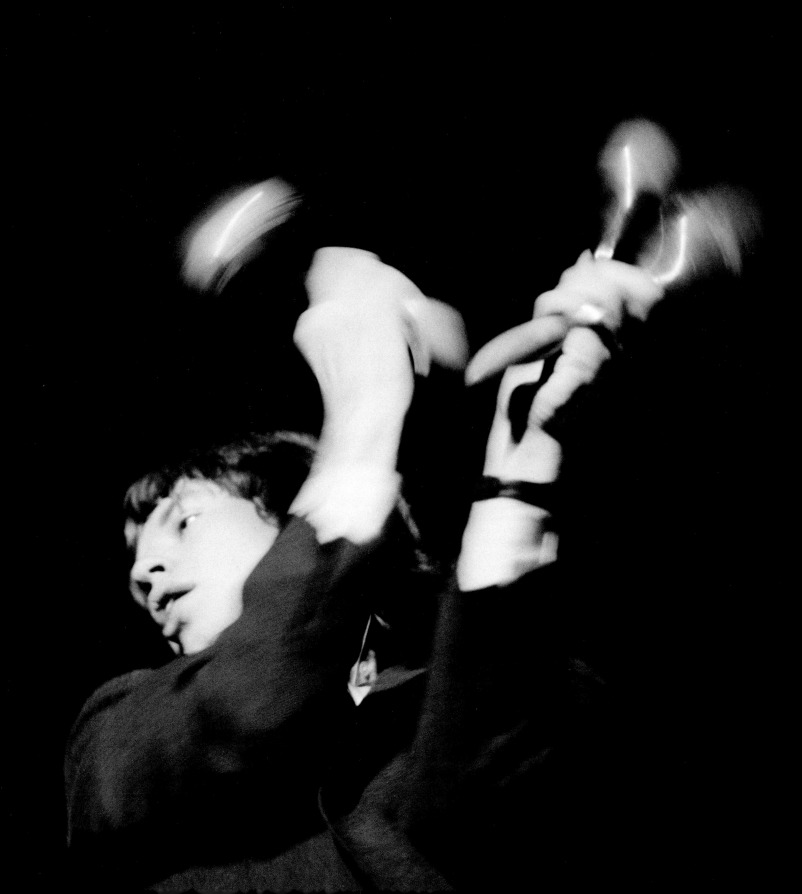

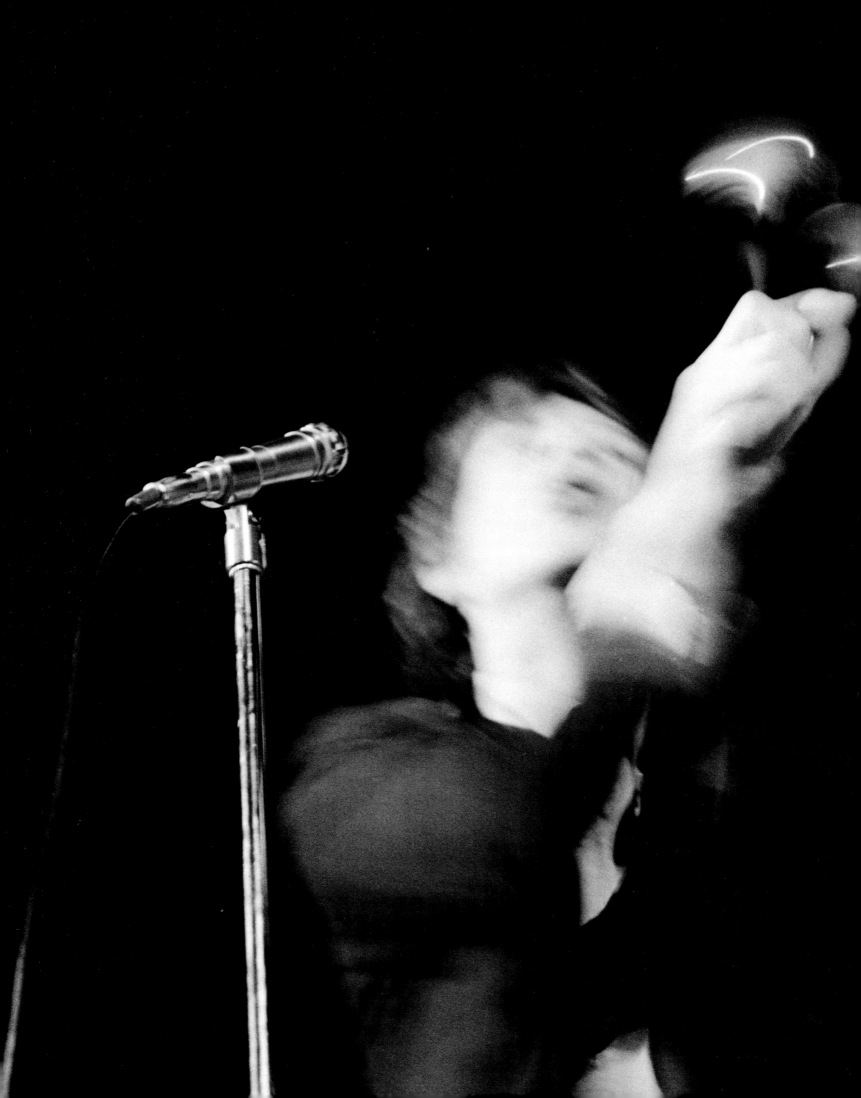

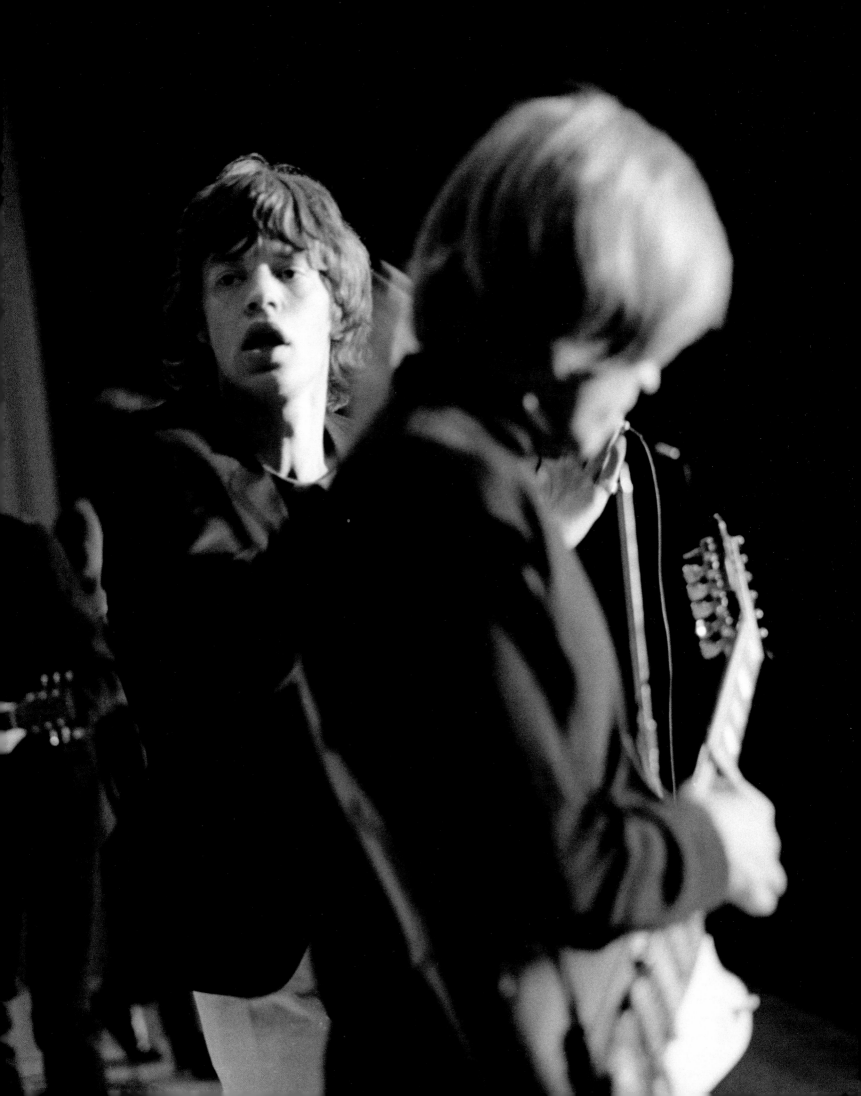

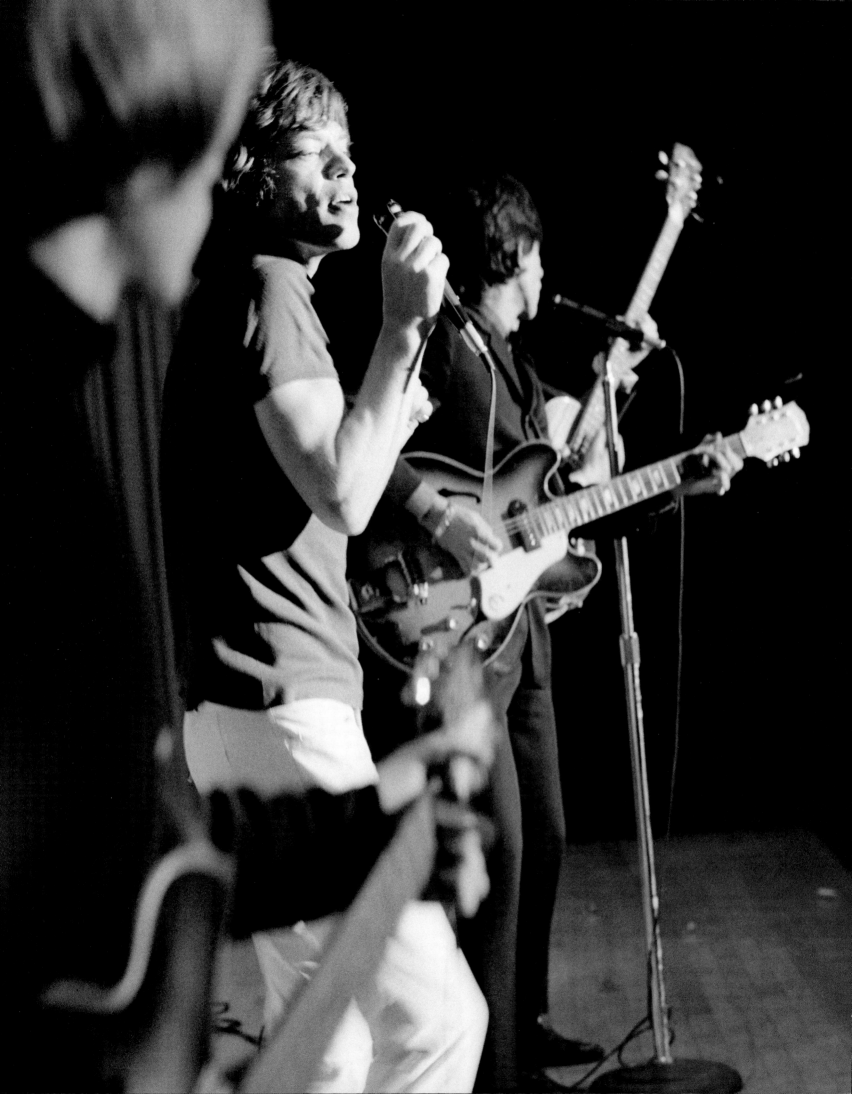

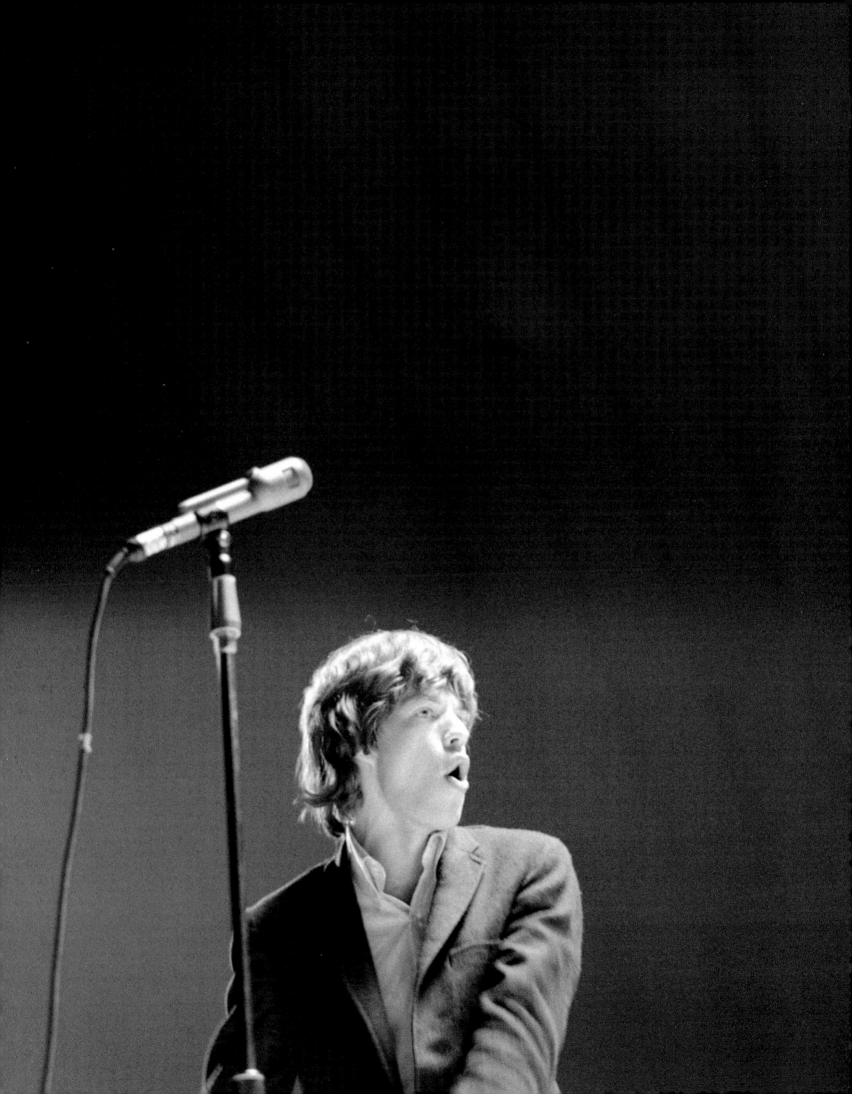

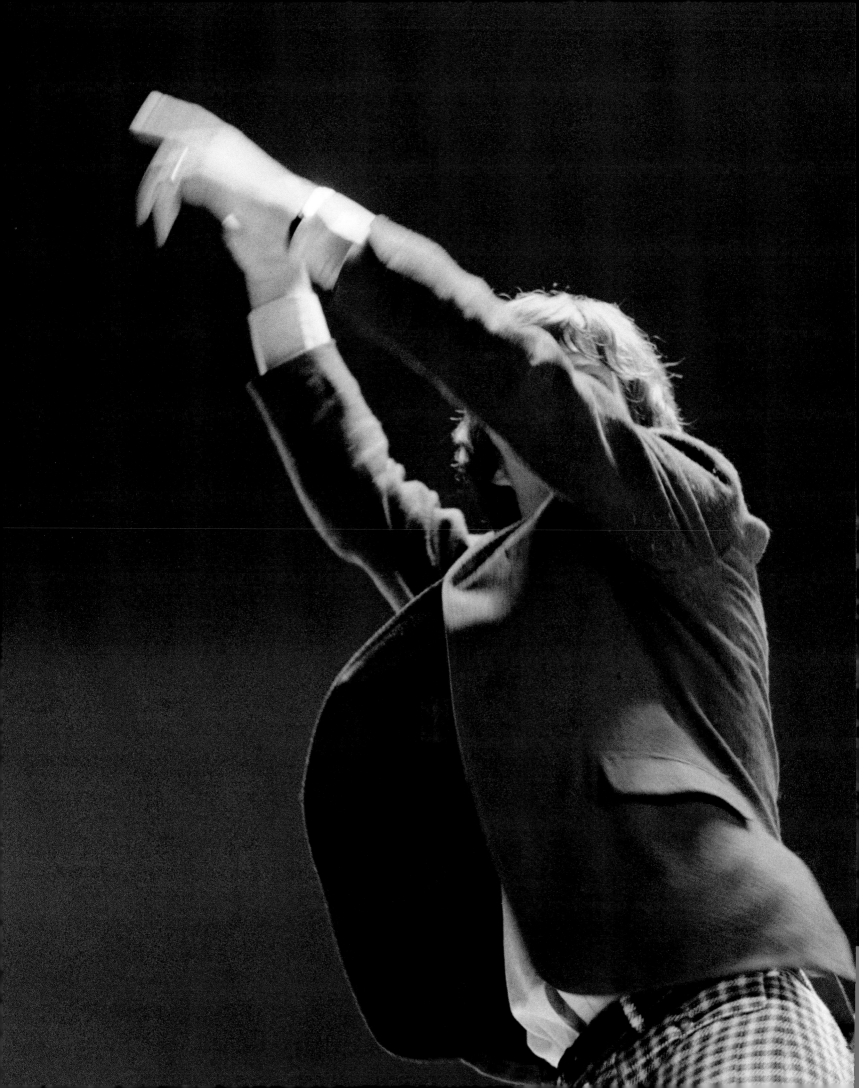

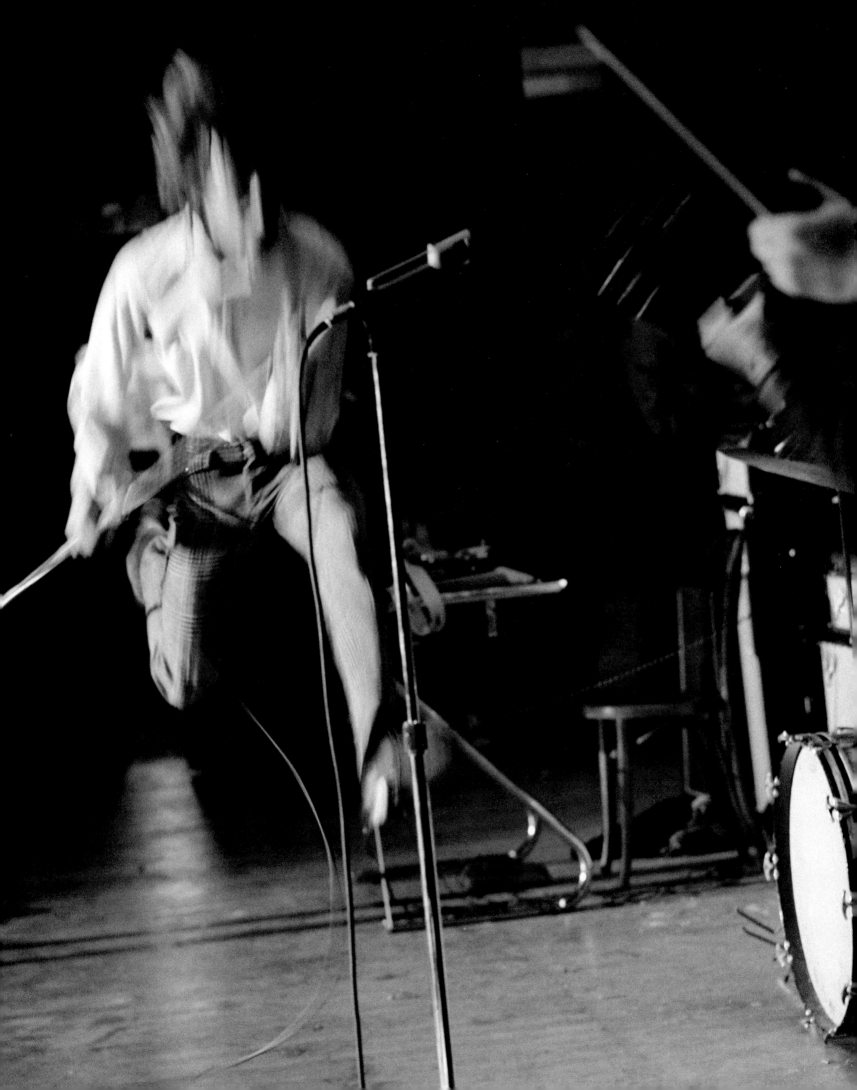

The photographs of Keith after the electric shock in Sacramento are probably the only two pictures taken with flash. It seems the mic was live because it wasn't earthed, and Keith pushed it away using his guitar. The metal strings made a circuit and he got electrocuted. There was this terrible bang and a real puff of blue smoke, which seemed to come out of his hair, and he was just thrown to the ground.

It was really frightening and the curtain came down and the music ended in that cacophony of people finishing at different moments.

I really thought he had died. I was closest to Keith of any of them, so it was particularly distressing, and somebody shouted at me to get my camera and my flash, because it was all pitch black. I got two or three frames, and fortunately he came round within minutes. He didn't appear to be hurt at all. I think he went on with the show.

65 –
I really thought he had died. I was closest to Keith of any of them, so it was particularly distressing

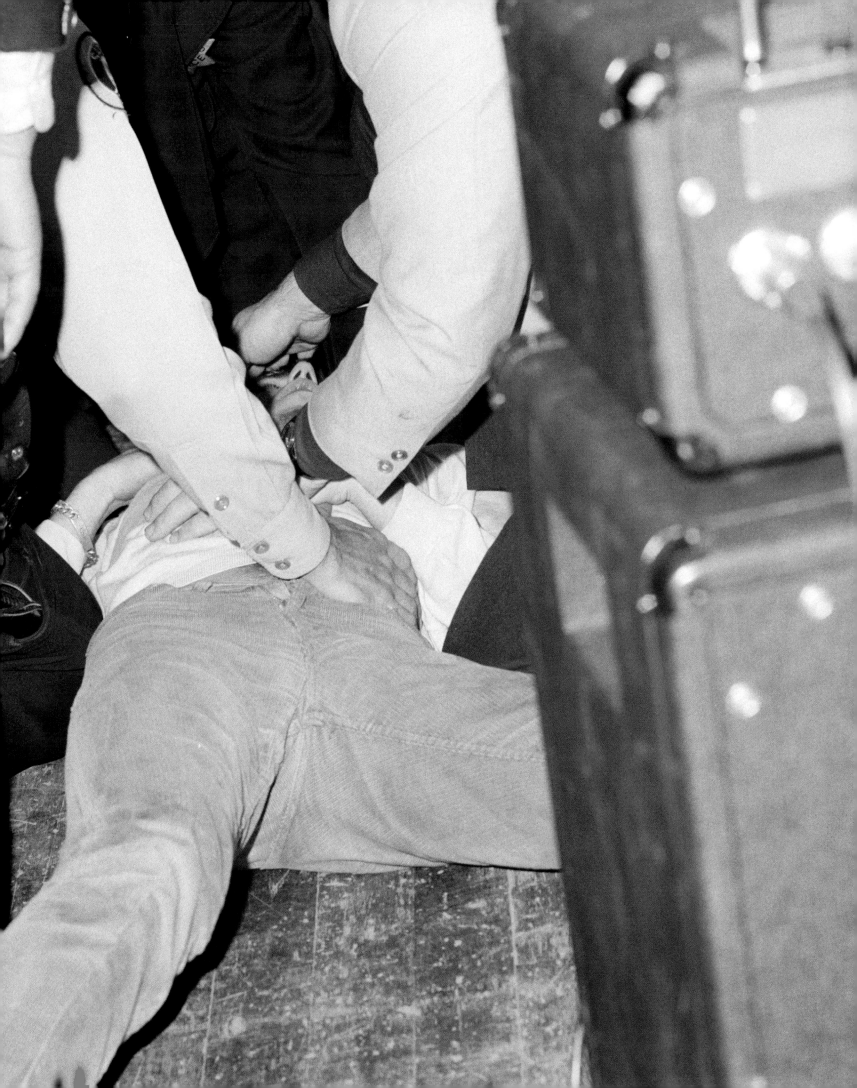

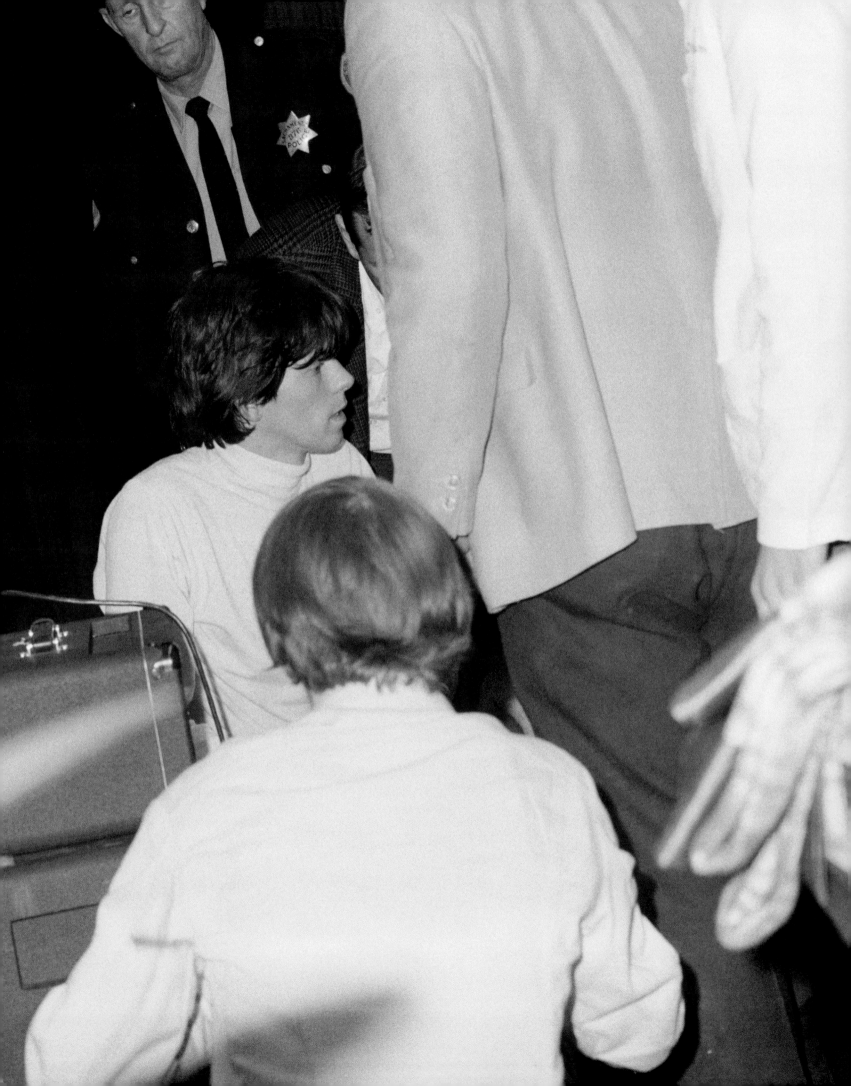

At the end of the tour there were days off. Keith rang me in my room and said, our aeroplane is going back to base and they've offered to give us a lift to Phoenix and did I want to go riding for a couple of days? So Keith took me down to Phoenix along with Ronnie Schneider, who was Alan Klein's nephew and the money man on the tour. It had all been set up and we were met at the airport and driven in a truck. We stopped en route and Keith bought us guns and chaps and cowboy hats. I had this ridiculous Hoss Cartwright-type ten-gallon hat and these leather chaps, and Keith bought me a fantastic Winchester pump action and we went off riding with a guide.

We went across the desert and through a herd of cattle, and got caught in a storm and flash floods, and then we came to a camp that they'd set up for us by a river, and they made a huge fire for us, and cooked, and we got drunk and slept under the stars. Our bedrolls were frozen to the ground the next morning. It was fantastic. We used my hat for gun practice so I came back with holes through my hat. I didn't do many pictures because I was having such a great time, but I did a couple of portraits of Keith. I think he quite fancied himself as a sort of Billy the Kid-type character. I think a lot of musicians have an affinity with the outlaw thing. Guitars and guns, definitely.

65 –
We used my hat
for gun practice

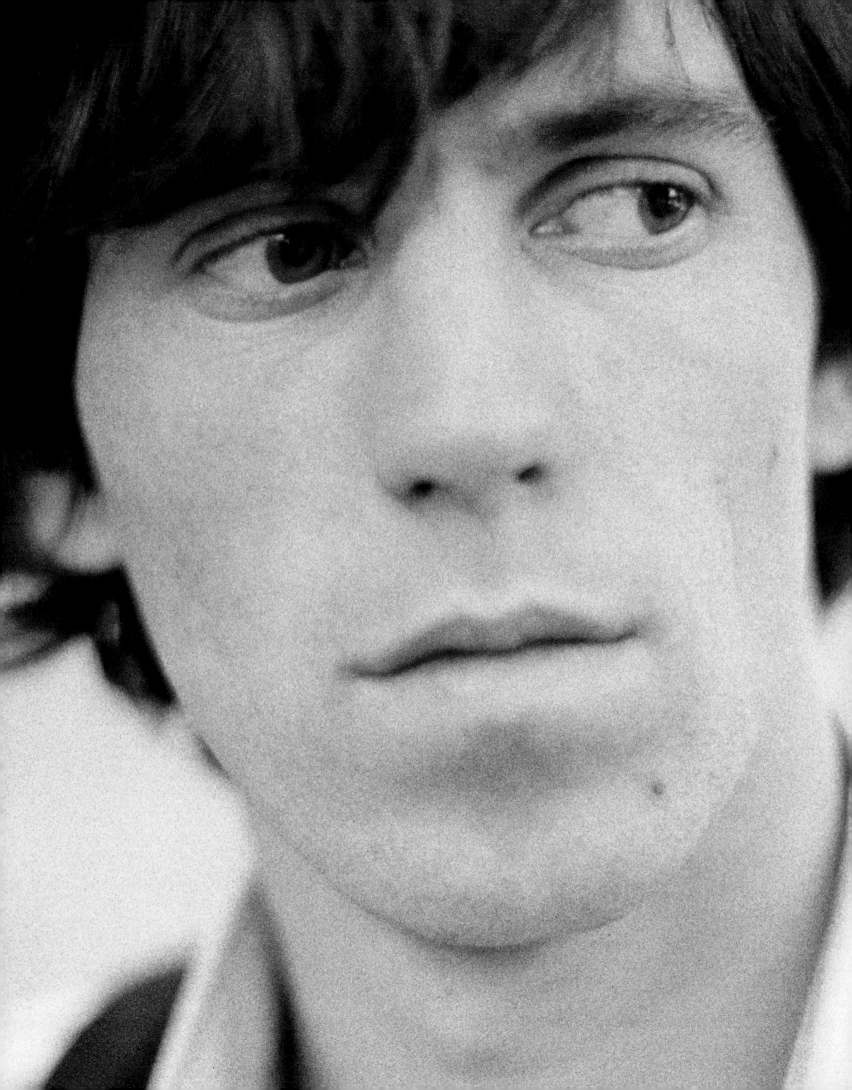

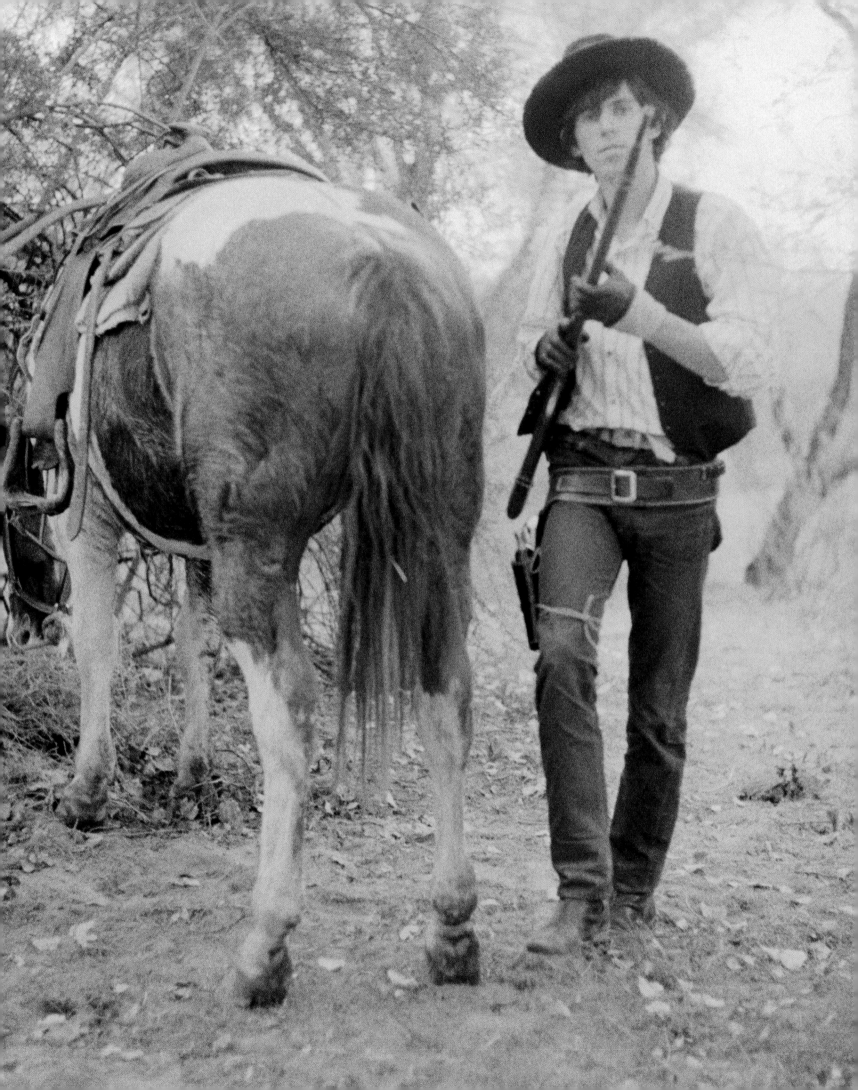

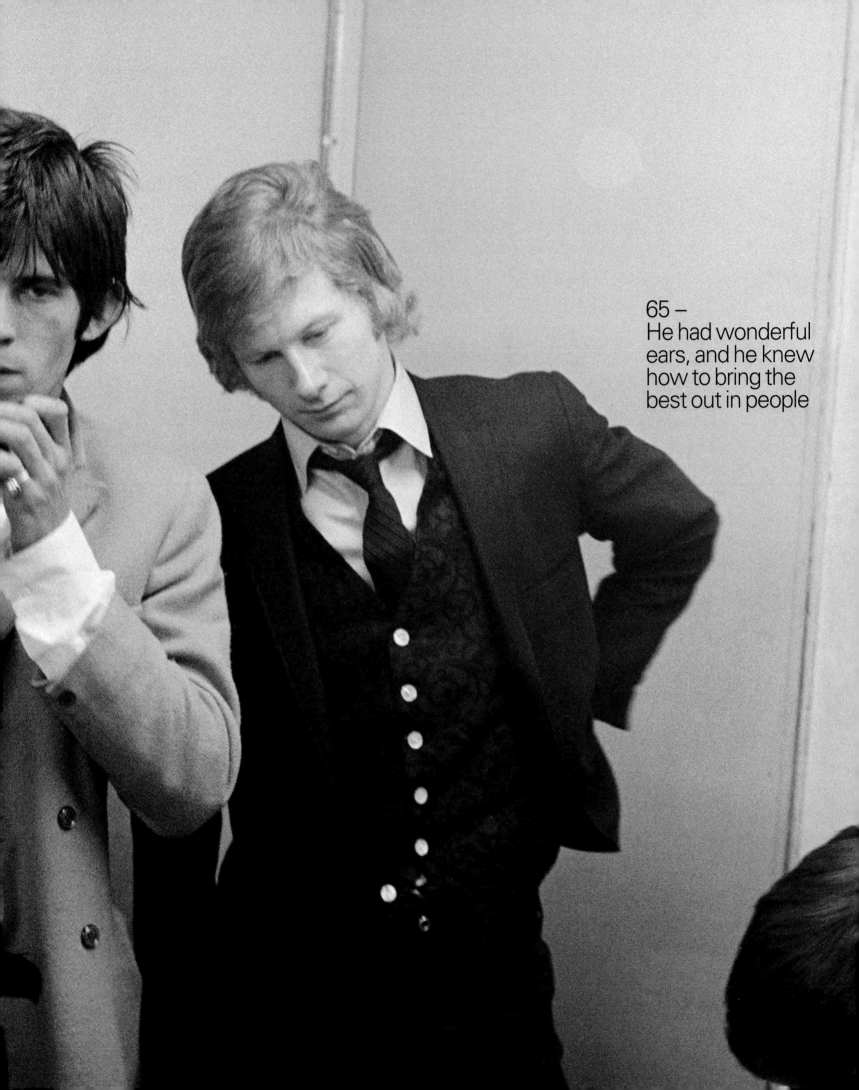

65 –
He had wonderful
ears, and he knew
how to bring the
best out in people

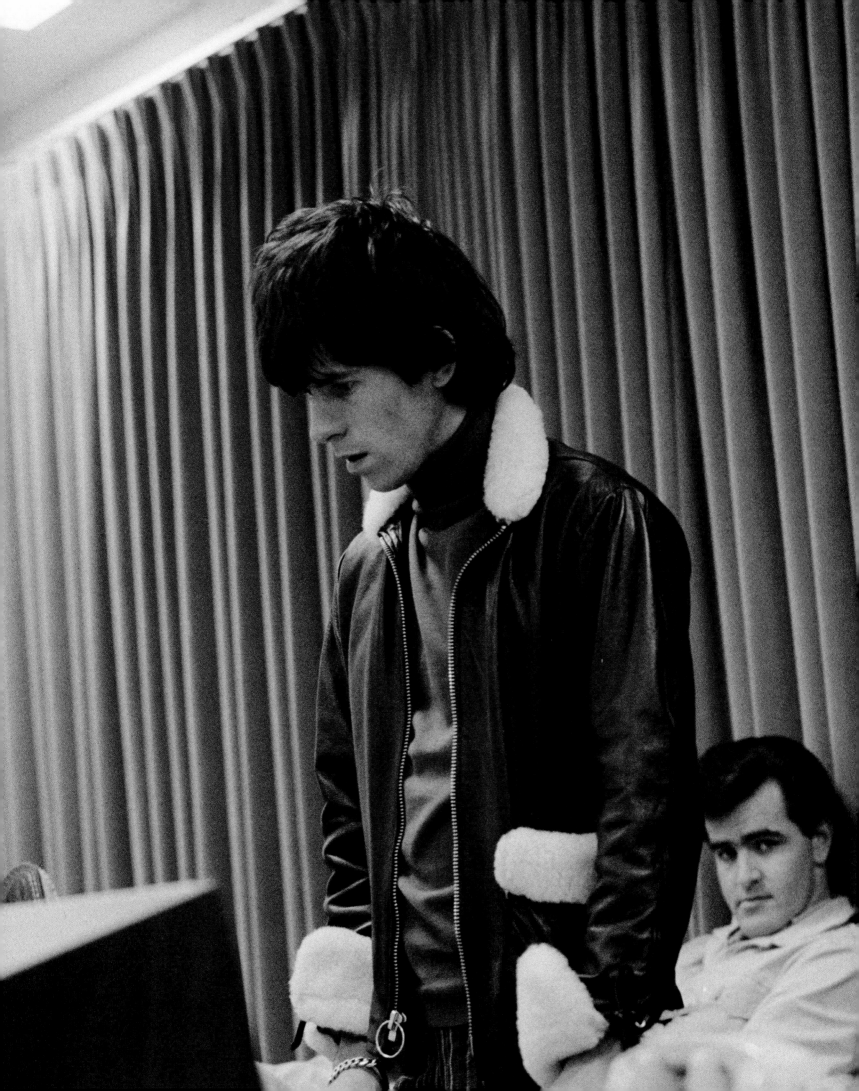

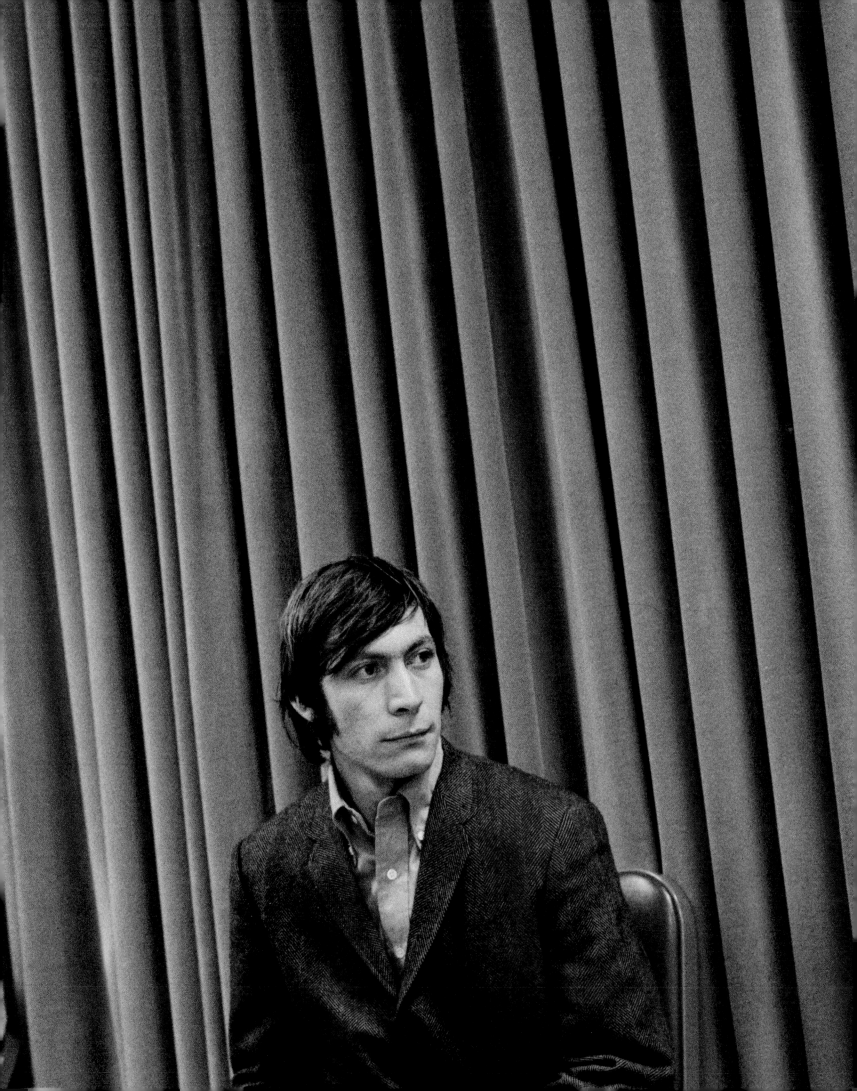

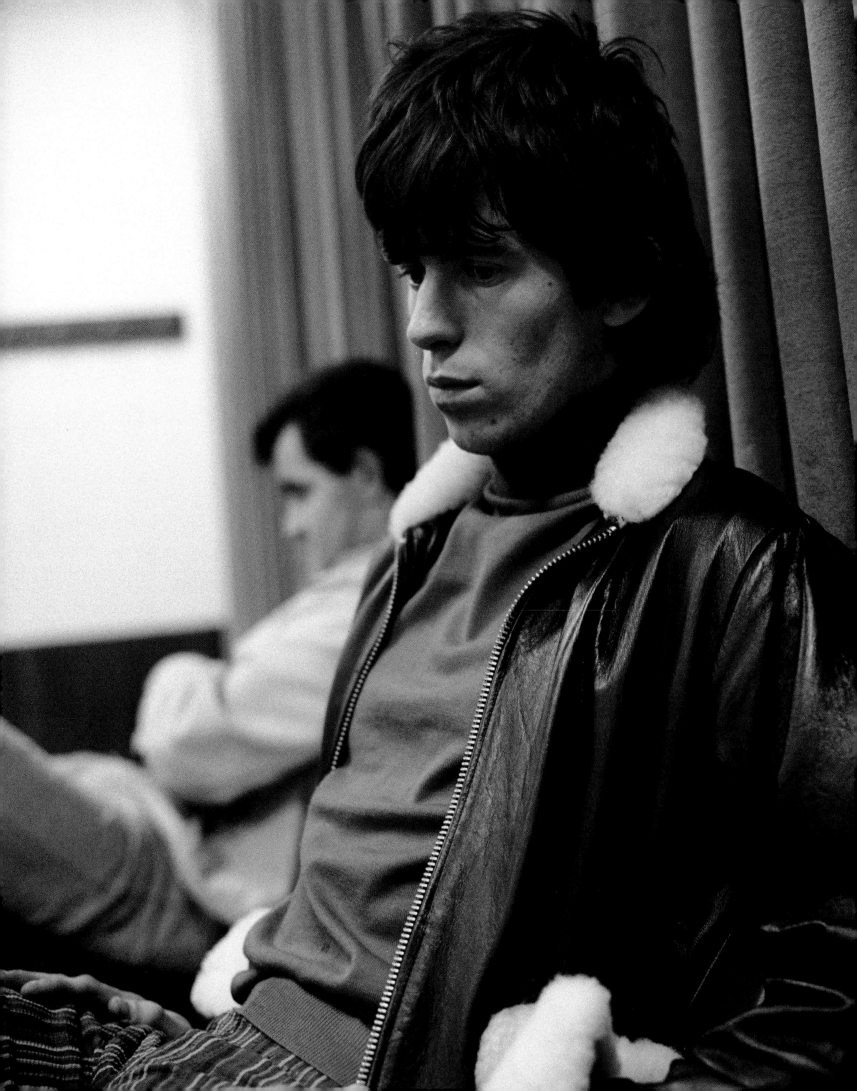

After the tour they went into RCA Studios in Hollywood in December '65, and recorded *Aftermath* with this great engineer called Dave Hassinger. Jack Nietzche was the musical arranger and Jack's wife came in every day with a great funky stew for everybody. I covered a couple of days of it, and it was a very nice, calm, rather civilised way to end, even though there was quite a lot of pressure on them.

I think they had to deliver. Mick and Keith wrote some songs on the road, and this was their window of opportunity to record and there was quite a lot of tension. I wanted to get the concentration and the focus.

Andrew was a real producer in my mind. He had wonderful ears for a great song, and he knew how to bring the best out in people. I think he was a crucial element in both the recording and in The Stones' evolution, in the way Mick and Keith became writers. Andrew knew how important that was before they ever did, and he knew that there was going to be a magic between them. He also knew that Brian didn't have it in him, which was part of Brian's problem, that he couldn't write a song.

Brian had this extraordinary talent to appear to be able to pick up and play almost any instrument, but an awful lot of people have said that he actually never focussed enough on anything to be as good as he could have been. So there was perhaps a tension already appearing in the recording studio where Brian was beginning to be sidelined. But I never saw that as a conspiracy. I always saw that as an organic part of the way the band grew.

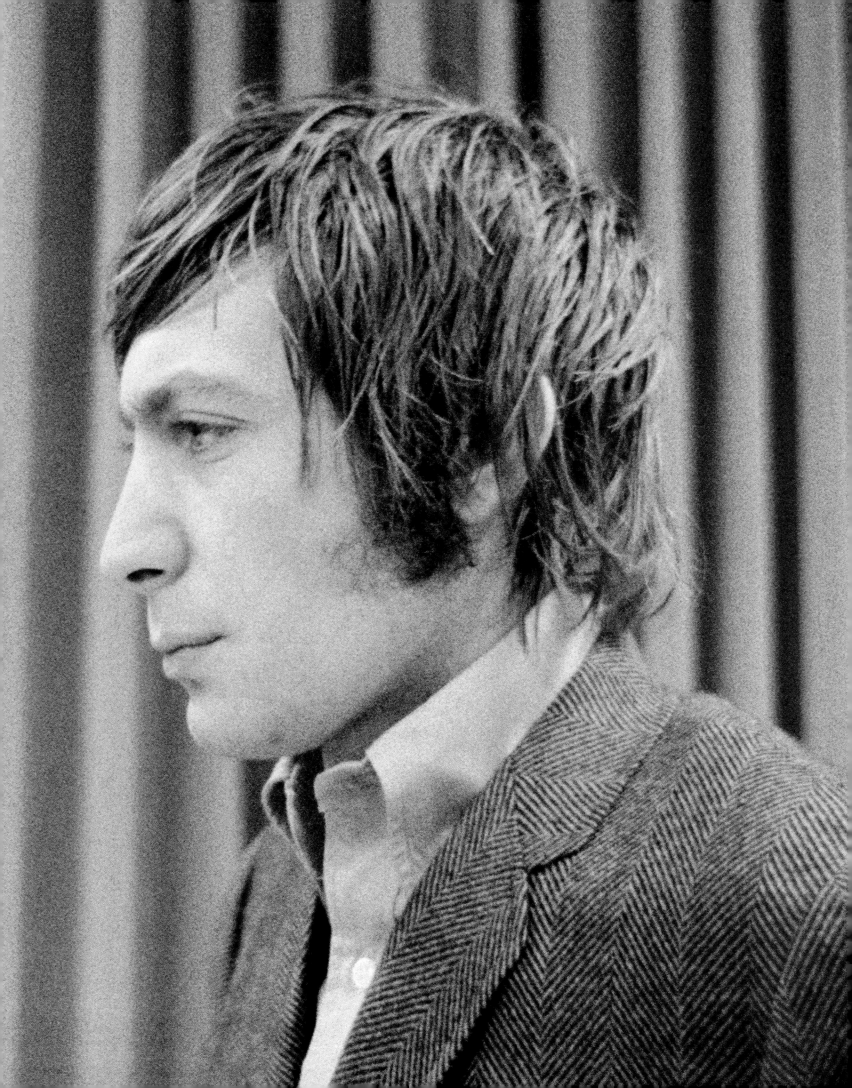

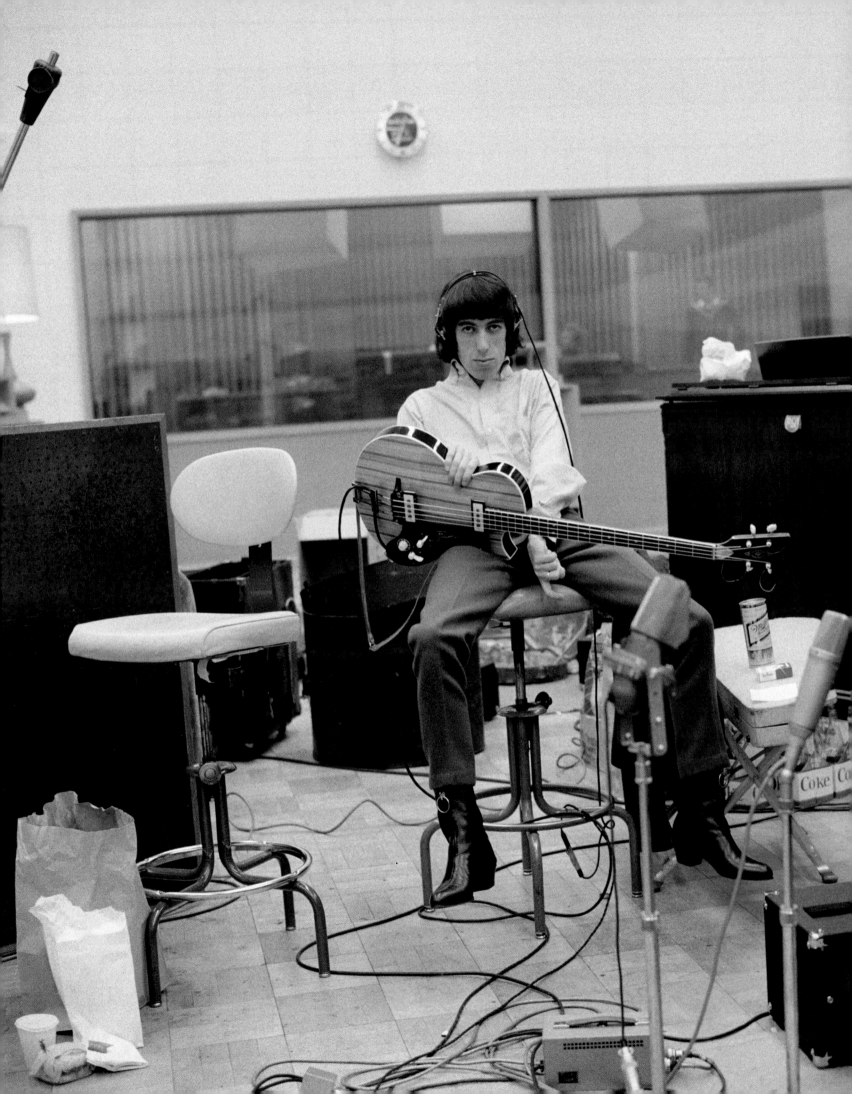

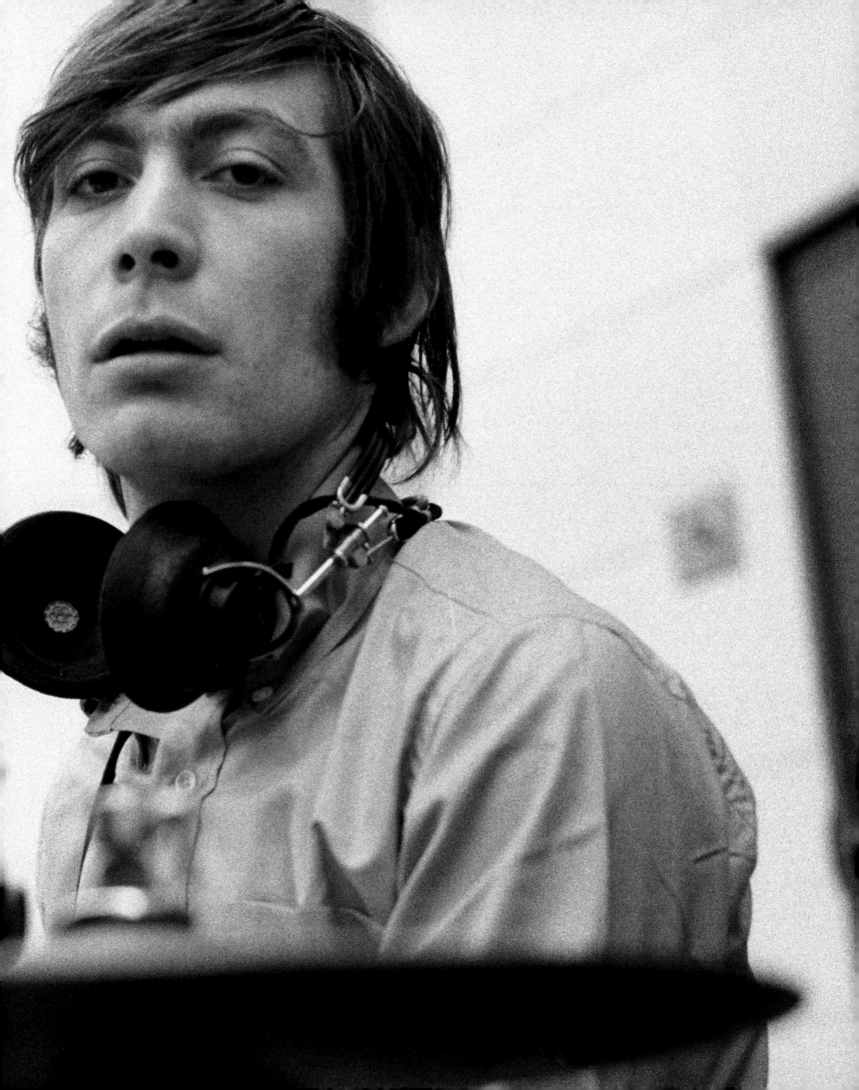

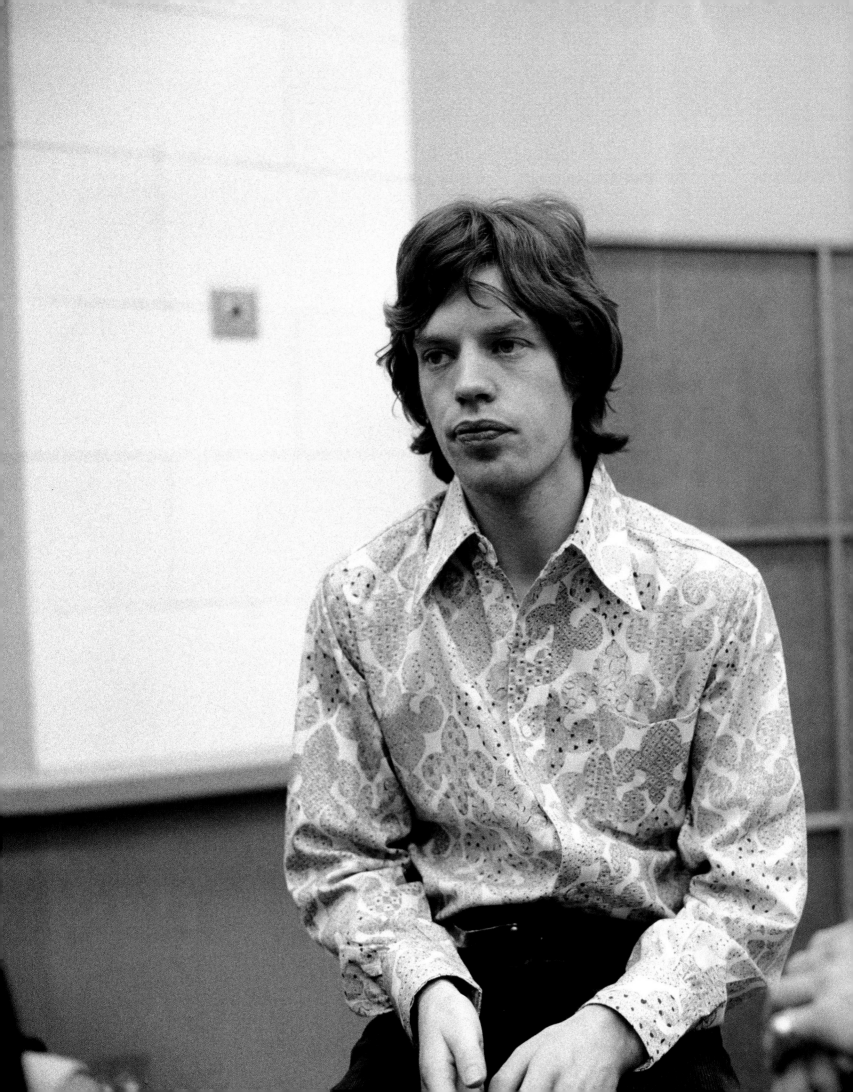

They weren't self-conscious at all and they were very comfortable with me taking pictures. We didn't set anything up. The thing about The Stones was they didn't want to do anything set up, like The Beatles would have done. They didn't want to "pose". They were very good when we did a studio session, but they didn't want to do those cheesy, corny, showbiz-y pictures. That was very definitely not The Rolling Stones.

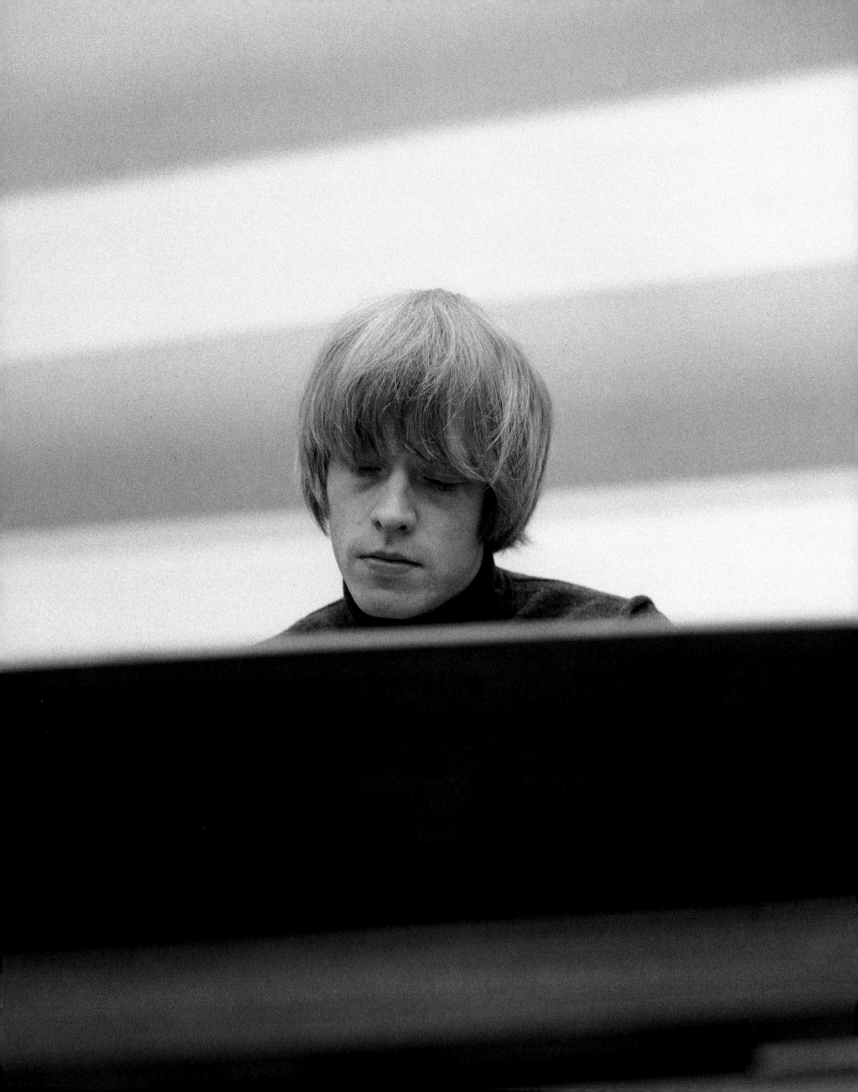

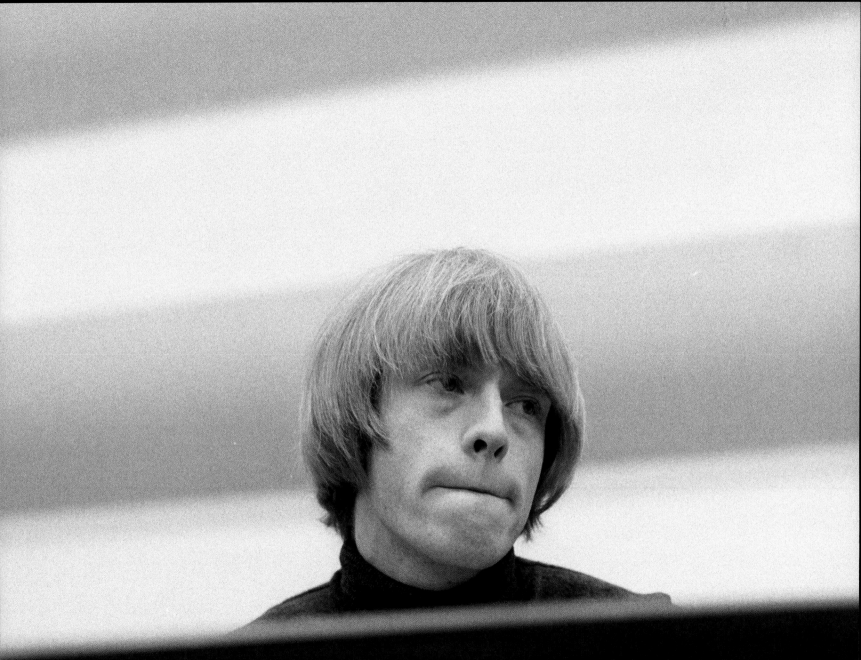

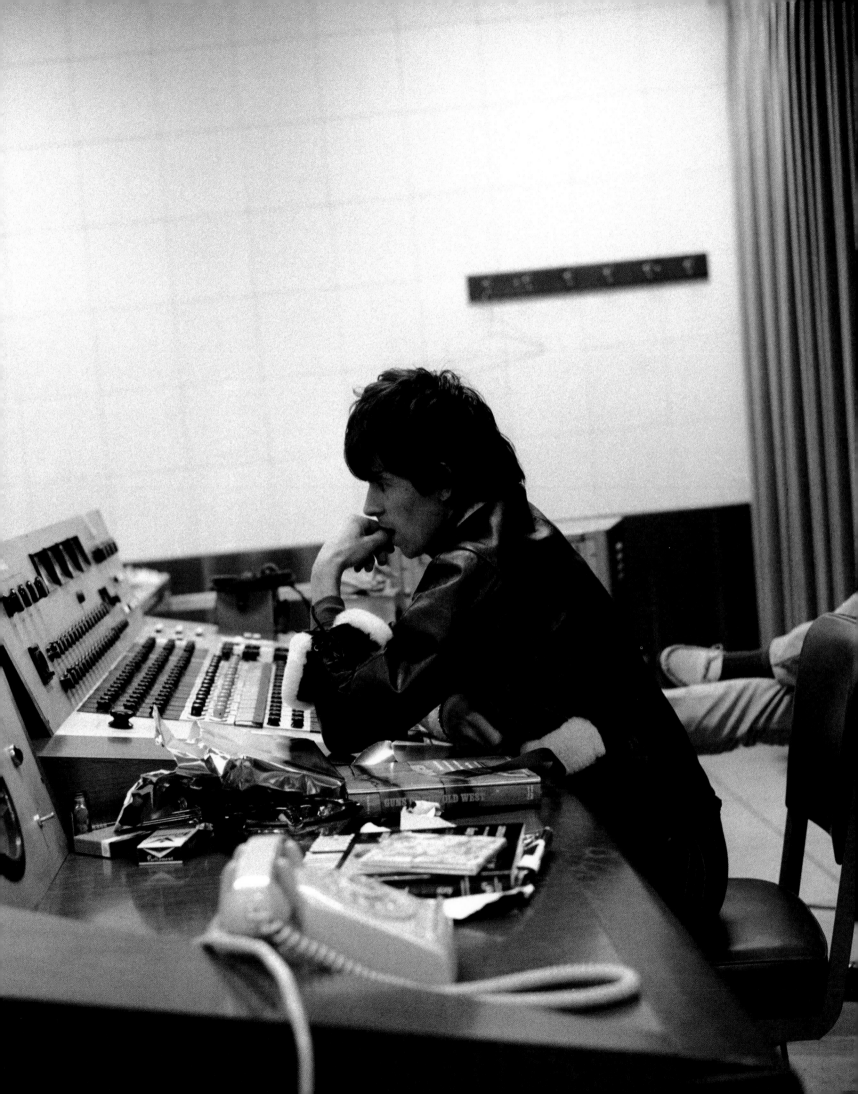

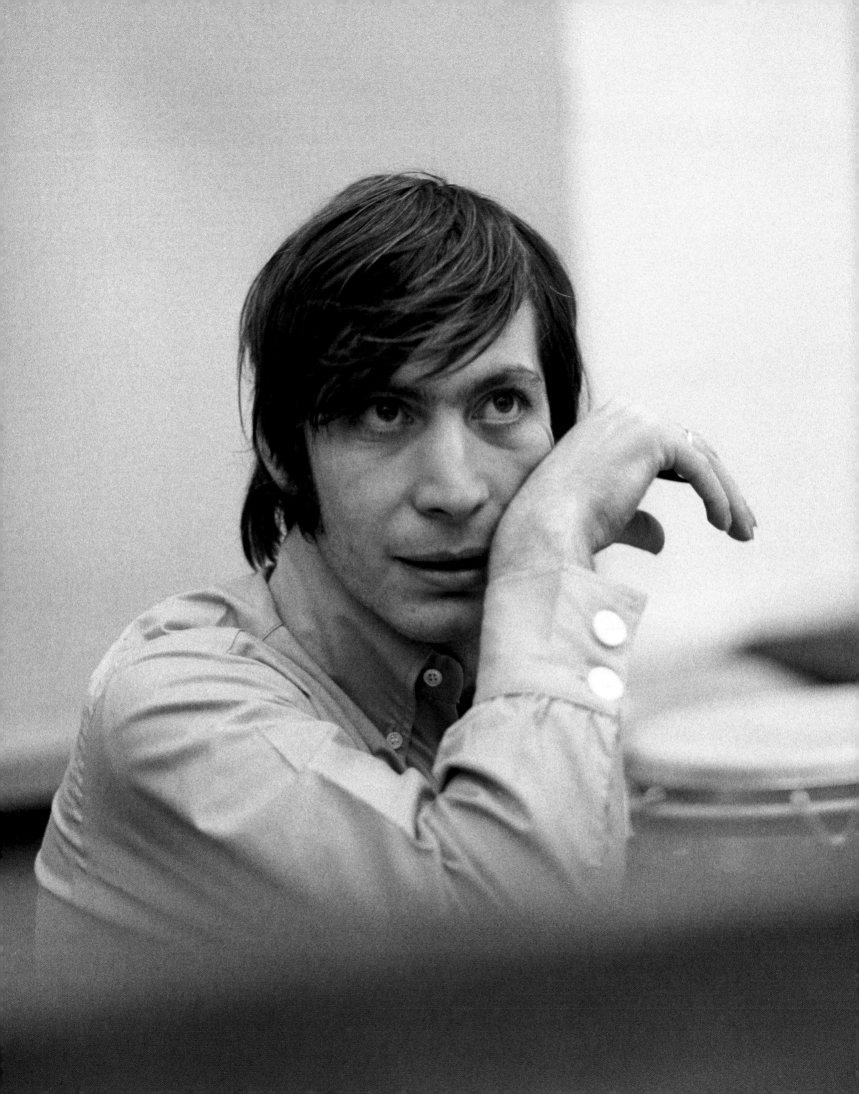

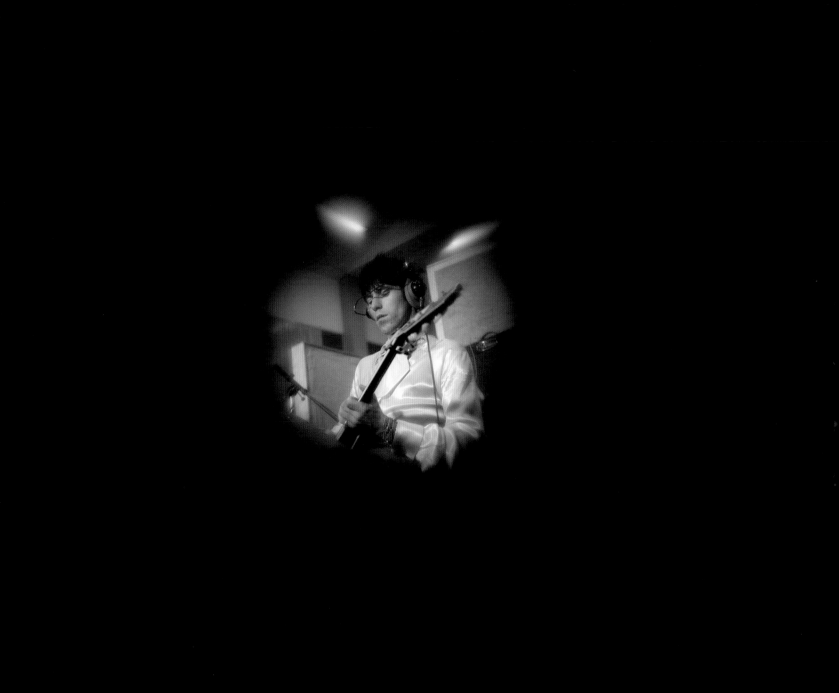

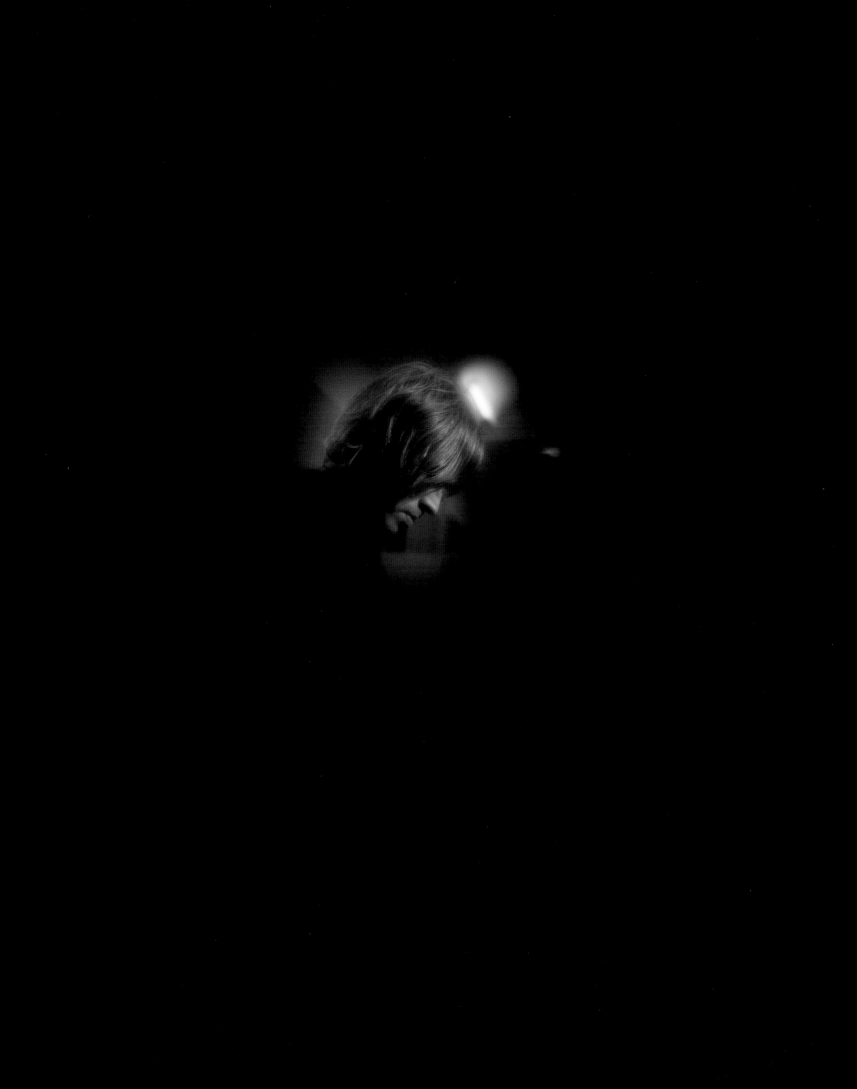

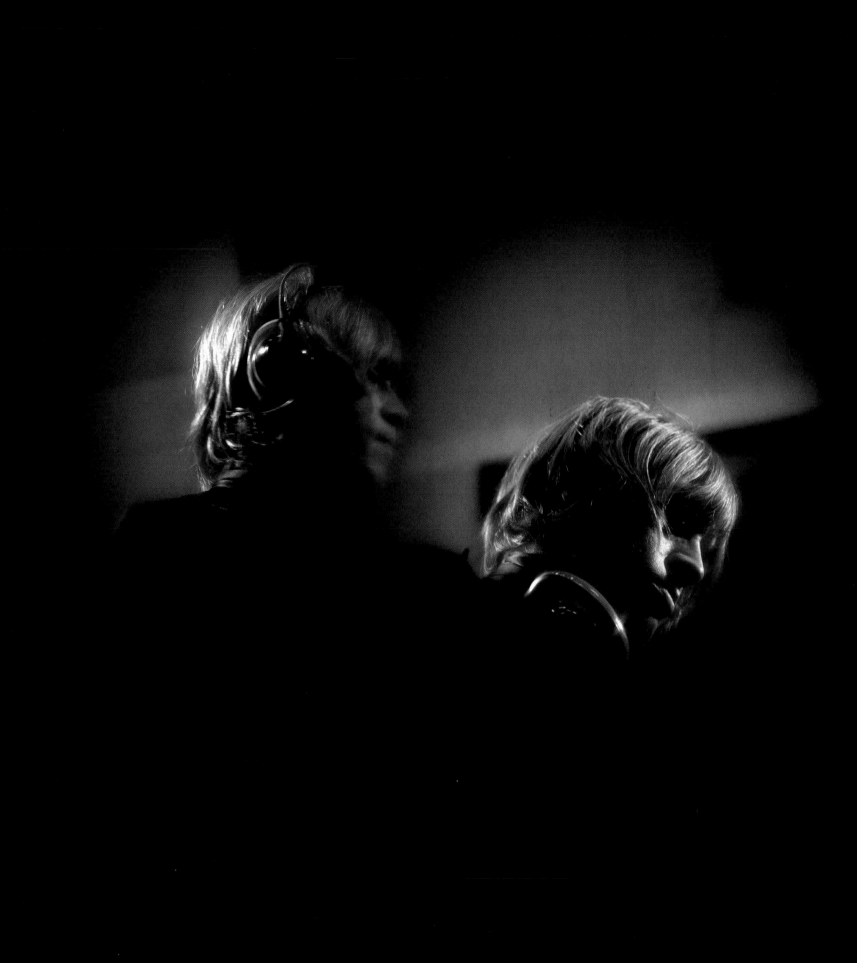

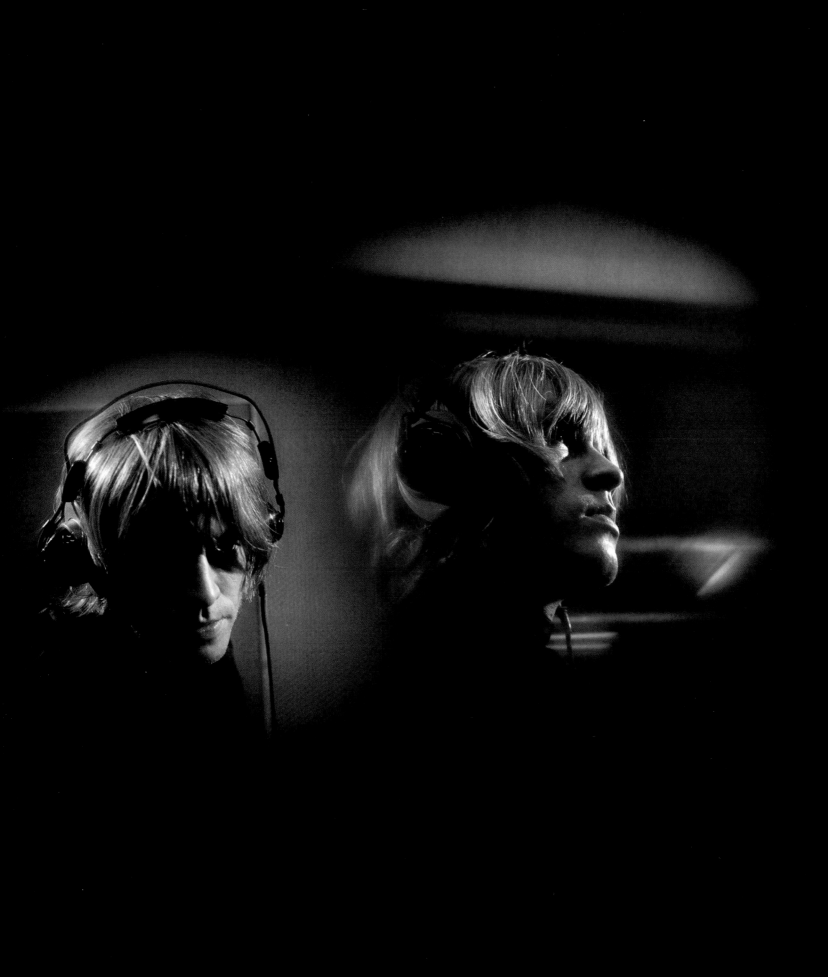

Between the Buttons was, in a way, my first attempt at conceptualising an image, and for various reasons we did the session early in the morning, but primarily because they looked fantastic at that time. There was a look to them at dawn, after working through the night, that had a special quality. And there was something really special about being on the streets at 5.30 in the morning, when it was completely deserted.

But it was cold and I knew I wouldn't have their co-operation for long, and Brian was becoming increasingly difficult. At one point I got quite upset because I felt he was ruining the pictures, but Andrew just said, "Don't worry about Brian. We are at a point now where Brian can do whatever he likes. He can't fuck The Stones up. He can only contribute to The Stones' image, whatever he does." And he was right.

So it was great because I knew that I was getting something really good. I wanted these strange compositions, as if the band could disappear into the atmosphere, so it was a bit ghostly and a bit acid-y and always trying to get away from the smiling, clean-looking thing. It was dirtier, grittier and moodier and as a result much more interesting.

66 –
Don't worry about Brian. We are at a point now where Brian can do whatever he likes

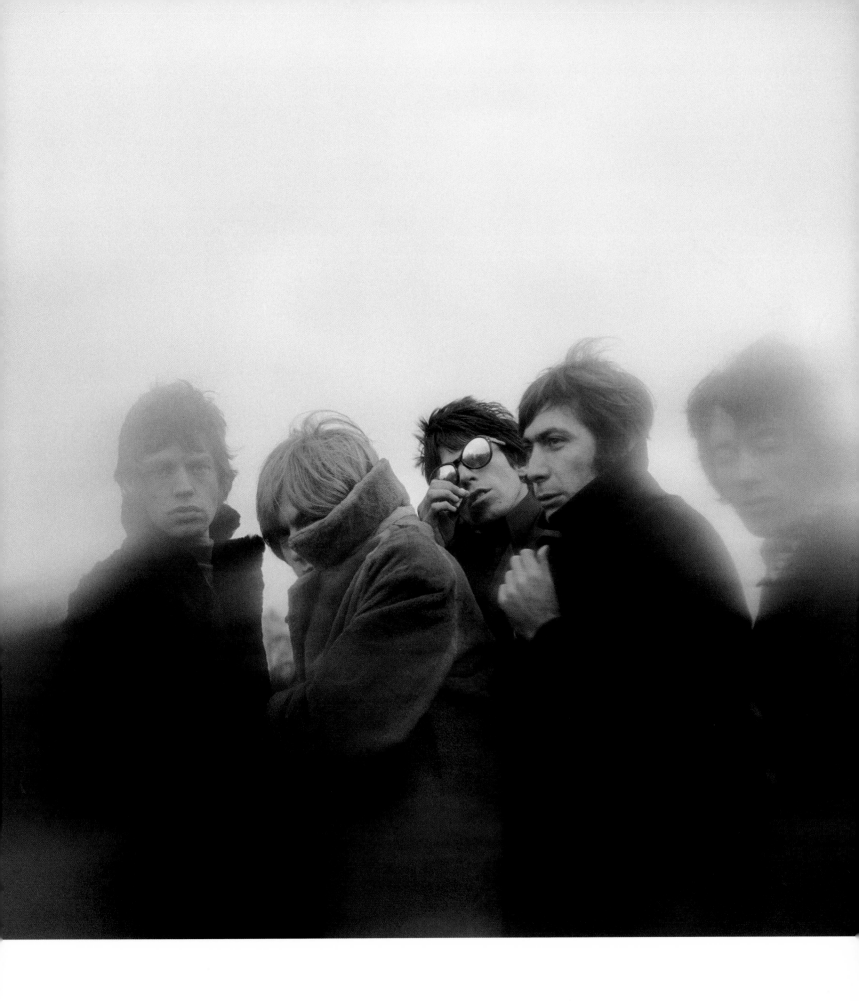

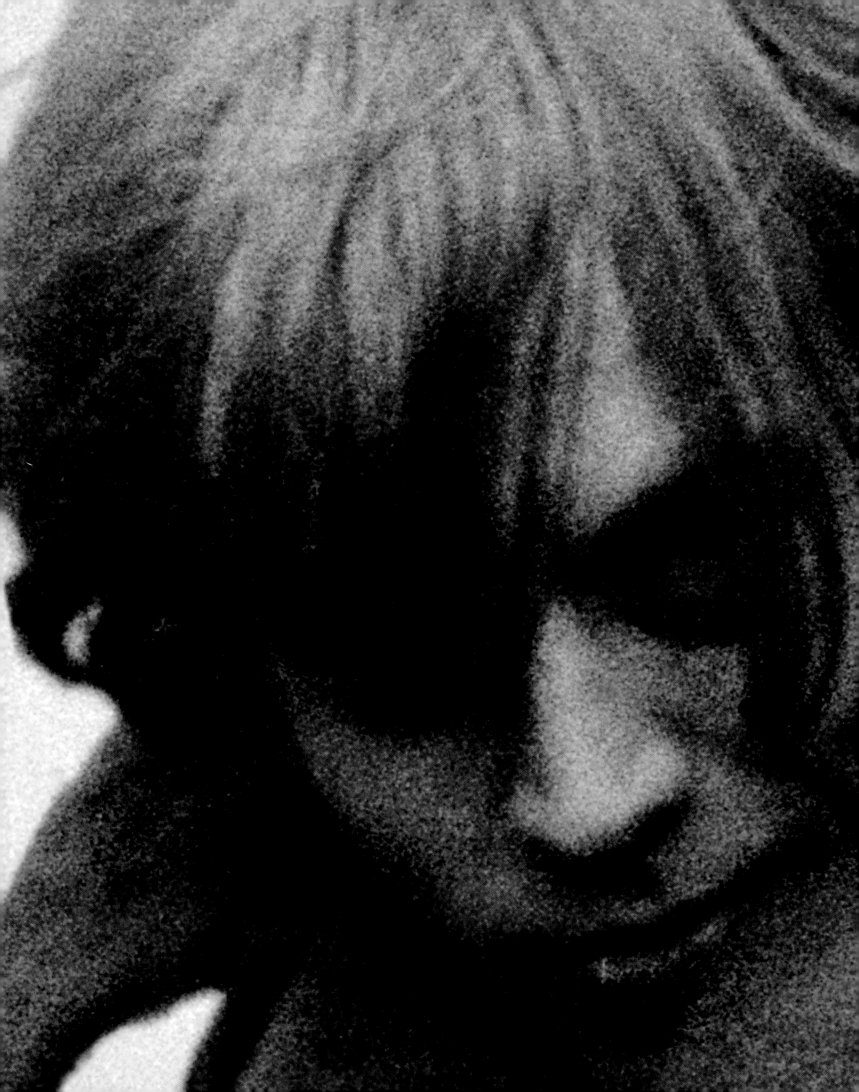

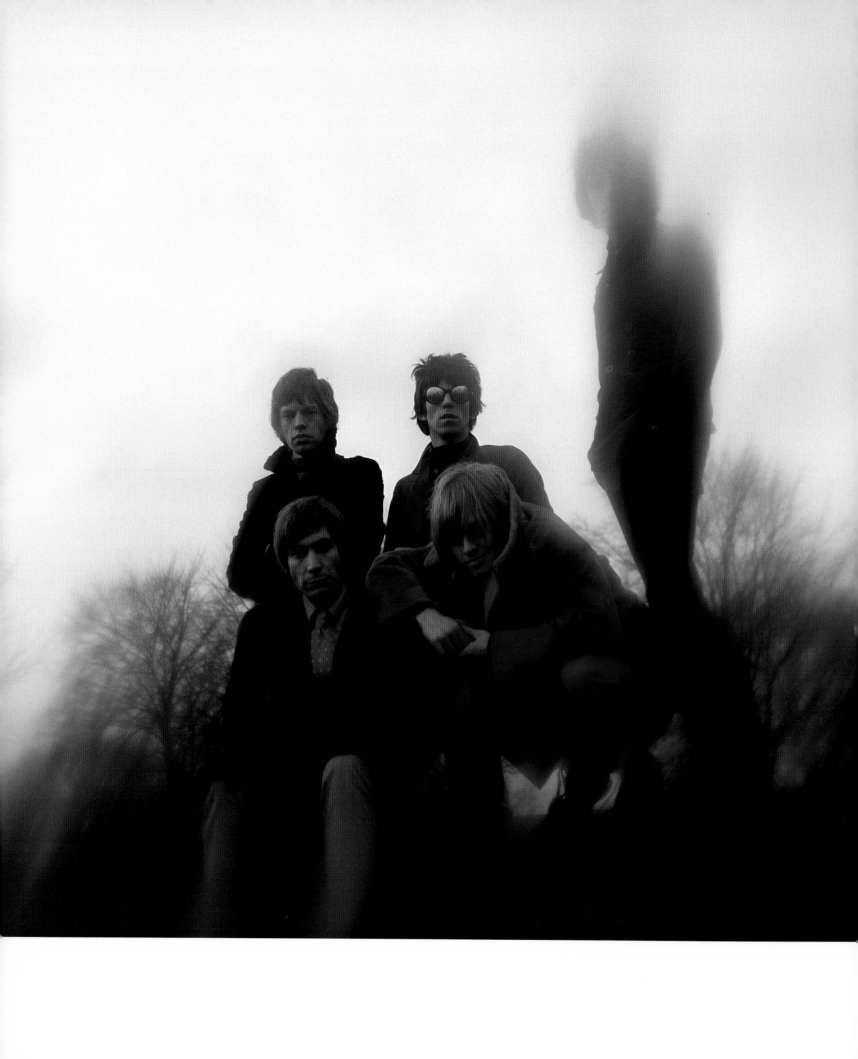

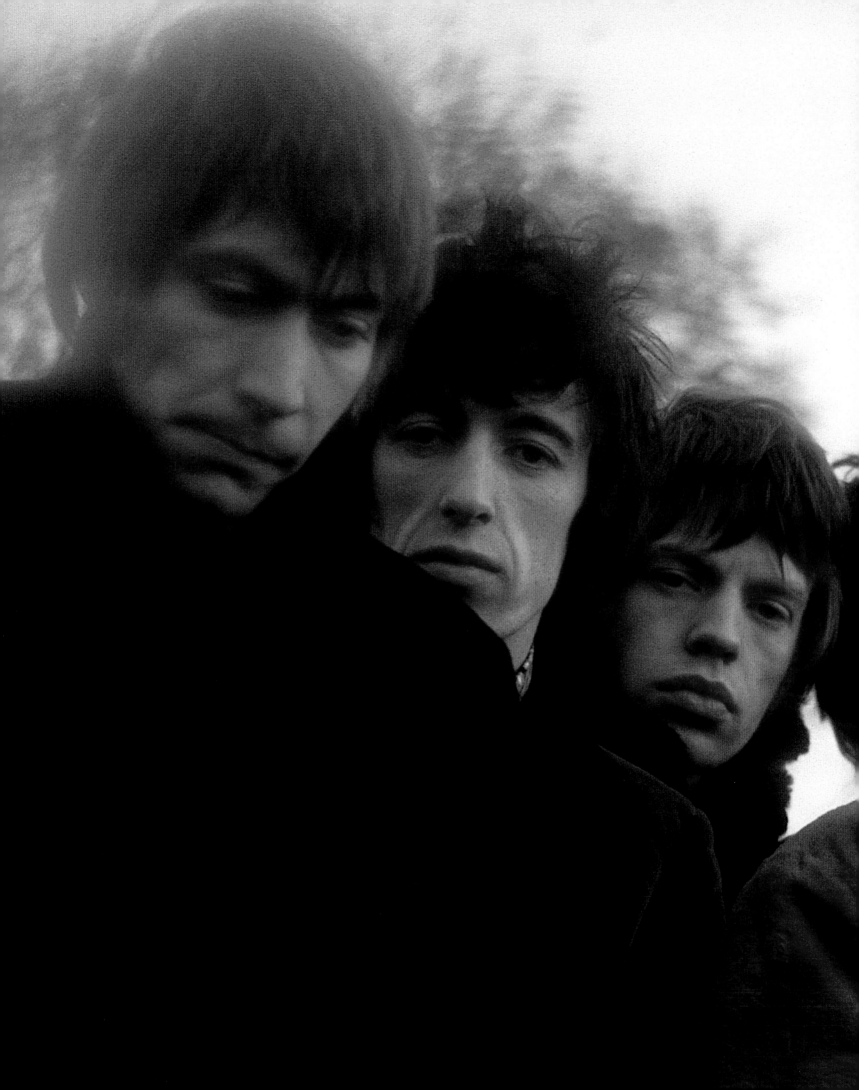

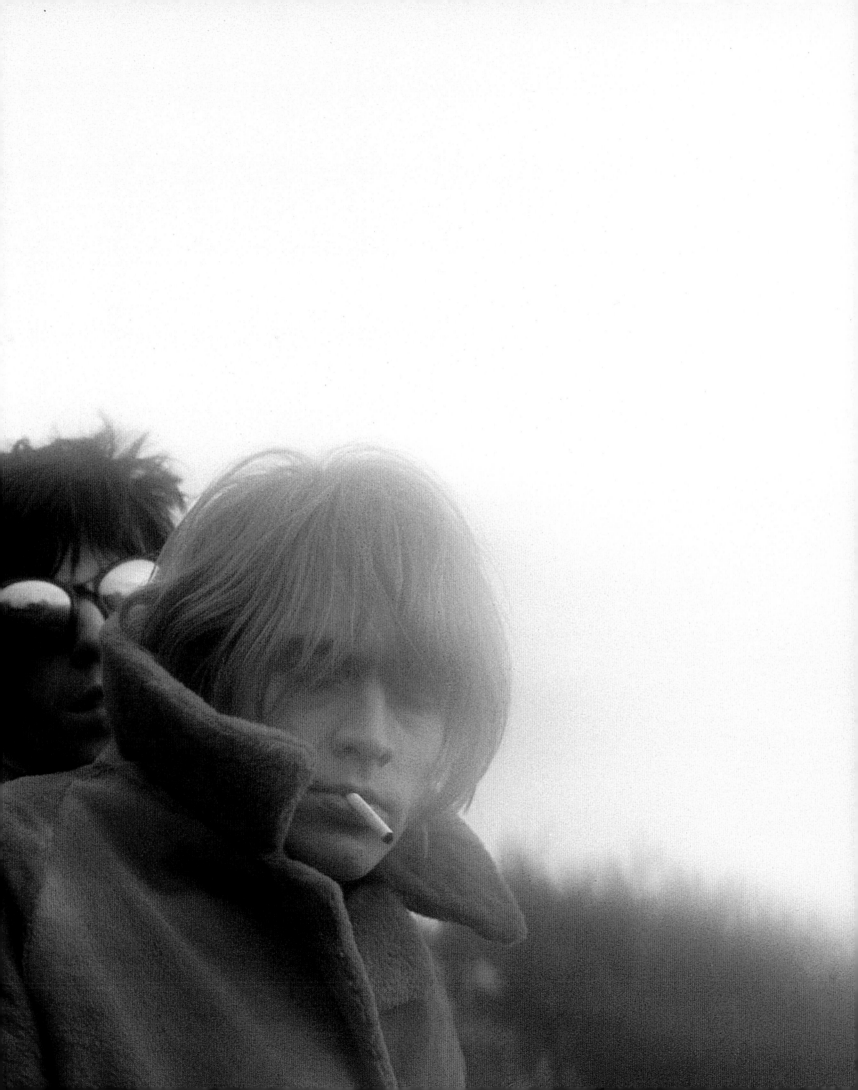

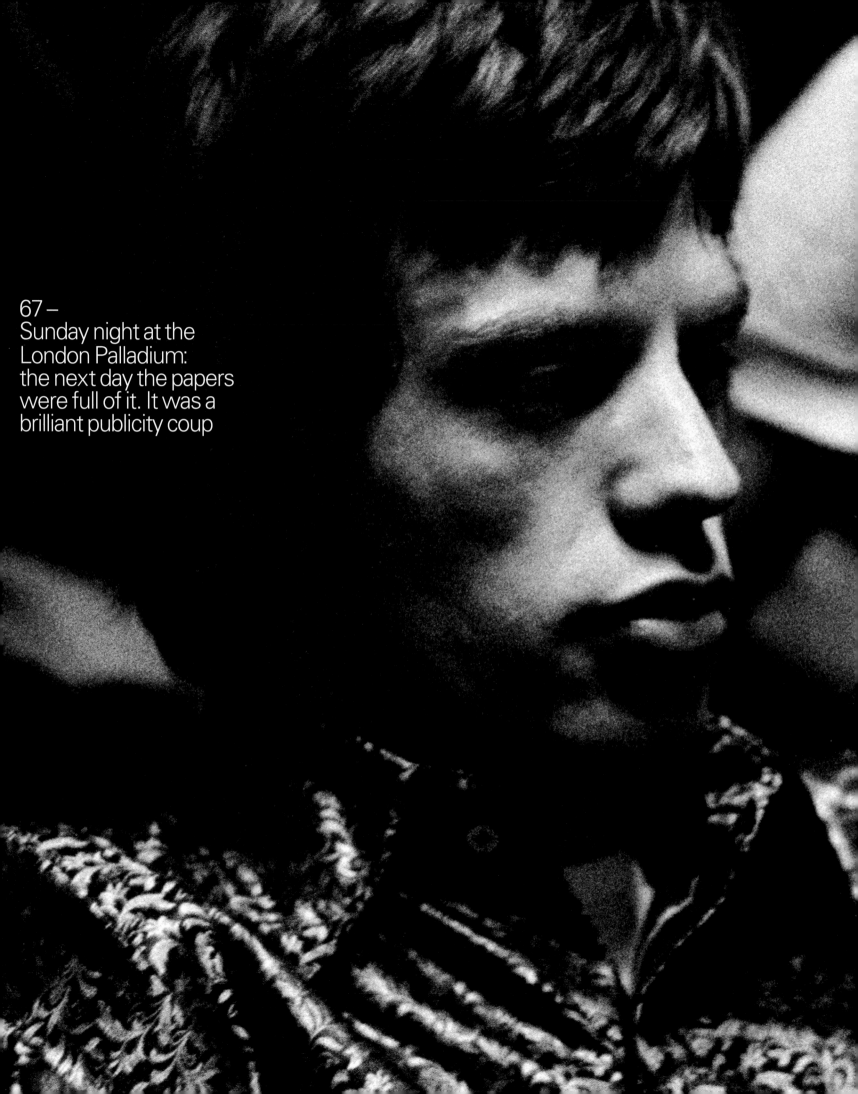

67 –
Sunday night at the
London Palladium:
the next day the papers
were full of it. It was a
brilliant publicity coup

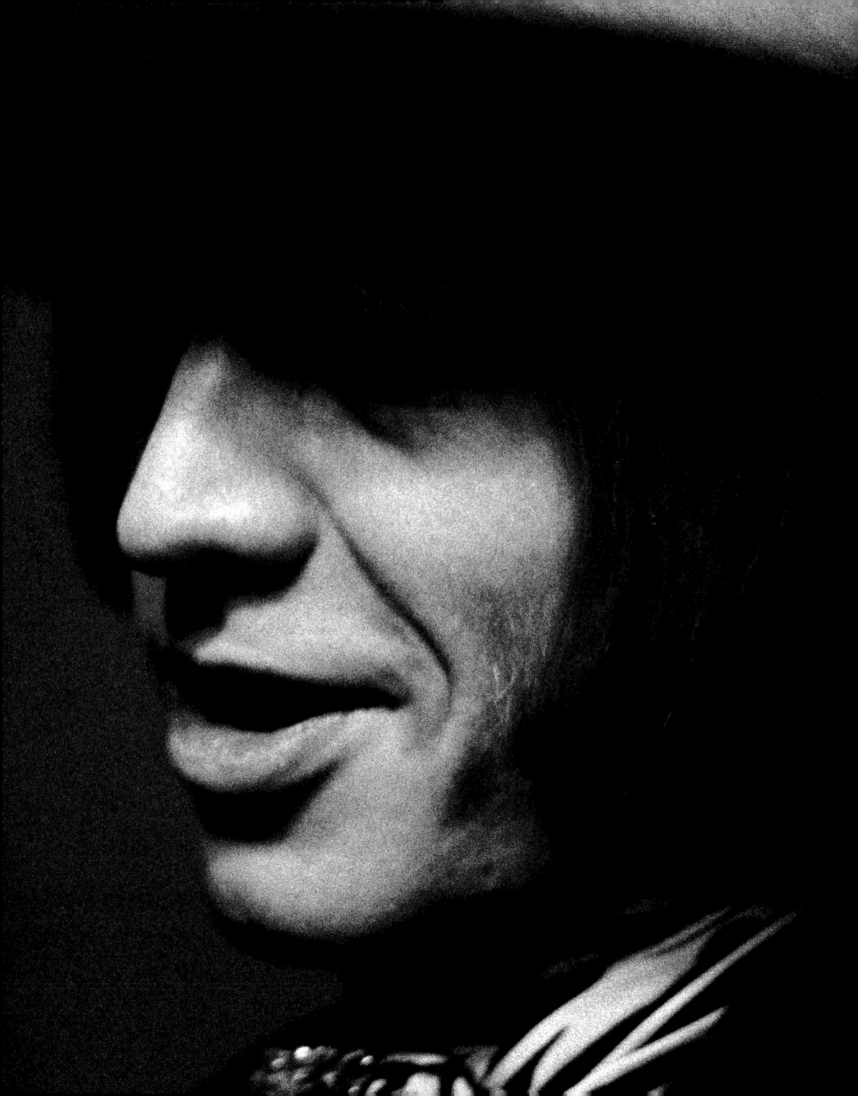

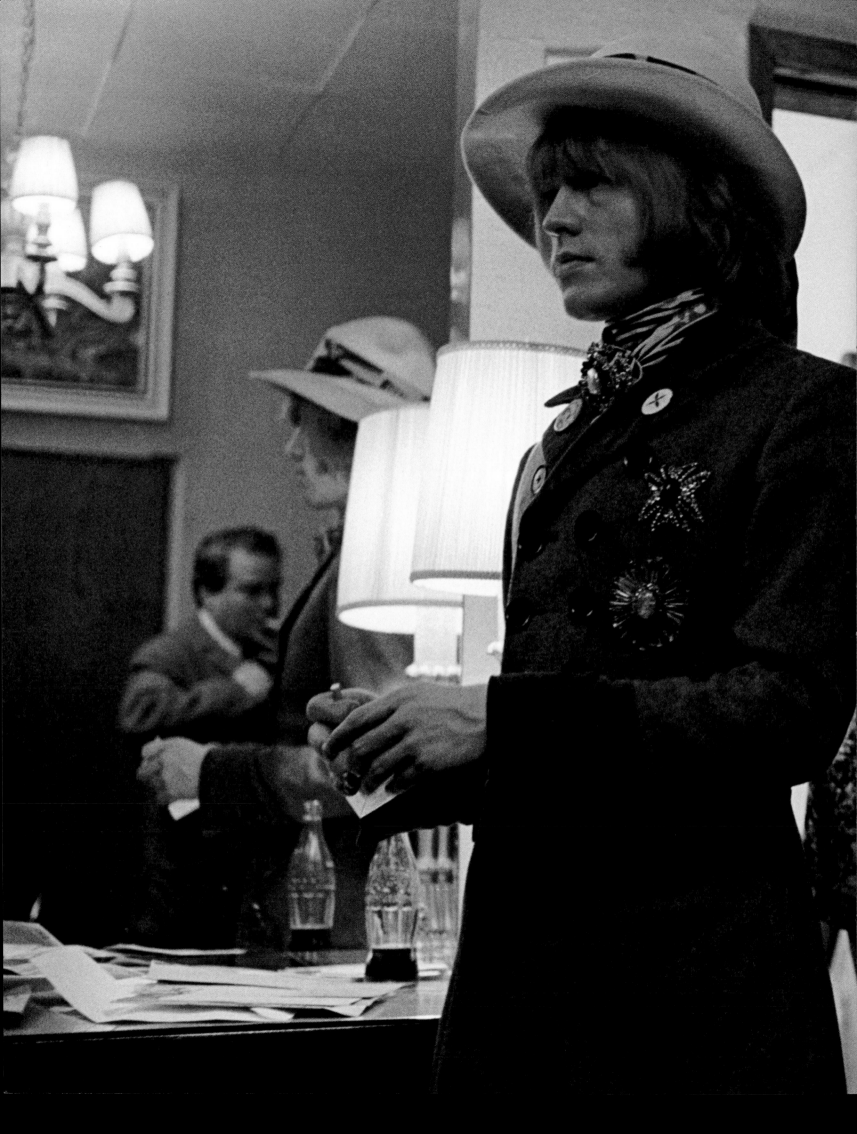

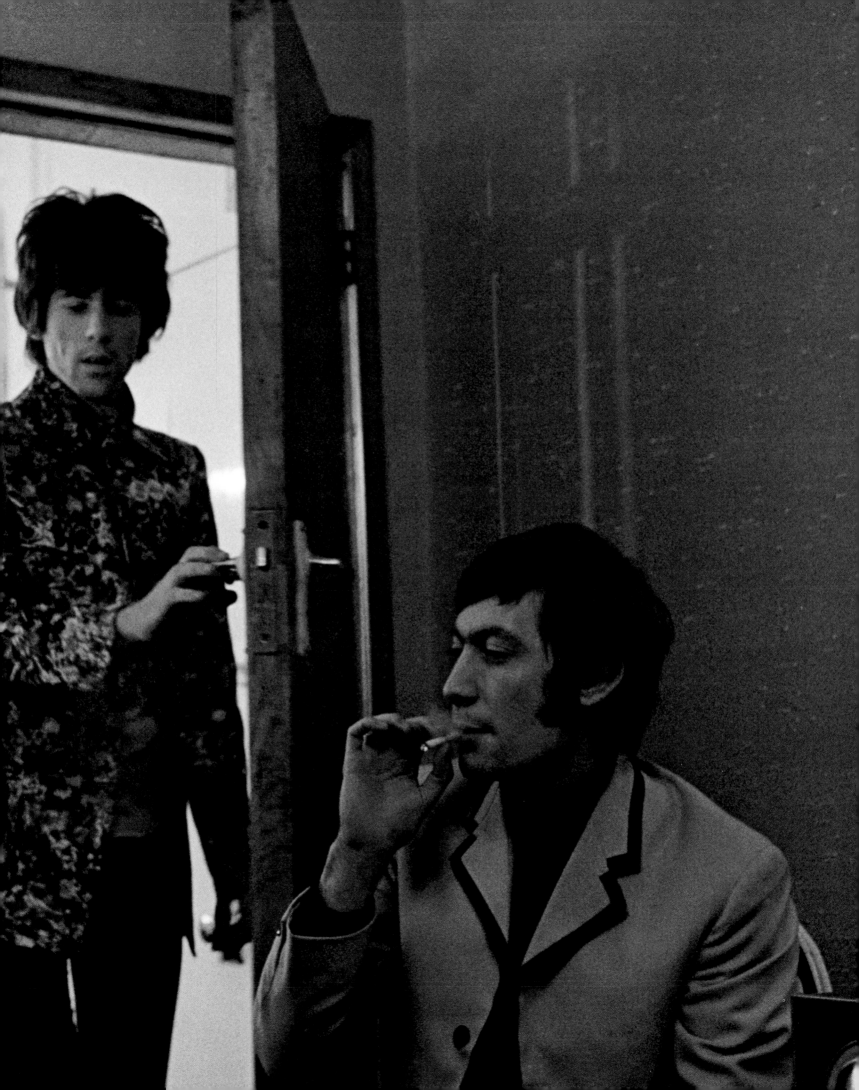

Sunday Night at the London Palladium was the biggest variety TV show in the country, with millions of viewers. At the end of every show there was a revolving stage with great glittery letters and the "TV topper" showgirls posed around it. It was a live broadcast and all the artists were supposed to stand on the revolve and wave. It was very cheesy, and The Stones caused an absolute sensation by refusing to go on.

I don't know to this day if it was planned by Andrew, but looking at the pictures, there's a tension in Mick and Keith in the dressing room beforehand that leads me to believe they knew. The next day the papers were full of it. It was a brilliant publicity coup.

Most of the controversial things they did back then, like pissing in the garage and not going on the Palladium roundabout, seemed to be fairly harmless and just a bit of "Fuck them". So I was sympathetic. The first time I saw them on some TV show when I was 15, I thought they just seemed like naughty boys. They didn't seem to be the devil incarnate.

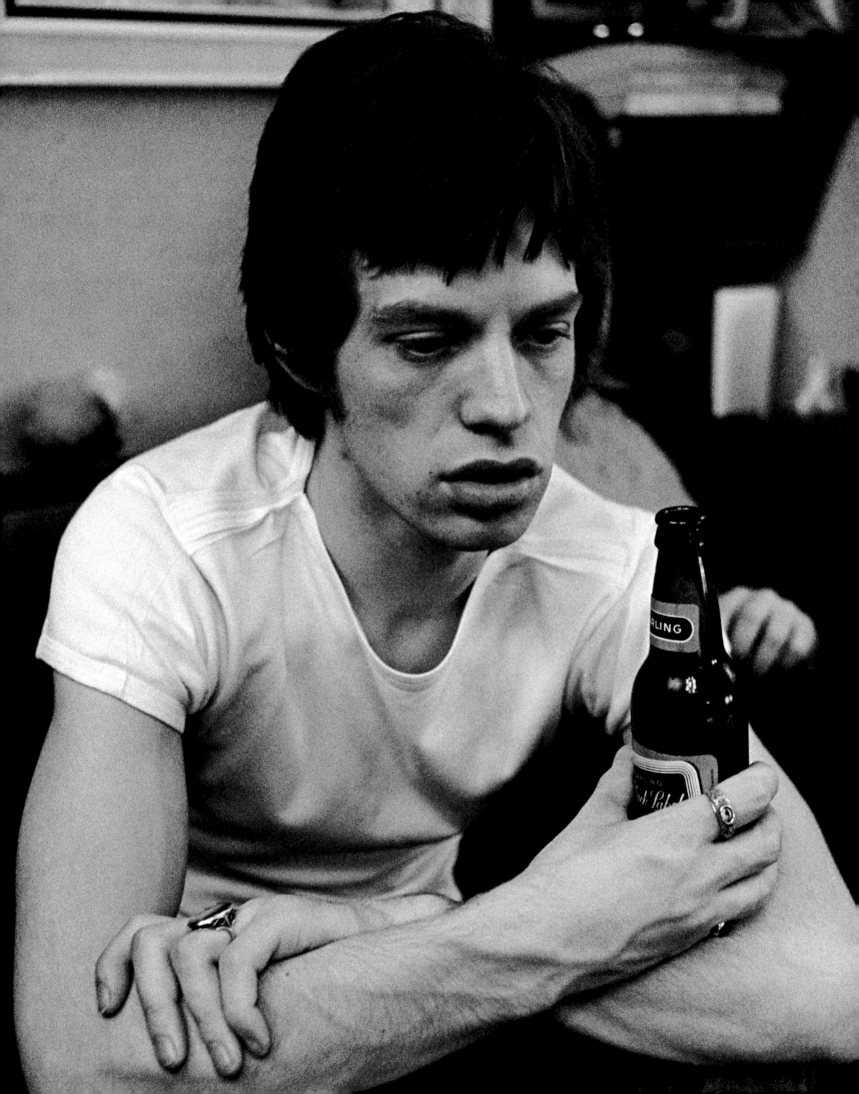

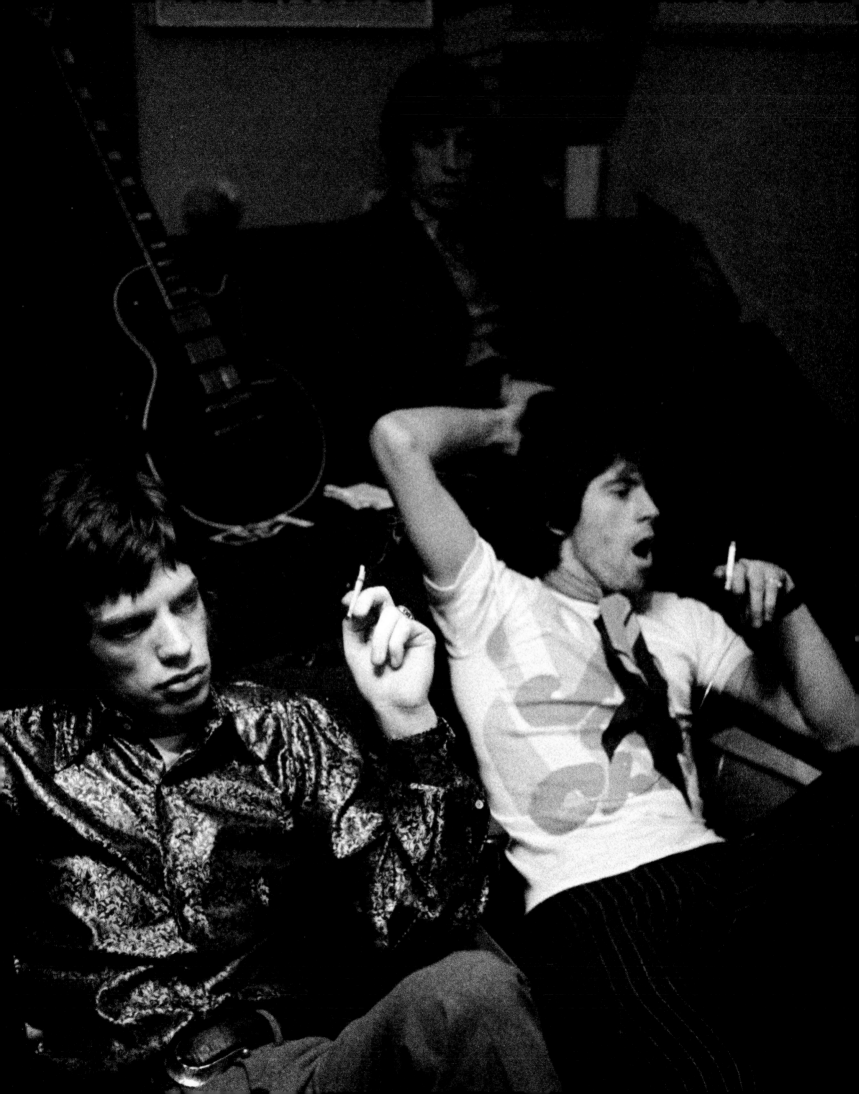

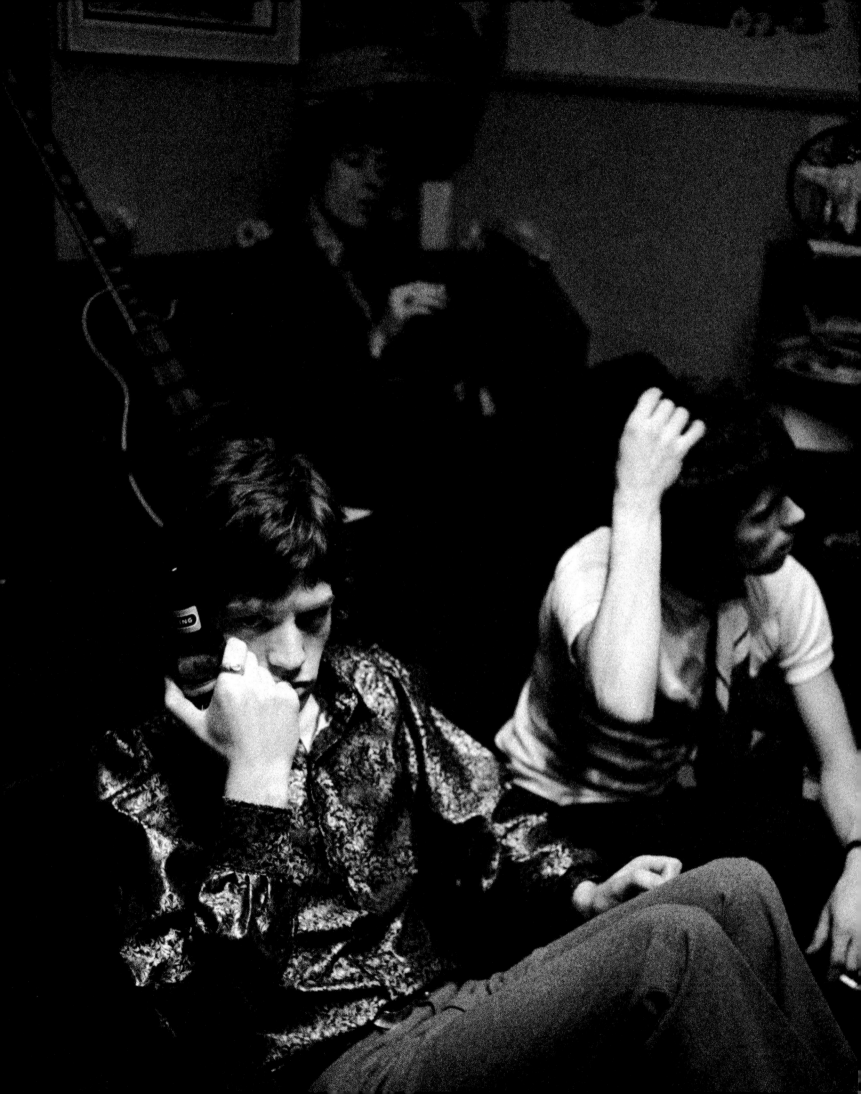

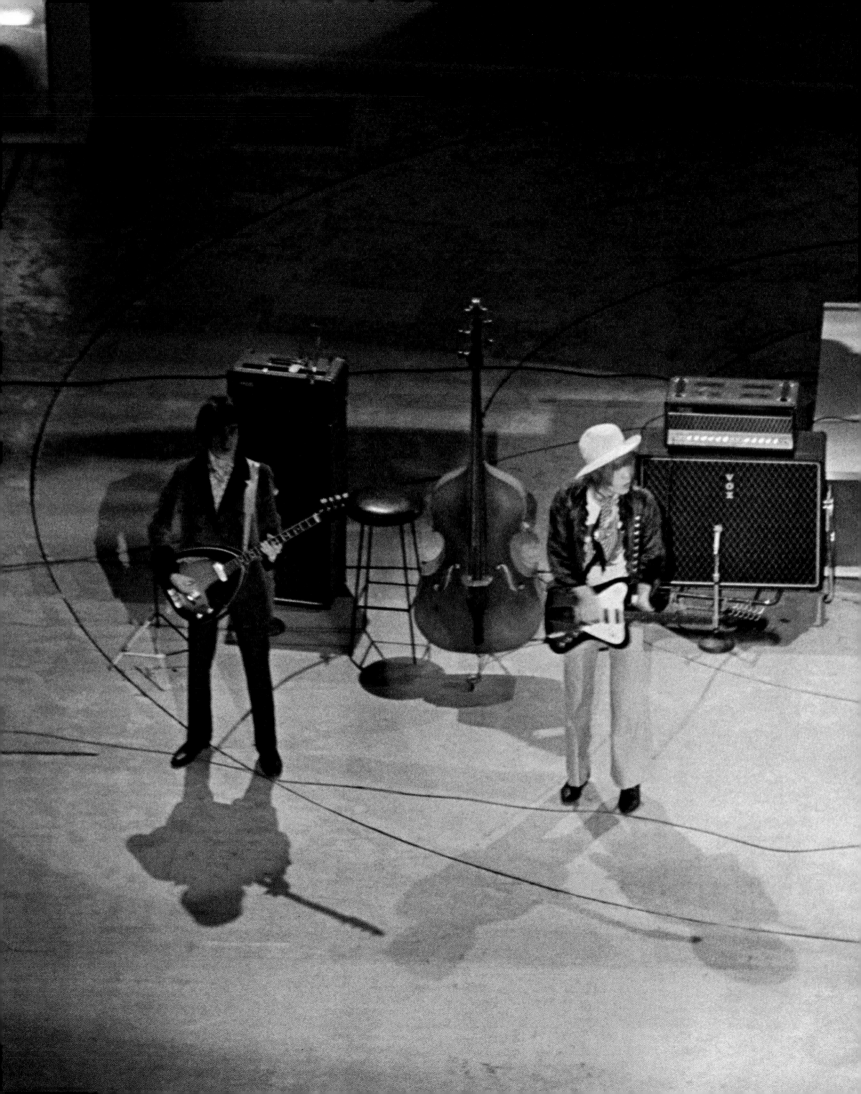

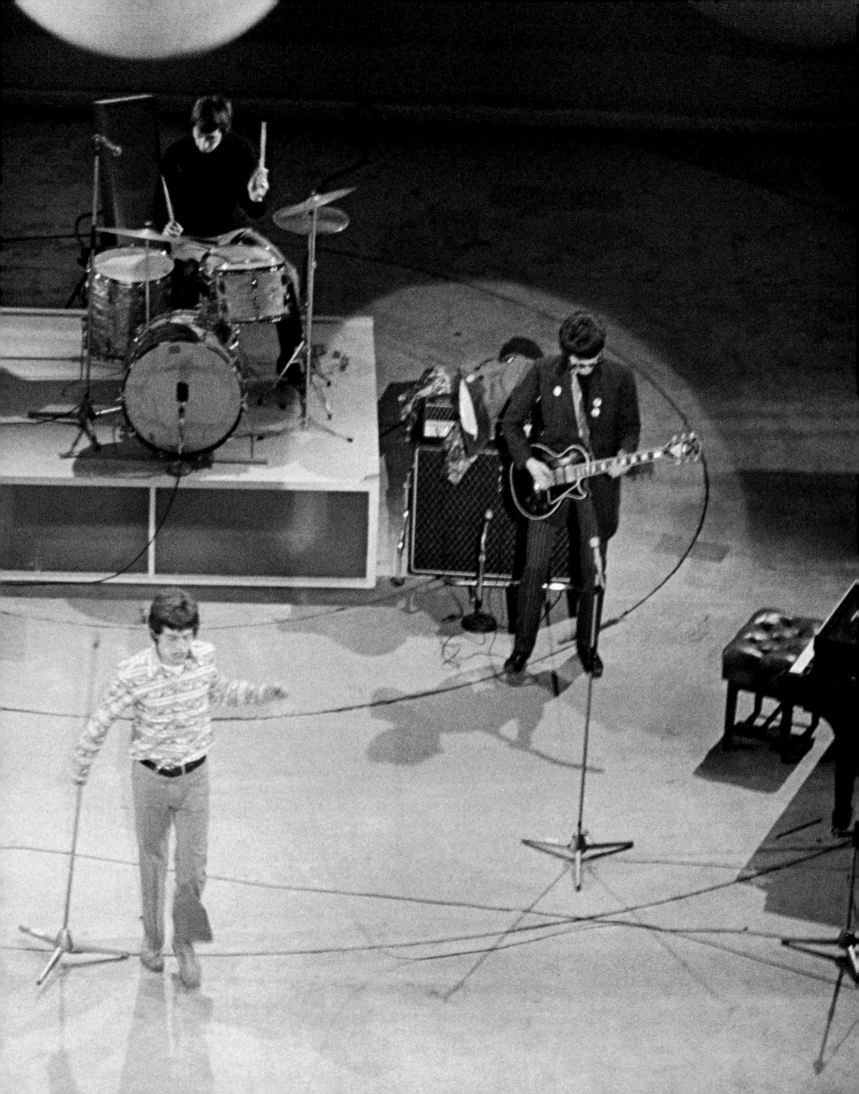

I'd first photographed Marianne in '64 and it was through her that I came to work with The Stones, because Andrew Oldham was her manager.

By this point, in '67, Marianne and Mick were absolutely together and their relationship was, I think, pretty fantastic, although in these pictures she's looking vulnerable and fragile. She was recording several songs at Decca Studios in West Hampstead, and Mick was producing, with The Stones' engineer Glyn Johns, who went on to produce The Eagles. Amongst other things Marianne was recording a couple of Beatles numbers, and Paul dropped by to give her support and hand claps.

Marianne and Mick were lovely together and he was very supportive and gentle. They were the Prince and Princess of pop music at the time. But there was a vulnerability to Marianne and I think she always found the process of recording quite difficult. I think she felt that success and fame and celebrity had come to her but, in a way, she hadn't really found her true vocation yet, and that wasn't really to come until *Broken English*, after she'd been through all the terrible times.

67 –
There was a vulnerability to Marianne and I think she always found the process of recording quite difficult

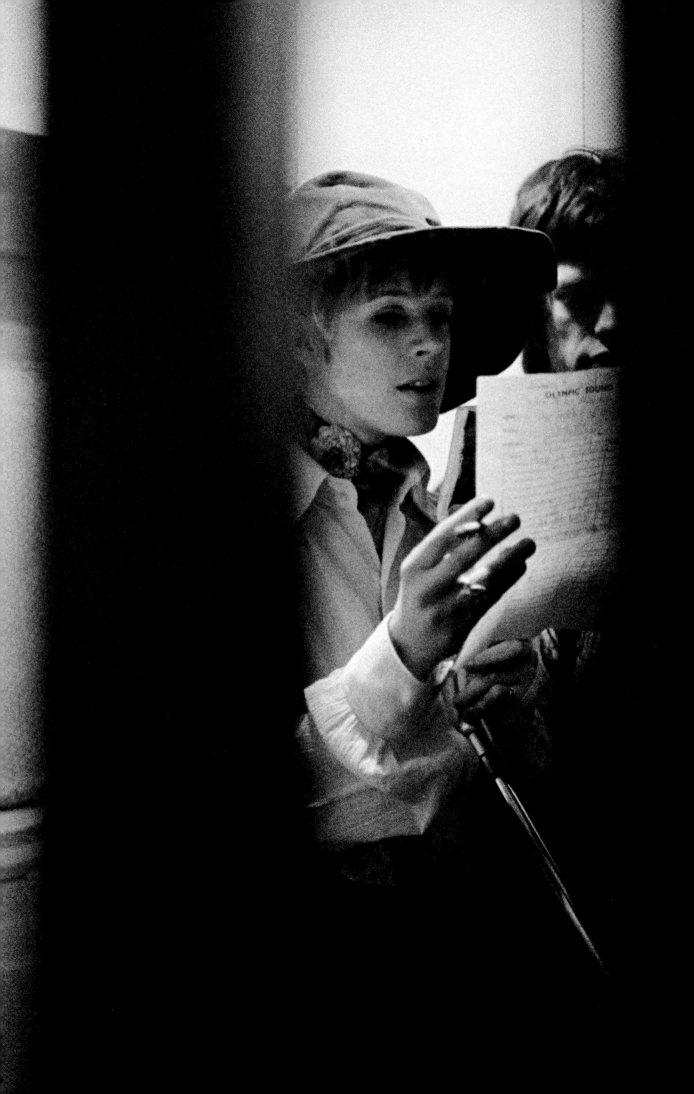

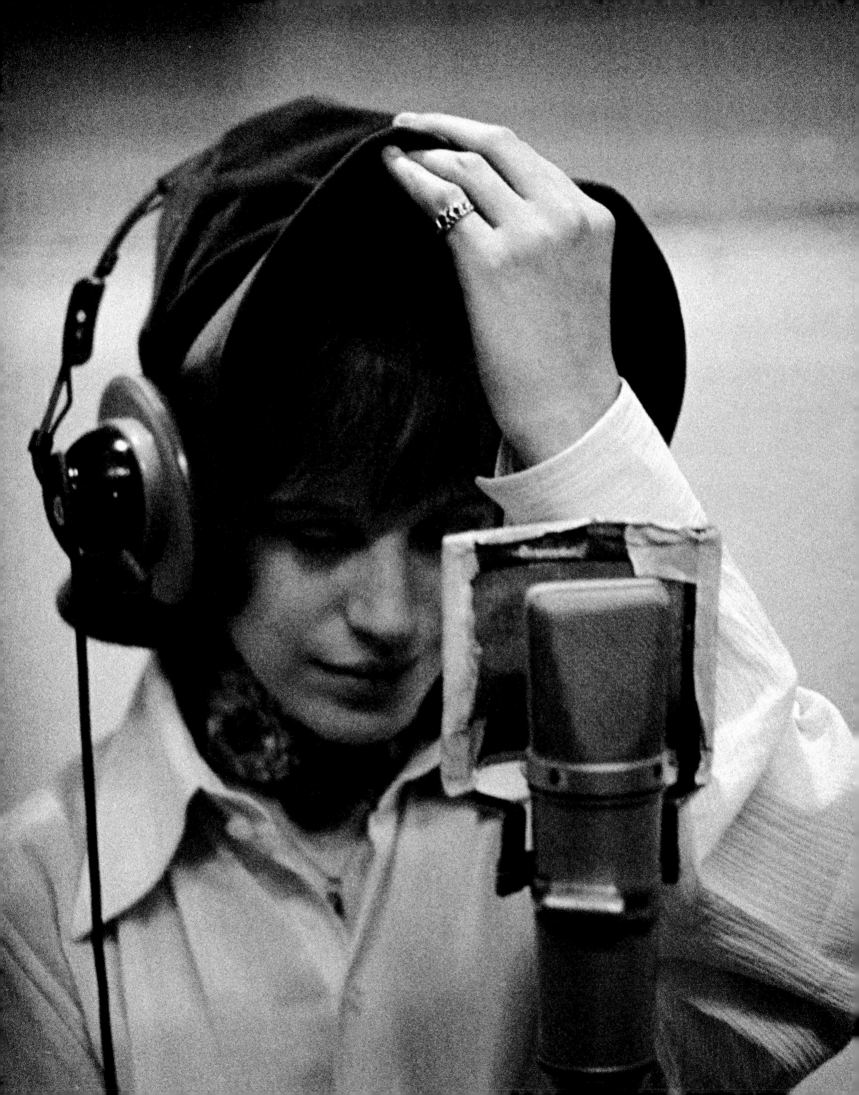

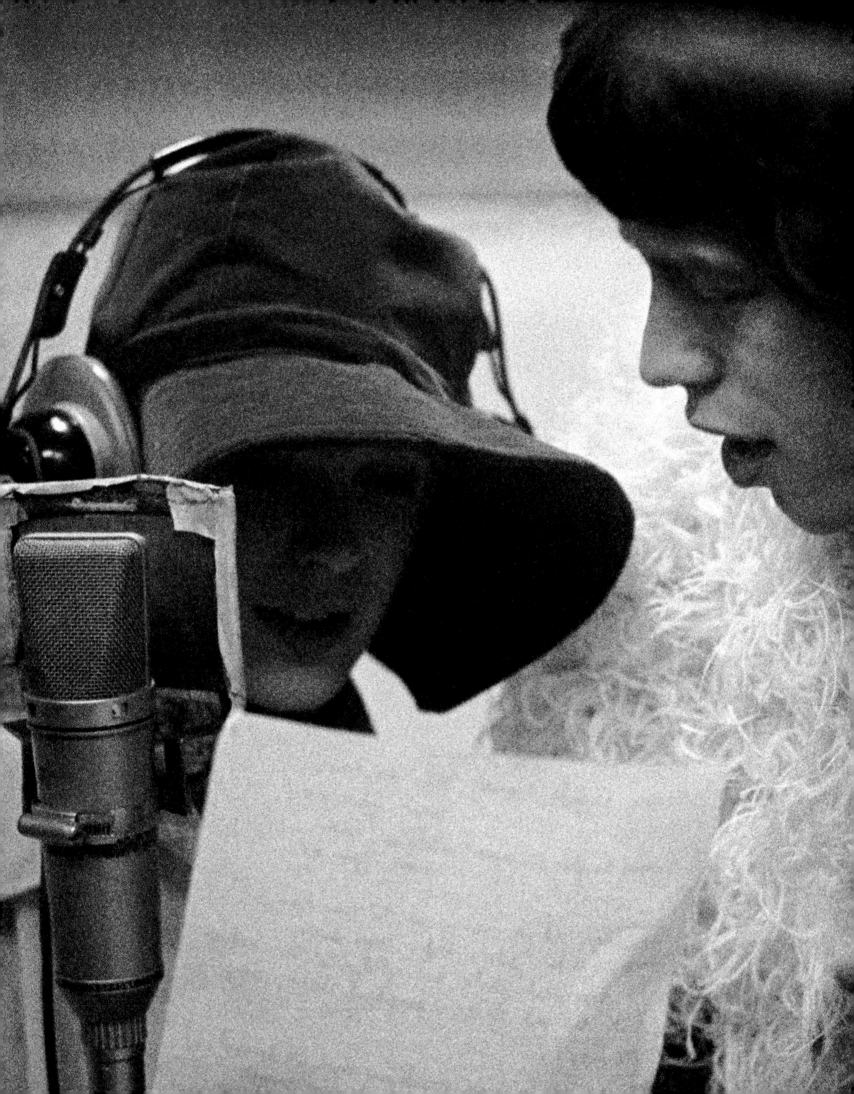

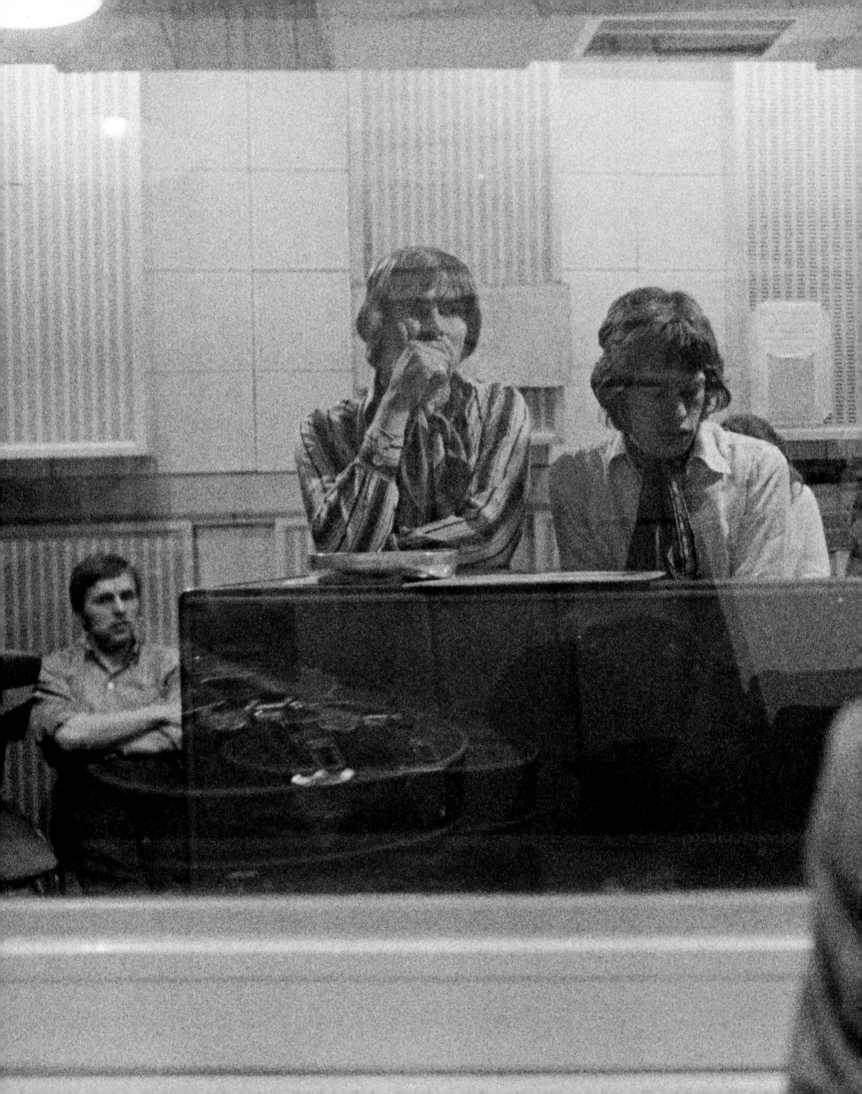

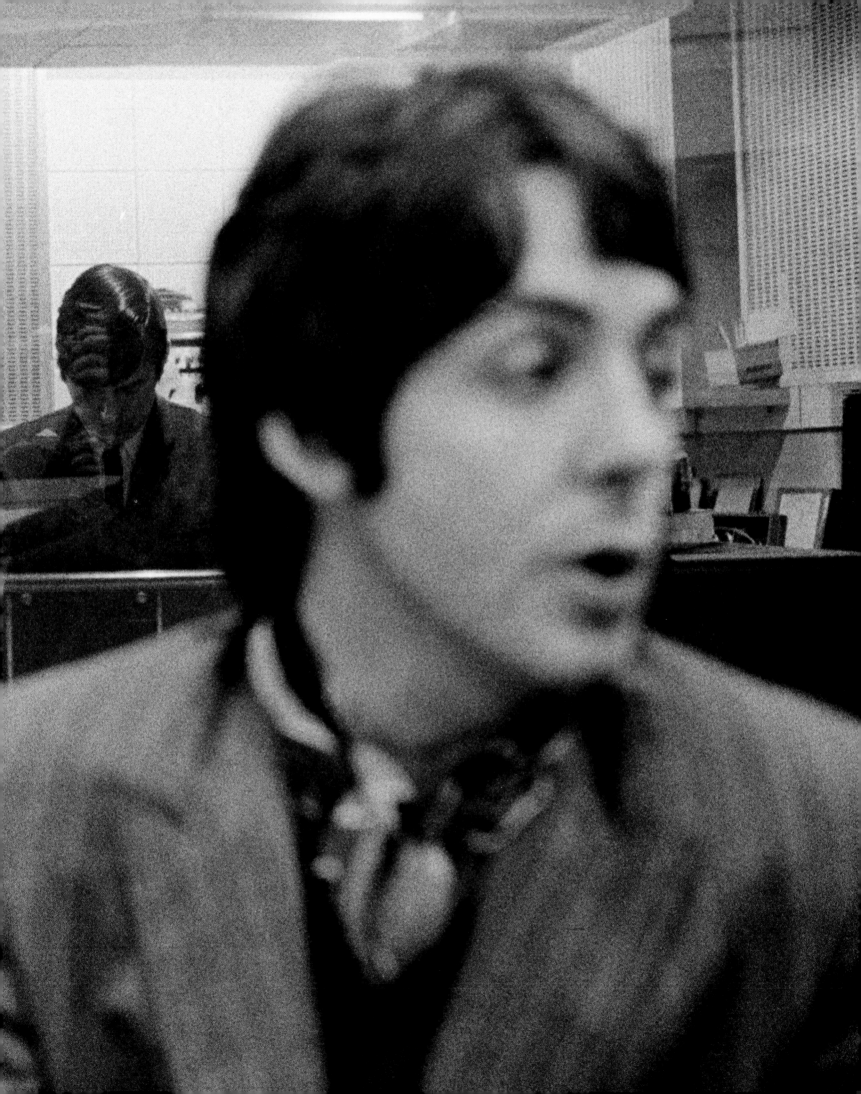

"Let people know what a good photographer he is?" asks Marianne, as an adjunct to our chat about Gered Mankowitz. There's a pause as she draws on a cigarette on the other end of the line. "You know, he was really good fun. That's why he was a good photographer. People just liked him."

They were close friends. Friends but never lovers. Mankowitz photographed Faithfull for the publicity stills of "As Tears Go By" and famously introduced her to The Stones. It's never just as simple as that, but the story comes close.

In 1964, 17-year-old Marianne was touring Britain to promote her hit single. In her biography she describes her public image, one that Mankowitz helped create, as "an eerie fusion of haughty aristocrat and folky bohemian child-woman - a tantalising ready-made image". It's an image that has stuck with her until the present day. A year later, in '65, Mankowitz helped to create the rough'n'tough look of The Rolling Stones for the cover of *Out Of Our Heads.*

So here are some brief footnotes to Mankowitz - a chat behind the back of the man who stood behind the lens; an extra-bonus eulogy by the tantalising Madame Faithfull as we ask her for more about this mercurial man - the man who made it all look so easy, the man who made it all look so very cool…

Do you remember first meeting Gered?

Marianne Faithfull: He was a great friend of this guy I was crazy about, Jeremy Clyde. Jeremy wasn't crazy about me but I met Gered through him. We were the same age, absolutely the same age, born the same year and everything. Gered had quite a lot to do with my getting closer to The Stones because he was working with them and I was really his friend.

Why was that? What was the connection between you?

MF: It was because he treated me… I mean he would always say how much he fancied me and all that, but he didn't make me feel like he just wanted to fuck me. He was interested in me as a human being. I know it sounds pompous but he liked me.

At age 17, pretty much everyone must have fancied you…

MF: It was awful. I mean, Mick poured a glass of champagne down my décolleté to get me to talk to him.

And did it work?

MF: No, it didn't work. In fact it had the opposite effect. What worked was Keith's moody silence and going into other rooms to play the piano. That absolutely fascinated me. But that's a whole other story. I felt safe with Gered and that's another reason we could do lovely pictures together. He just became hot shit as a photographer at that time.

How would you describe the mood of The Stones then? Were they a hard bunch of people to penetrate? Or were they unguarded?

MF: Completely unguarded.

Because you get this feeling with the photos that they're very accessible, easy…

MF: …yeah, they really didn't look as evil as Andrew wanted, did they?

They come across as a hard-working band…

MF: Definitely a working band. They've always been like that really - they still are.

Travelling, rehearsing, recording, playing live, none of the decadence that comes later with Michael Cooper.

MF: What Gered was doing was really like a reporter almost, recording what was in front of him. It was before Michael came along, and Michael really marked the beginning of this so-called decadence.

So Gered's time was a bit more serious?

MF: I suppose so, but he wasn't really - he was a hell of a lot of fun. I think, personally, when all the drugs started, Gered just backed off a bit.

So he was less of a participant, an insider?

MF: Yes, in the sense that he wasn't going to take as many drugs to be an insider. But I don't know if they were all into drugs that much yet. It was before all of that. It was pre-drugs, really. It was alcohol and a bit of speed. I was so young and protected I hadn't even had a drink or a cigarette yet. But we had a lot of fun together. I remember I went with Gered to see Spike Milligan a lot. I went with him to see Nina Simone.

I love the photo of you and Mick in the studio. What were you recording?

MF: "Sympathy for the Devil".

Do you remember the photograph being taken?

MF: I was able not to take any notice of Gered, which I think has got a lot to do with why those photos are so wonderful. He was brilliant at blending in and becoming invisible. I remember him with a part of my soul, or mind, but just in a sense that there was this guy who I loved and trusted, who I didn't have to worry about. That was quite rare in those days. That was his great gift and Andrew must have realised that.

How did he get on with the band? Who did he seem to get the most out of?

MF: He got on best with Keith. Have you seen the pictures of Redlands and the decoration of Redlands? Keith invited Gered down to do those, which were really wonderful. It was Keith he got on with.

Who were you closest to?

MF: Gered, and thereby, sort of Keith, but not really. I didn't hang out with The Stones. I used to go down to the sessions just to watch. I started hanging out with Keith and Brian and Anita later, just before I went off with Mick, but that's a whole other story.

And this is after all a book about Gered's relationship with The Stones. Any closing words…

MF: I'm not sure. (Pause) Yeah, just let people know what a good photographer he is.

02 –
Marianne Faithfull
in conversation
with Jefferson Hack

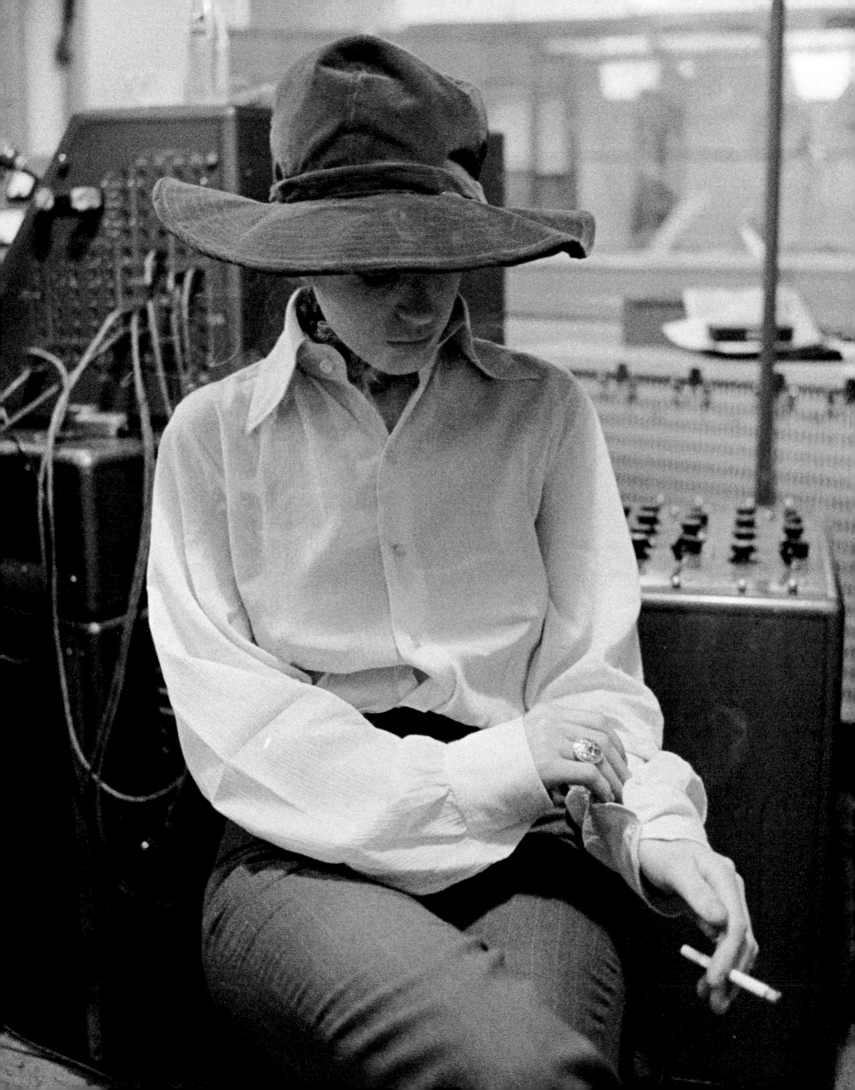

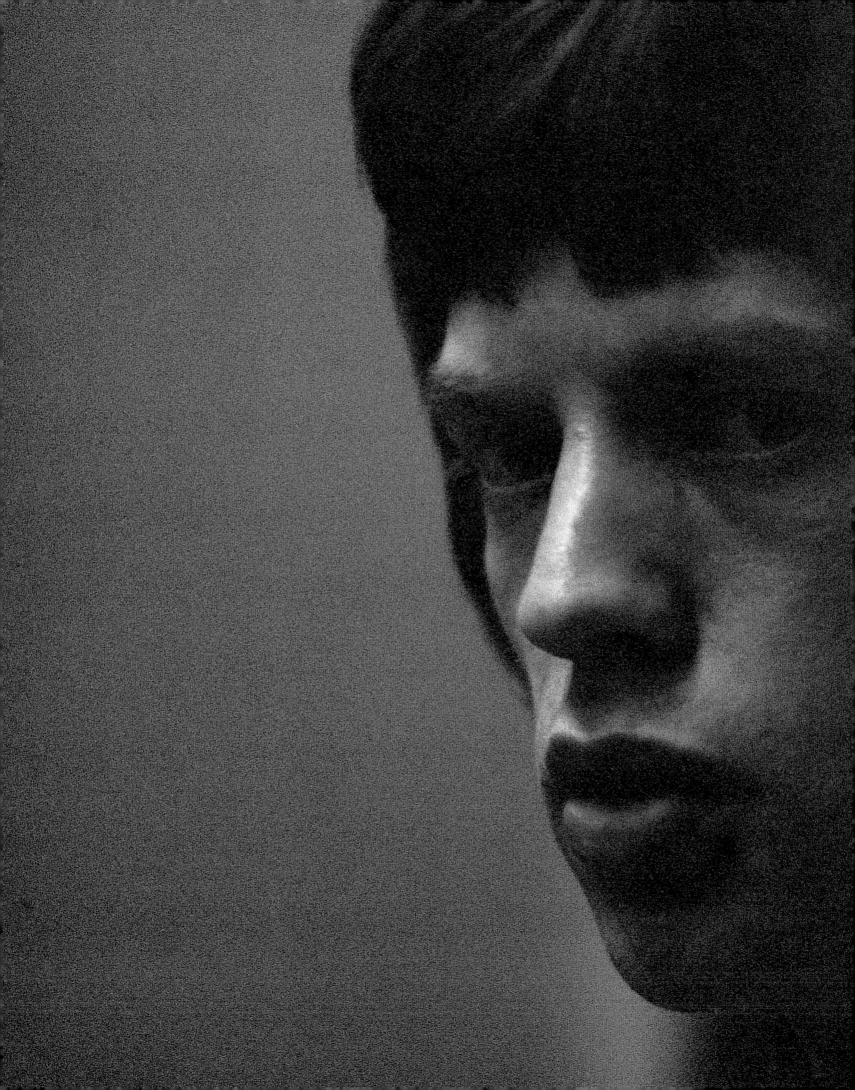

Satanic Majesties was the last session that I did. It was at Olympic Studios in Barnes, and there was a tremendous tension within The Stones, particularly between Mick and Keith and Andrew. There was a real rift, and it was just darker, stranger and weirder. They were growing apart. Andrew had Immediate Records, which was going very well, and The Stones were getting into other places, other things, other drugs, and they wanted more control over their career.

The band would not arrive until the early hours, even though the session might be booked from ten o'clock, and we'd sit there twiddling our thumbs, and they'd turn up at two o'clock in the morning with a little entourage of people and they'd be out of it and cold and unfriendly. It was generally a bad vibe.

It was frustrating - nothing was really getting done. During this period, the photographer Michael Cooper suddenly appeared in the entourage. At one point I was in the control room with Andrew, and Mick came in and just announced that Michael was shooting the next cover, and I knew that was me finished. I was out, and in a way it came as a relief. I was doing other things, and I'd just started to work with Hendrix. And by then things were too uncomfortable working with The Stones.

The strange thing about the *Satanic Majesties* pictures is they really do reflect a darker, more stressed, more stoned, weird vibe. And the look of the band is darker. The whole era had become more knowing, wilder, more experimental, and in a way they were more confident because their success had been consolidated. They wanted to push and perhaps Andrew wanted to repeat a formula. They needed to go their separate ways.

67 –
There was a tremendous tension within The Stones

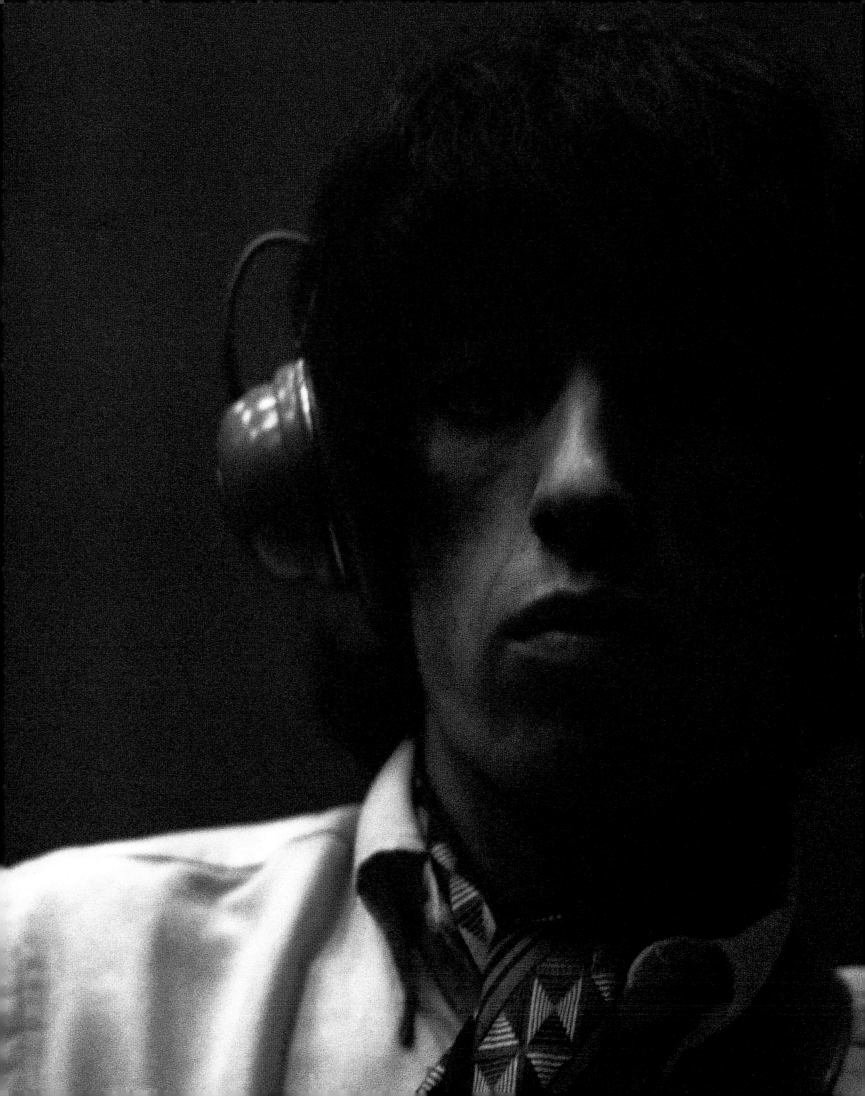

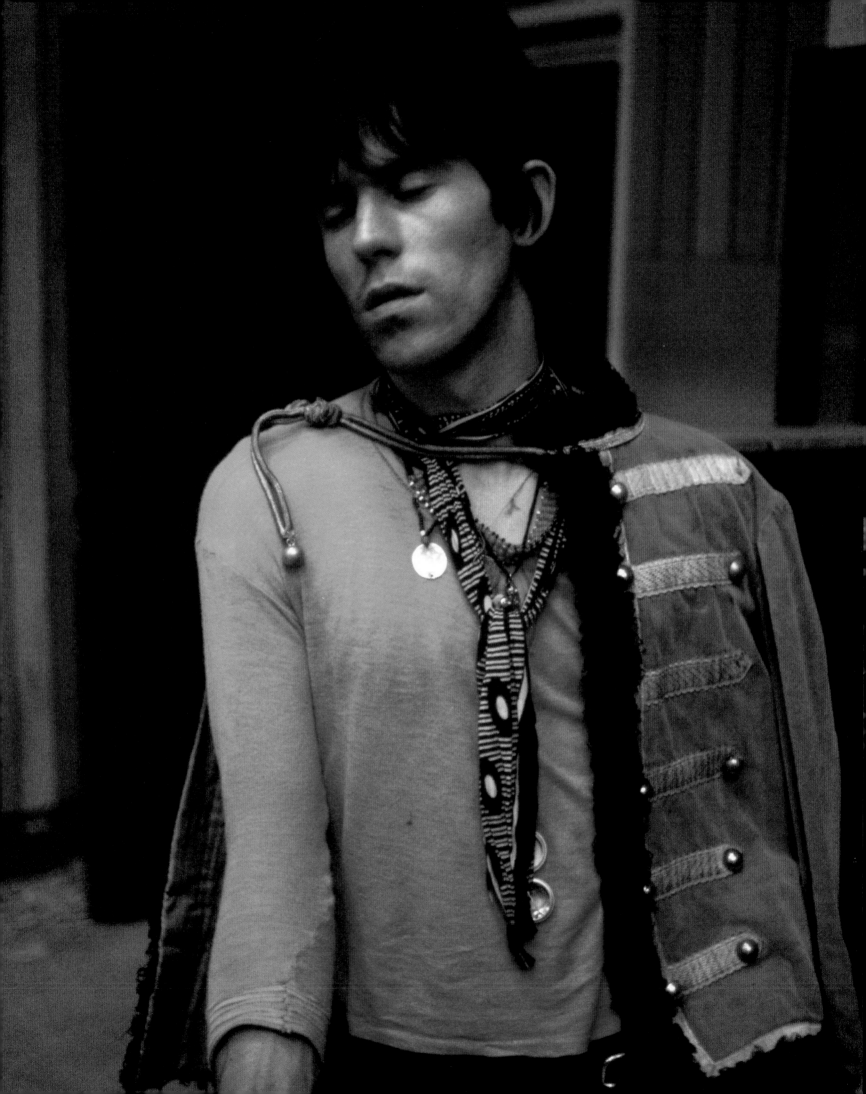

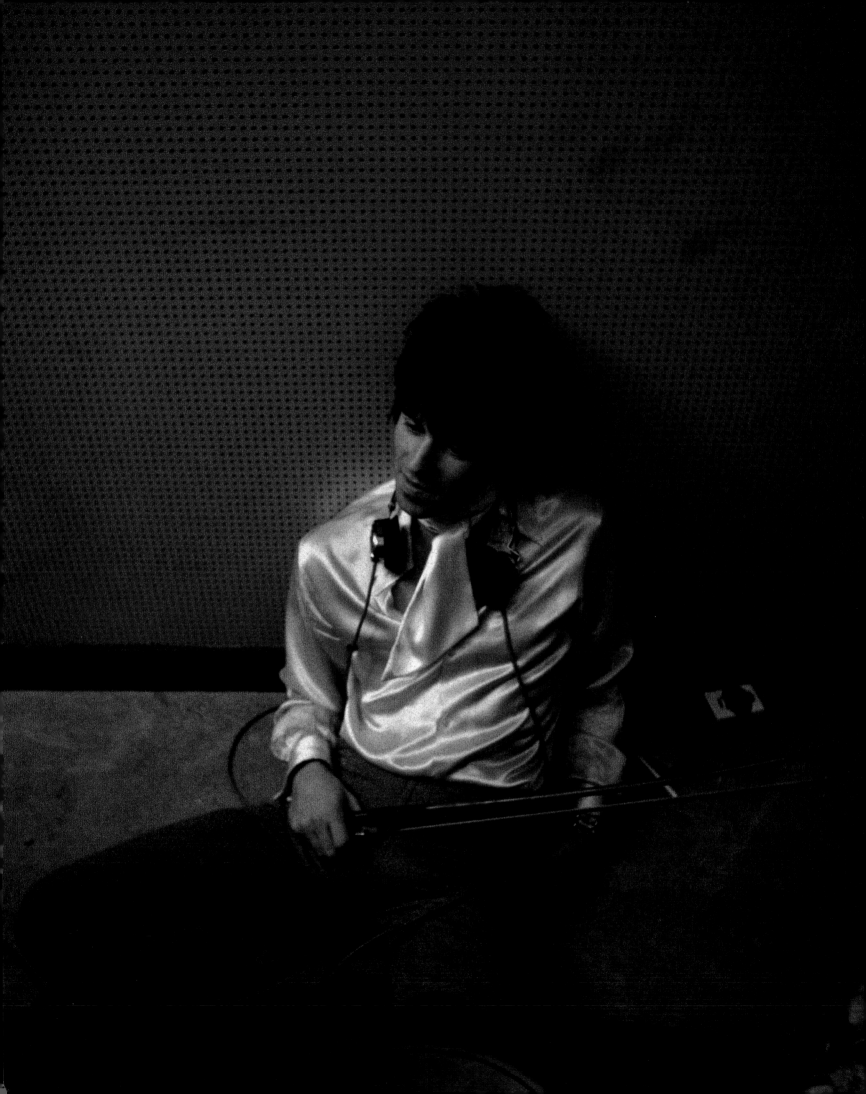

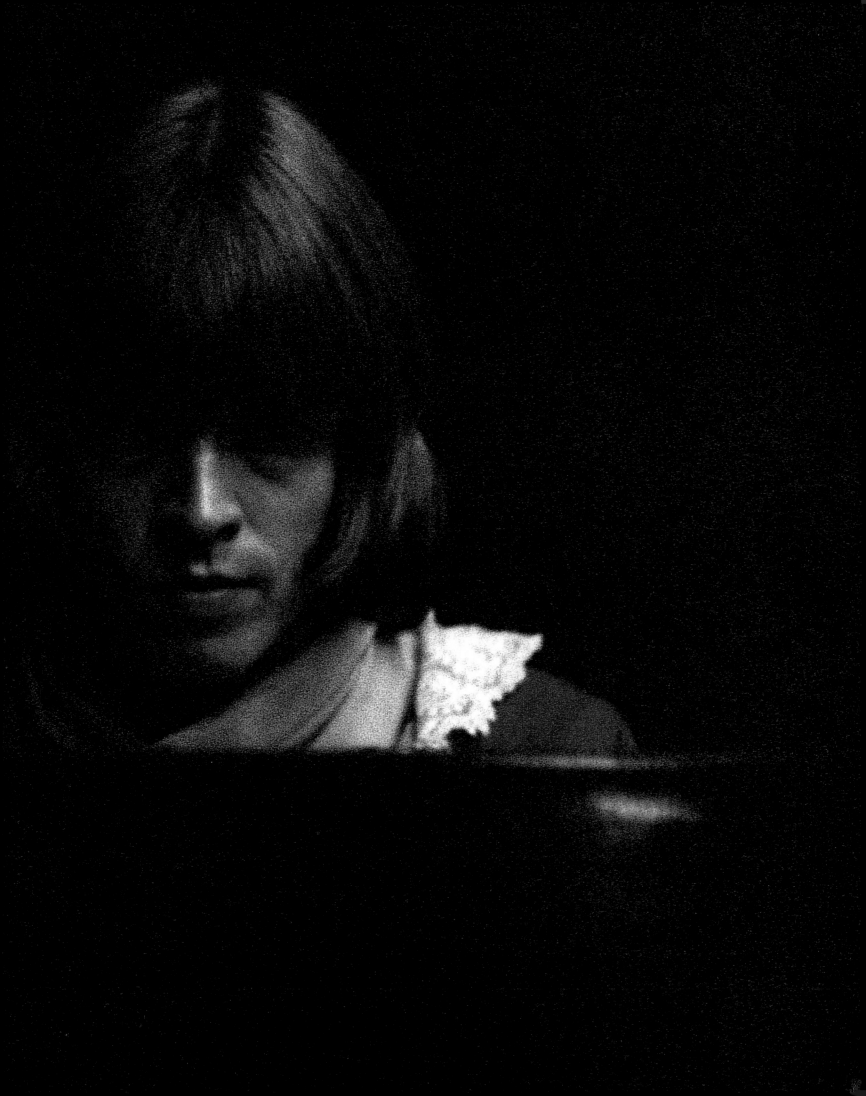

The
Stones
65 –
67

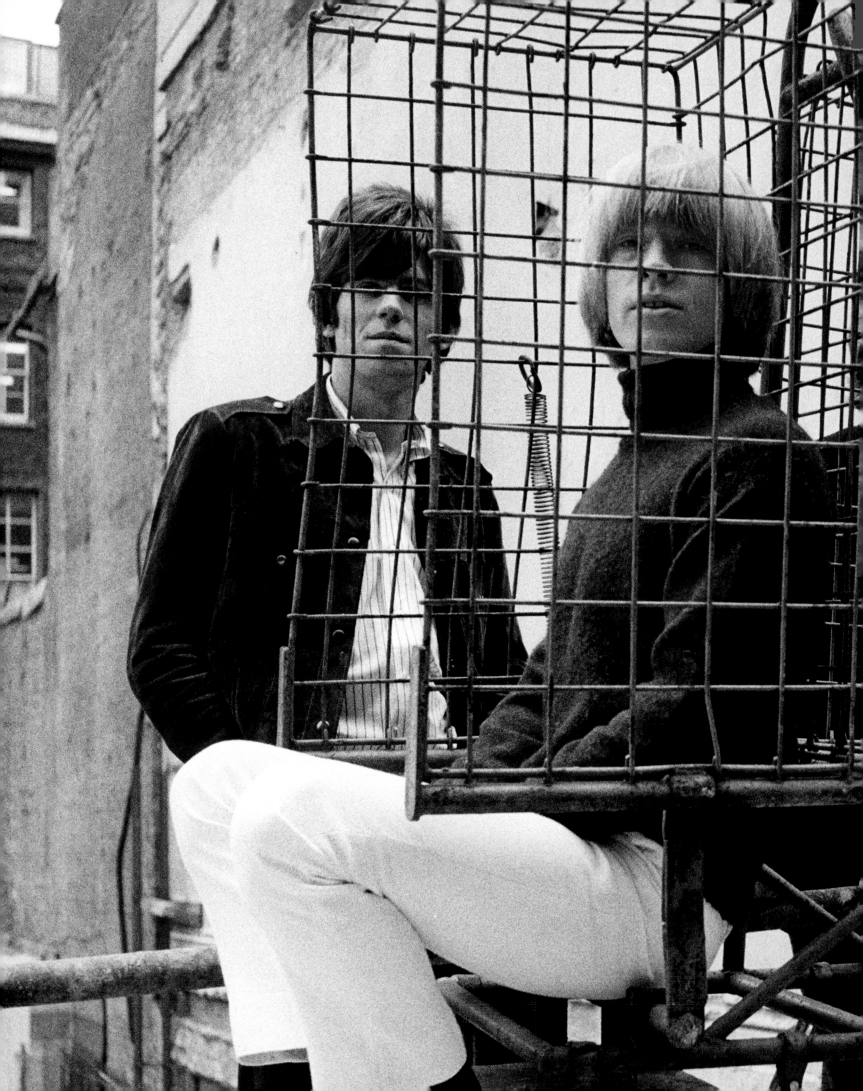

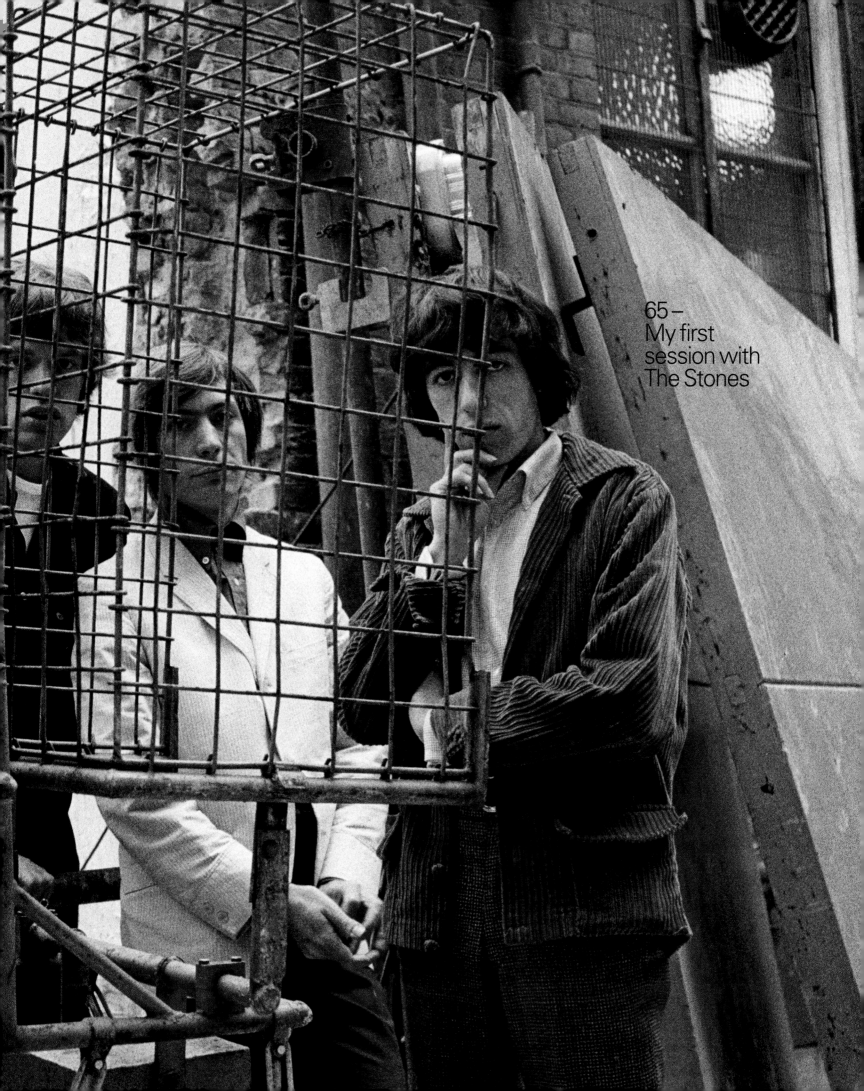

65 –
My first
session with
The Stones

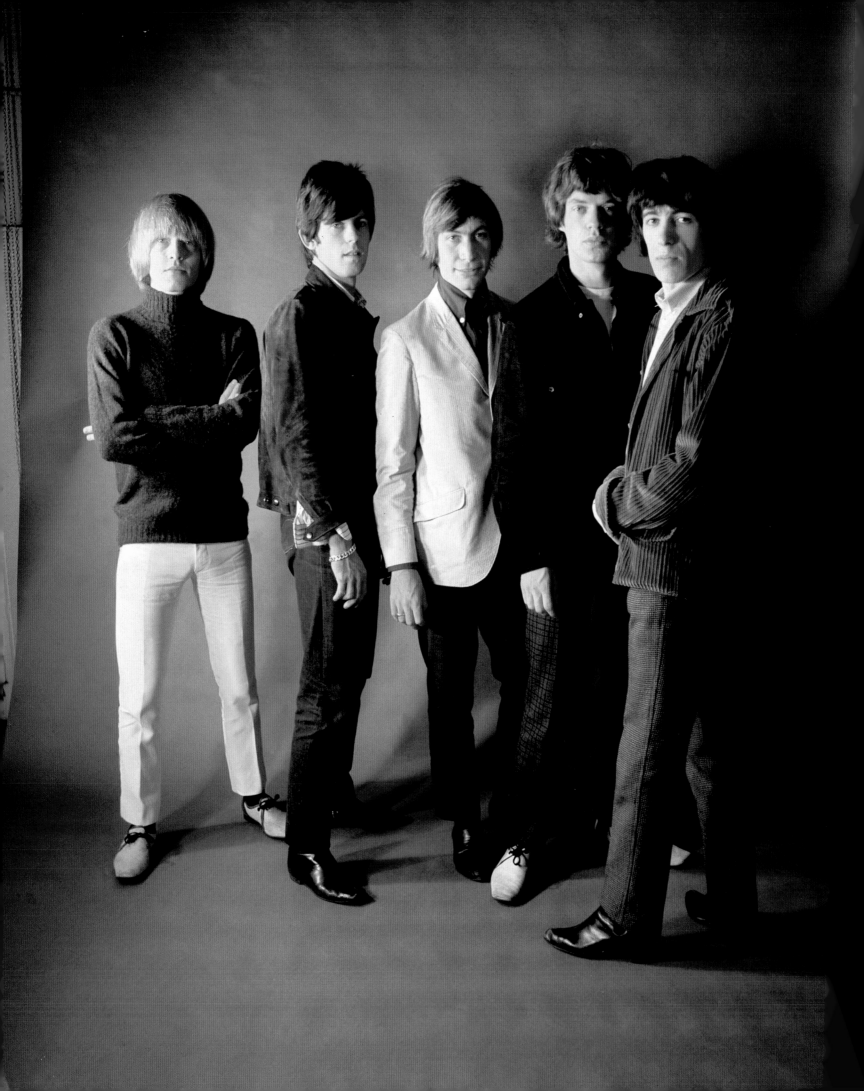

savage animals and should be kept locked up. Andrew was brilliant at exploiting that angle, and at the very first session we'd taken an image which looks as though they're in a cage.

This was the first session. I'd met Brian socially at a place called The Pickwick Club, which was a sort of theatrical, showbiz supper club and discotheque, and he was the first Rolling Stone I met and was very charming and friendly and nice. But it was through Marianne that I started taking photographs of The Stones.

I'd been working with a singing duo called Chad and Jeremy, and they were doing a TV show called *Thank Your Lucky Stars*, which was in Birmingham, and Marianne was there promoting "As Tears Go By". We were all travelling back to London on the train and Jeremy asked Marianne to have dinner with us. I immediately fell in love with her and arranged to photograph her, and then my pictures came to the notice of Andrew, who was managing and producing Marianne, and he asked me if I'd like to work with The Stones. This was in early '65. So I met all of them at the office in Iver Court, near Baker Street, and we broke the ice and set up the first session. They all turned up with Andrew, in my funny

little studio in Mason's Yard, behind Piccadilly. I used to split the sessions, half in the studio and half outside around the studio. I was positioned so that I had Mason's Yard offering various different backgrounds, and also Ormond Yard which was at that time pretty much a building site. There was this huge building being put up, and I photographed the band there.

This picture is an out-take, and it shows the cage that, with careful cropping, made them look like caged animals. This one shows the reality a bit more, but also it shows at the back two boards which were used to block off the building site at night. It was through these boards that I posed the guys for what were to become the *Out Of Our Heads* and *December's Children* record covers.

I don't think the session lasted very long, maybe two or three hours, and somebody produced a football and we had a great kick around. The funny thing was that Andrew was almost harder to deal with than any of the Stones. The band were all very responsive, very co-operative, very nice. There was no hint of moodiness or difficulty.

In those days there was no make-up and no stylist. I didn't even have an assistant. And they weren't so famous that they couldn't mess around in the street without getting mobbed. From my point of view the most important thing was that I was able to produce a lot of material at a time when they needed a lot. They needed a record cover, which I had no real expectation of getting. But I composed everything to make it useable for a cover. And they liked working with me.

Andrew was thrilled because it was such a productive session, and the band were thrilled because it meant they didn't have to do another photo session for a while. It was the beginning of a fantastic three years of being their unofficial-official photographer. They must have felt quite confident in me. And I think also they were quite amused by the fact that I was so young, and that made me no threat. I guess I just fit in. I never asked them why. But we got really good pictures.

65 –
Andrew was thrilled because it was such a productive session; the band were thrilled because they didn't have to do another photo session for a while

This book is dedicated to Julia, Jessica and Rachel.

I would like to thank:
Alex Proud and Rankin for their support.
Briar, Kirk, Sarah, Diana, Emily, Paul, Dave and
Sophie at Vision On; Warren, Ryan and Katie at
Spin; Jefferson and Roger.

This book could never have existed without
Jeremy Clyde, Marianne Faithfull, Tony Calder
and most especially Andrew Loog Oldham.
Finally I want to thank The Rolling Stones for
being the greatest rock'n'roll band in the world!

Photography Gered Mankowitz
Art Direction and Book Design Spin
Reprographics AJD Colour Ltd
Print Toppan Printing Ltd, Hong Kong
Gered Mankowitz interviewed by
Roger Morton
Marianne Faithfull interviewed by
Jefferson Hack

The Stones 65-67 first published in Great
Britain in 2002 by Vision On Publishing Ltd
112-116 Old Street
London EC1V 9BG
T +44 (0)20 7336 0766
F +44 (0)20 7336 0966
www.vobooks.com
info@vobooks.com

ISBN 1 903399 54 8 (softback)
ISBN 1 903399 57 2 (hardback)

Printed in Hong Kong